RUGBY
IN FOCUS

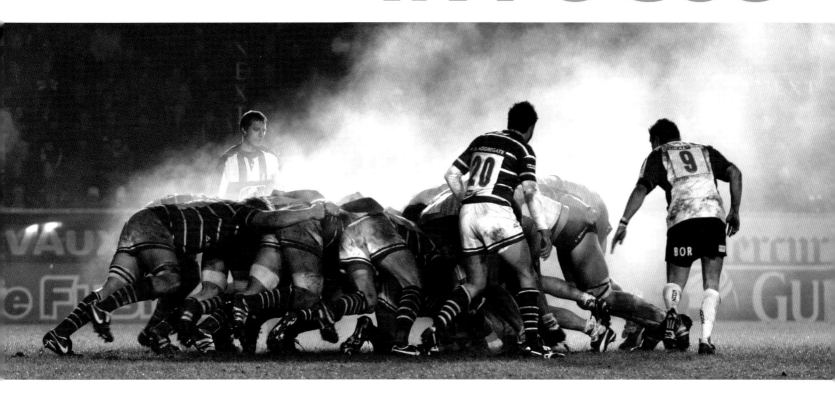

AMMONITE
PRESS

PRESS
ASSOCIATION
Images

First Published 2011 by
Ammonite Press
an imprint of AE Publications Ltd,
166 High Street, Lewes, East Sussex BN7 1XU

Text © AE Publications Ltd
Images © Press Association Image
Copyright © in the Work AE Publications Ltd

ISBN 978-1-90667-258-4

British Cataloguing in Publication Data. A catalogue record of this book is
available from the British Library.

Author: Richard Dewing
Editor: Jimmy Topham
Managing Editor: Richard Wiles
Picture research: Press Association Images
Design: Richard Dewing Associates

Typeset in Myriad MM
Colour reproduction by GMC Reprographics
Printed and bound in China by Hung Hing Printing Co. Ltd
www.ammonitepress.com

1 THE GAME

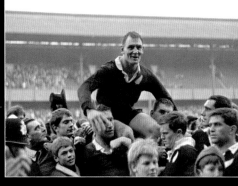

2 THE PLAYERS

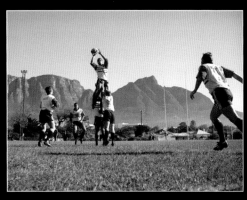

3 THE LIONS

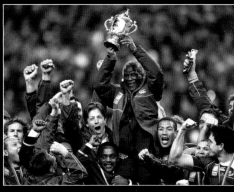

4 THE WORLD CUP

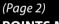

(Page 2)

POINTS MAN

Australian fly-half Michael Lynagh follows through after a kick attempt taken from near the touchline. Lynagh accumulated points at a remarkable rate throughout his career. When he retired in 1995, he held the record for leading all-time points scorer, with 911 points. Until he handed over kicking duties to Marty Roebuck late in his international career, Lynagh had scored in every test in which he had played.

Introduction

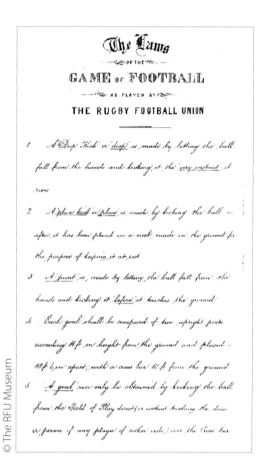

© The RFU Museum

THE 1871 LAWS
Following the formation of the RFU in January 1871, the first written sets of rules were drawn up by three lawyers – all ex-Rugby School pupils – that finally standardised the game of Rugby and can be recognised as the basis of the 'Laws' that are in use today. The original booklet can be viewed in the Rugby Museum at Twickenham Stadium.

In 1838, a form of football where the player handled the ball was being played at Rugby Public School in England. Pupil Jem Mackie was particularly adept at 'running-in' the ball to enable a 'try' at scoring a goal. This was some 15 years after another pupil, William Webb Ellis, had supposedly first picked up a football and run with it. By 1845, running with the ball had been written into the first ever set of rules for 'Rugby football'.

In October 1863, the Football Association met for the first time to standardise a common set of rules in a bid to unite the 'kicking' and 'running' games. The FA rules failed to meet with the approval of the rugby paternity, however, and several clubs, led by Blackheath, refused to join the FA. This was the moment in history when two great sports, football and rugby, went their separate ways. In January 1871, the 21 rebel 'rugby' clubs met in the Pall Mall Restaurant, London, to agree to draw up their own code of practice, and so formed the Rugby Football Union (RFU).

The popularity of rugby quickly spread, and the first international fixture took place between Scotland and England at Raeburn Place in Edinburgh in March 1871, the start of what later would become the Four (England, Ireland, Scotland and Wales), Five (France joined in 1910) and now Six Nations (Italy joined in 2000) Championship. In 1879, the fixture between Scotland and England was established, becoming known as the 'Calcutta Cup' match, in reference to the trophy presented to the winning team, which was made from melted down silver rupees and donated to the Union by the disbanded Calcutta Club of India.

Rugby was not finished with rule changes, however, and by 1895 it was clear to several Lancashire and Yorkshire clubs that their players needed to be compensated for 'broken time', that is losing pay by taking time off work to play the game. Despite their arguments, it was made clear to these clubs that the idea of breaking the amateur ethos was not acceptable to the RFU. As a result, that year 22 clubs met in the George Hotel, Huddersfield and formed the breakaway Northern Rugby Football Union, which by 1901 had become The Rugby League.

The Rugby League pioneered a new 13-a-side version of the game, which quickly spread to Australia and, after the 1905 'All Blacks' tour, New Zealand. The 'split' would last exactly 100 years, and when the RFU finally agreed to a professional game in 1995, the trend of hard-up Union players signing for

League teams was reversed, with former League players Scott Gibbs, Alan Bateman, Jonathan Davies, Jason Robinson and Shontayne Hape becoming dual-code Internationals.

Around the beginning of the last century, the game was spreading quickly, and in response Pierre de Coubertin, generally regarded as the father of the modern Olympic movement, who had been a rugby referee himself, introduced the sport into the 1900 Summer Olympics in Paris. Rugby remained part of the Games through to 1924, with the gold medals going to France in 1900, Australia in 1908, and the USA in both 1920 and 1924. After a 92-year hiatus, rugby, at least in its 'Sevens' variation, will be back at the Rio de Janeiro Olympic Games in 2016.

During the latter part of the 19th century, the game spread from the British Isles to the Empire outposts of South Africa, Australia, New Zealand and Rhodesia (Zimbabwe), as well as to France, the USA, Canada, Germany, Uruguay and Argentina. The first British Isles tour to Australia and New Zealand took place in 1888, while W.E. Maclagan captained the first tour to South Africa in 1891. A New Zealand side, led by captain Dave Gallaher, embarked on their country's first tour to the British Isles, France and Canada in 1905, and set the standard thereafter for 'All Black' rugby by winning 34 matches; but for their infamous disputed try against Wales, they would have remained undefeated.

International touring was now firmly established, and the International Rugby Football Board (established in 1889) oversaw the schedule and became the arbitrator for the laws of the game. To be a member of a touring side was, and still is, the pinnacle of a player's career, and to be an 'All Black', 'Springbok', 'Wallaby' or 'Lion' is to write your name into the history of the game. This is as true today, when the Lions take on the World Champions South Africa on the Highveld, as it was when the New Zealand 'Invincibles', who remained unbeaten in 32 matches, toured the British Isles in 1925.

Twickenham became the home of England rugby in 1909, two years after RFU committee member Billy Williams bought an 'old cabbage patch' or some 10¼ acres of market garden for £5,572 12s 6d. On 2nd October, 1909, the first ever match was played at the newly built stadium, when Harlequins met Richmond. Two famous names of English rugby, Ronald Poulton-Palmer and Adrian

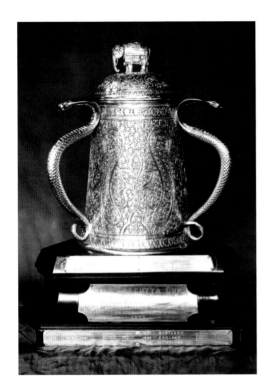

HISTORIC TROPHY
The Calcutta Cup, contested annually by England and Scotland. As the name suggests, the trophy has its origins in India, where, in 1872, a match was played between teams representing England and Scotland, Wales and Ireland. This led to the establishment of the Calcutta Football Club in 1873. When the club disbanded in 1878, its funds were withdrawn from the bank and the silver rupees melted down to make the cup, which was presented to the RFU with the stipulation that it should be competed for annually.

Stoop, both played for the 'Quins', helping their team to a 14–10 win. The first international match to be played at Twickenham came the next year on 15th January, when England beat Wales 11–6.

The two world wars were stumbling blocks in the development of rugby, but they cemented the strong connection between the game and the armed forces. In 1921, King George V unveiled a war memorial at Twickenham to the fallen players of the First World War, and the venue continues to host the annual Army versus Navy match. Twickenham was even put to use as a civil defence depot during the Second World War, when the United Services administered representative fixtures. In 2008, well over 50,000 people attended an invitation charity match, raising £1.1 million for the Help for Heroes campaign to support servicemen wounded in action.

Tradition is a still a strong factor in the game. The Varsity match between Oxford and Cambridge universities was first played as far back as 1872 and continues to this day, although it doesn't feature the same number of future internationals it once did. The Grand Slam and the Triple Crown matches are valued dates on the sporting calendar, as is any Bledisloe Cup match between Australia and New Zealand, while Barbarians fixtures continue to have the same allure today as they have always had.

The Barbarians first graced a rugby pitch on 27th December, 1890, when a scratch fifteen came together to demonstrate the best of the game – flair, courage, spirit and passion. In 1948, the Barbarians were invited to play the Australian team in their last match of the tour. Such was the interest generated by this game, which the Barbarians won 9–6, that it has become customary for every touring side to Great Britain to play their final fixture against the 'Baa-Baas'. These games have produced some memorable moments in rugby history, including the most remarkable try ever scored, by Gareth Edwards against the indefatigable All Blacks in 1973.

It began with an All Blacks attack in the Baa-Baas' 22. Cliff Morgan's commentary captured the passage of sporting excellence: *"Kirkpatrick to Williams. This is great stuff. Phil Bennett covering, chased by Alistair Scown. Brilliant! Oh, that's brilliant! John Williams, Pullin, John Dawes. Great dummy! David, Tom David, the halfway line. Brilliant by Quinnell. This is Gareth Edwards. A dramatic start. What a score!"*

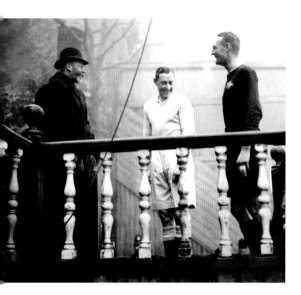

OXBRIDGE TRADITION
The captains of Oxford and Cambridge universities are introduced to King George V before the Varsity Match at The Queens Club in 1919. Held first in 1872, the Varsity Match is one of the world's longest-running sporting fixtures.

The last 25 years have seen a huge shift in the growth of the game: 1987 saw the staging of the first World Cup. The 1995 World Cup in South Africa arguably changed the political course of a nation, when Nelson Mandela wore the jersey of Afrikaner captain Francois Pienaar as he presented him with the Webb Ellis Trophy. The game has spread to such diverse nations as Fiji, Ukraine, Samoa, Romania, Spain, Portugal, Japan, Kenya, Tonga, Namibia and China. In fact, there are now 95 nations on the International Rugby Board World Ranking List. The first Women's International took place in 1987, and the 'RFUW World Cup' started in 1991, the USA beating England 19–6 in the final in Cardiff.

The 'Open' era began in 1995 when the last rules maintaining amateurism were swept away and the game became a fully professional sport. The major club sides joined a 'Premiership', among them a couple of the original founding members of the RFU, Harlequins and Wasps. Sadly, several of the big clubs that were successful in the amateur era have failed to flourish and have returned to their original status, such as Blackheath, Richmond, Bedford and London Welsh.

In 1996, a year after the sport turned professional, a global contest between Australia, New Zealand and South Africa, the 'Tri-Nations', was established. In addition to this, the best teams in the three nations play in their own professional league, the 'Super 14', featuring four teams from Australia, and five each from South Africa and New Zealand.

With the expansion of both men's and women's rugby around the world, the strength and quality of international competition, and the revival in 'Sevens' rugby, all backed by a strong amateur base, the sport has never been healthier. Add to this the increased interest in the game through extended media coverage and the boost of the Seventh World Cup in New Zealand, and all the indicators point to continued growth in the years ahead.

Rugby in Focus not only encapsulates this fascinating history as a visual record, but also illustrates the power of the photographer to capture the moment. In many ways, the pictures speak for themselves, but captions are included to provide context and to add another level of insight. In the case of rugby, photographs vividly demonstrate the endeavour required and the excitement generated in this ultimate of team games. The skill of the participant is matched by the skill of the photographer as he records another stepping stone in a fascinating journey.

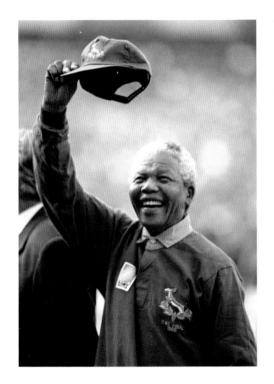

TRULY HISTORIC MOMENT
South African President Nelson Mandela waves to the crowd just before kick-off in the Rugby World Cup Final between New Zealand and South Africa on 24th June, 1995. The match, won by South Africa 15–12, was the culmination of a remarkable tournament that came to symbolise the reconciliation of communities in newly-democratic South Africa.

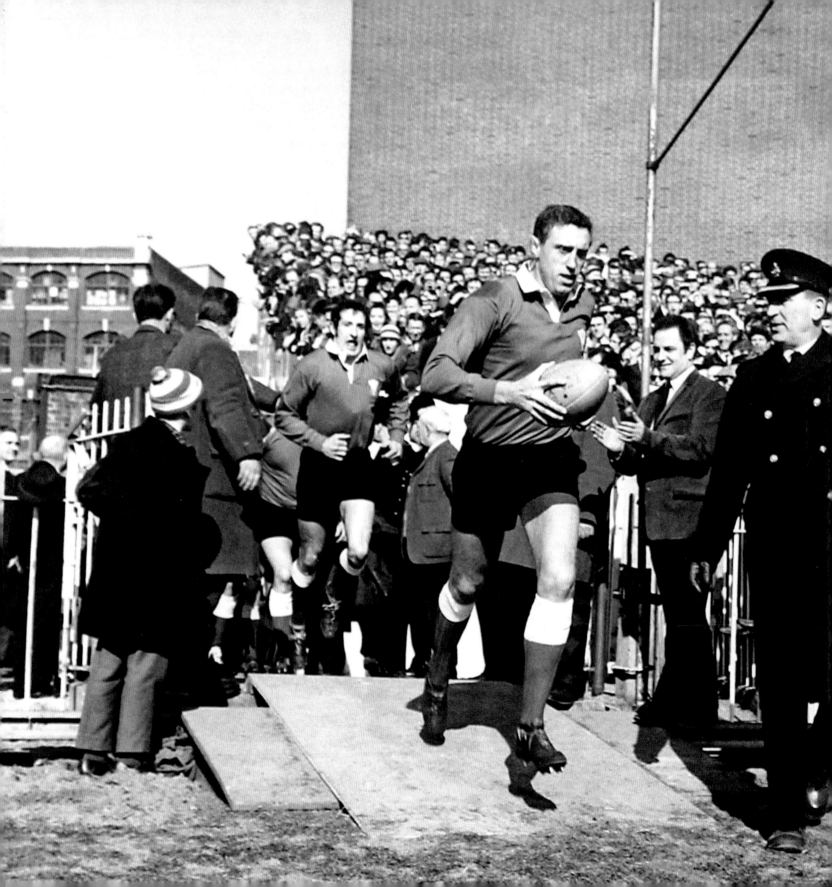

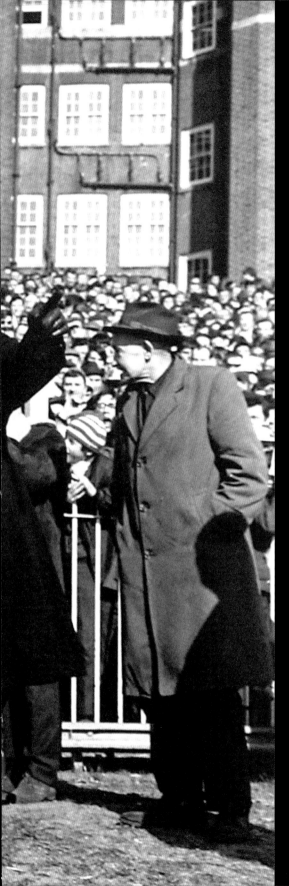

1 THE GAME

A photograph means most to the viewer when it perfectly captures the 'moment'. In the game of rugby there are many such 'moments'.

Witness the lineout jumper frozen in time high in the air, or the steam rising as a tribute to the work rate of the forwards in the scrum. Feel the crunching physicality at the point of contact, be it in the tackle, in the ruck or maul. Focus on the skill of a side step and the elation on scoring the try. Behold the pride in performance, the pain of defeat and the joy of victory.

All this endeavour, energy and emotion is illustrated in the following pages.

PRIDE OF WALES
Wales captain Brian Price leads his team out to face Ireland in the Five Nations Championship. The game ended 24–11 and Wales went on to secure their 16th Five Nations Championship, taking the Triple Crown on their way to the title. They only lost out on winning a Grand Slam by a single point, after an 8–8 draw against France in Paris.

Date: **8th March, 1969**
Venue: **The Arms Park, Cardiff**

THE KICKING GAME

Wales's George Davies (second R) attempts a difficult conversion in the game against England during the British and Irish Championship. Accustomed to playing at centre, Davies was switched to fullback for the three victories against England, Scotland and Ireland in Wales's 1905 Triple Crown triumph.

Date: **14th January, 1905**
Venue: **The Arms Park, Cardiff**

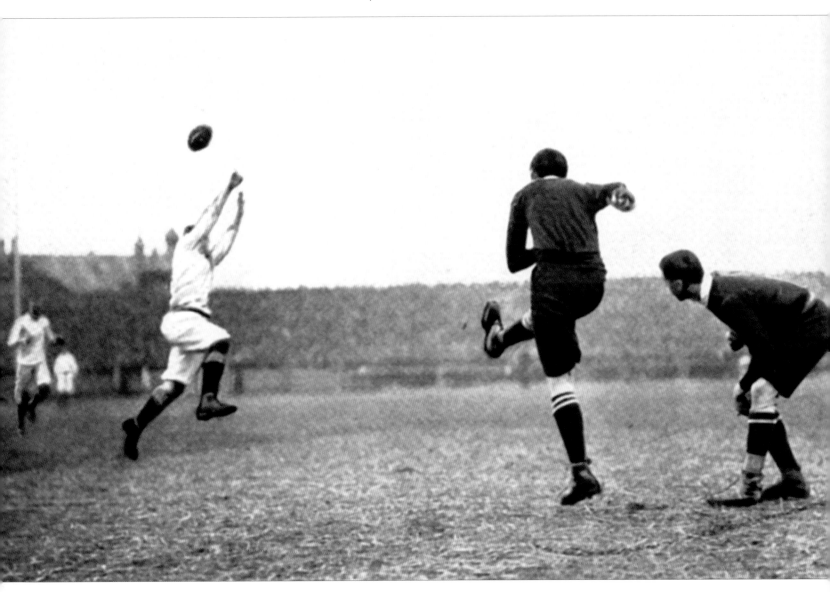

THE COUNTRY EXPECTS
(L–R) Lord Howe (third L), Prime Minister Herbert Asquith, King George V and Arthur Hartley (President of the Rugby Association) watch the Five Nations Championship match between England and Ireland.

Date: **14th February, 1914**
Venue: **Twickenham, London**

TWICKERS *(over page)*
A view of Twickenham before the match between England and New Zealand. Known affectionately as 'The Cabbage Patch', a reference to what was grown on the land before construction of the stadium, Twickenham played host to its first international match on 15th January, 1910, between England and Wales.

Date: **3rd January, 1925**
Venue: **Twickenham, London**

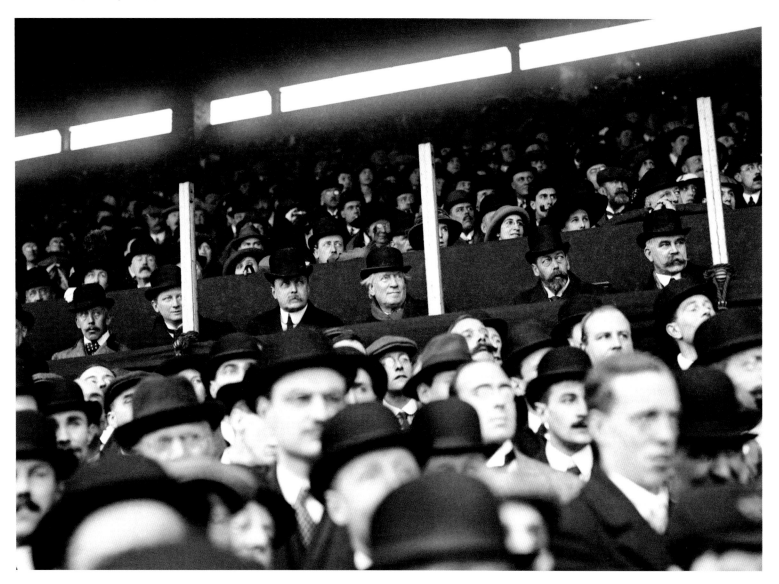

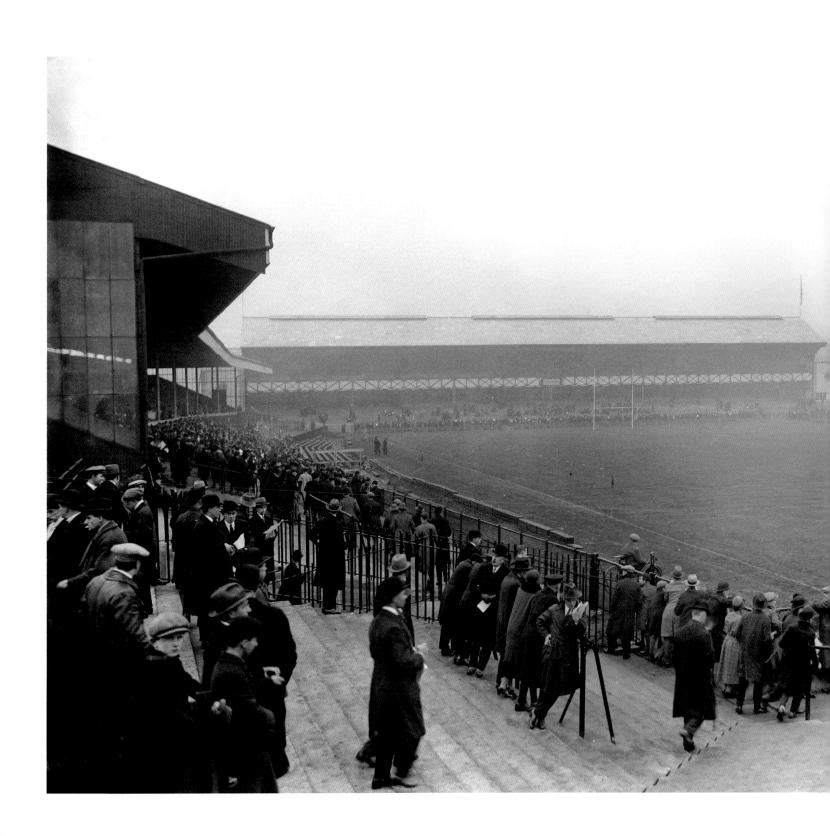

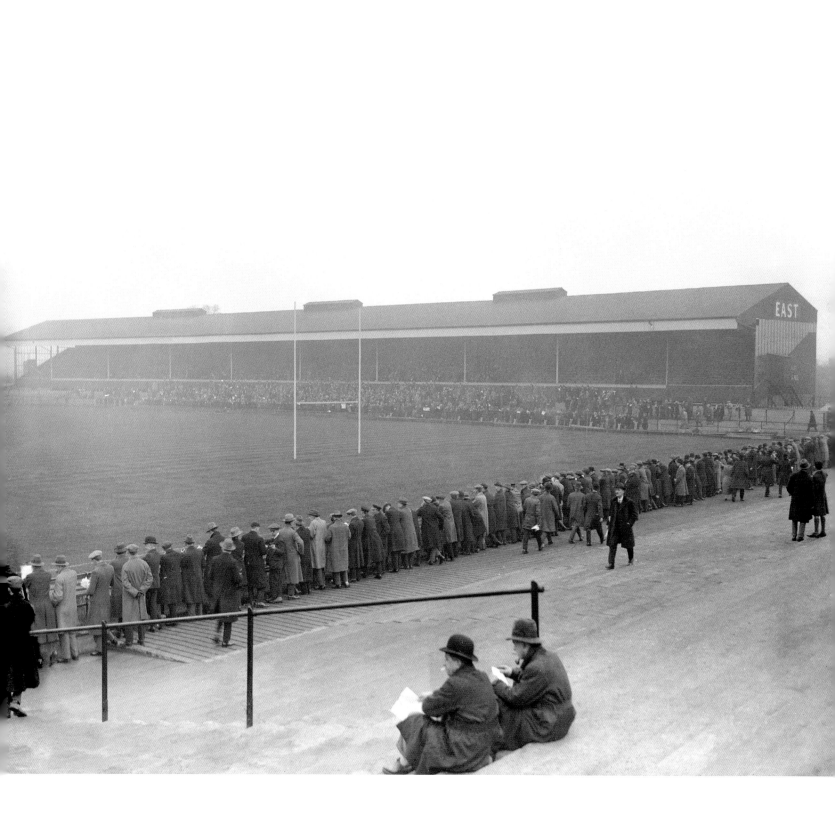

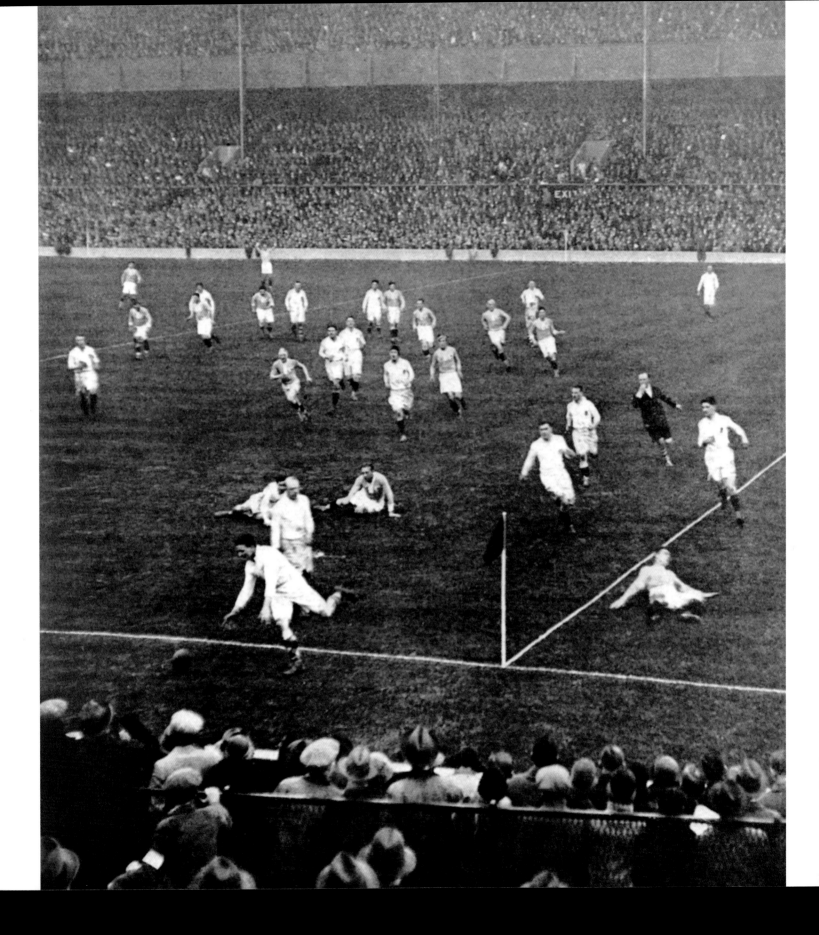

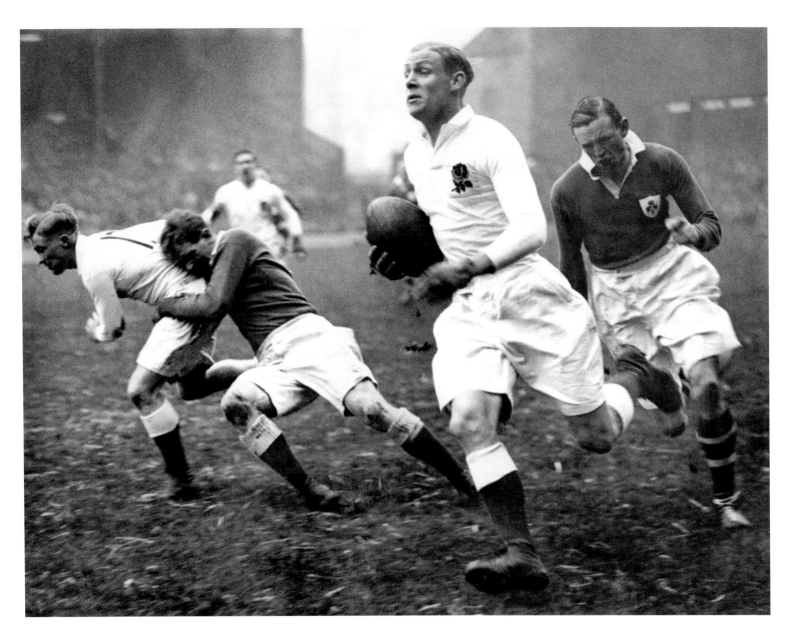

CLOSE RUN THING

A French attack breaks down by the corner flag in a Five Nations Championship match against England. The English eventually ran out 18–8 winners.

Date: **25th February, 1928**
Venue: **Twickenham, London**

THE LINE BECKONS

England's Peter Cranmer (second R) outstrips Ireland's David Lane (R) after receiving a pass from team-mate Roy 'Bus' Leyland (L). Cranmer, a talented all-round sportsman, captained Warwickshire County Cricket Club in addition to playing rugby, and he decided to concentrate wholly on cricket after the Second World War. Playing at centre three-quarter, he was capped 16 times by England, and was part of the Triple Crown winning sides of 1934 and 1937.

Date: **9th February, 1935**
Venue: **Twickenham, London**

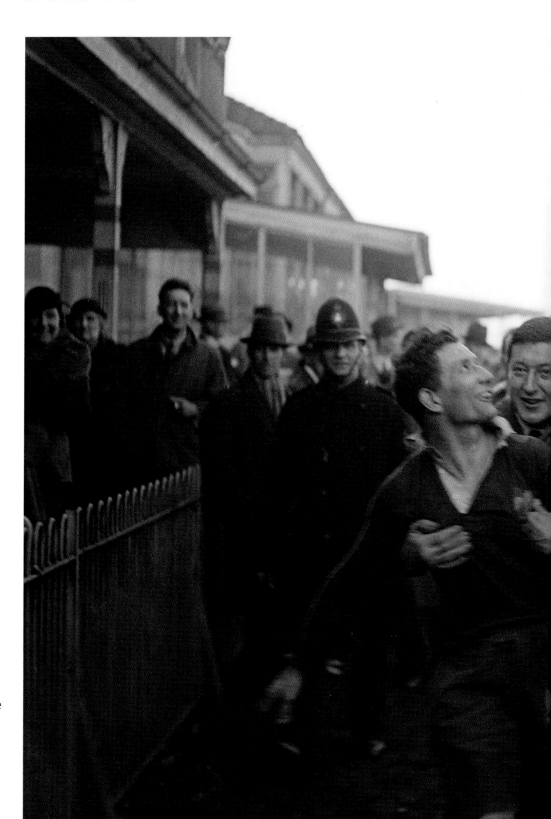

HOSPITALS RUGBY CUP

W.E. Henley, Captain of St Mary's Hospital, with the Hospitals Rugby Cup, being chaired by members of the team after the 11–3 victory over King's College Hospital. The Cup is still fought for by the five London medical schools' first teams: St Bartholomew's and The Royal London; King's College London Medical School; St George's, University of London; Imperial College School of Medicine; and Royal Free and University College Medical School.

Date: **20th March, 1935**
Venue: **Richmond Athletic Ground, London**

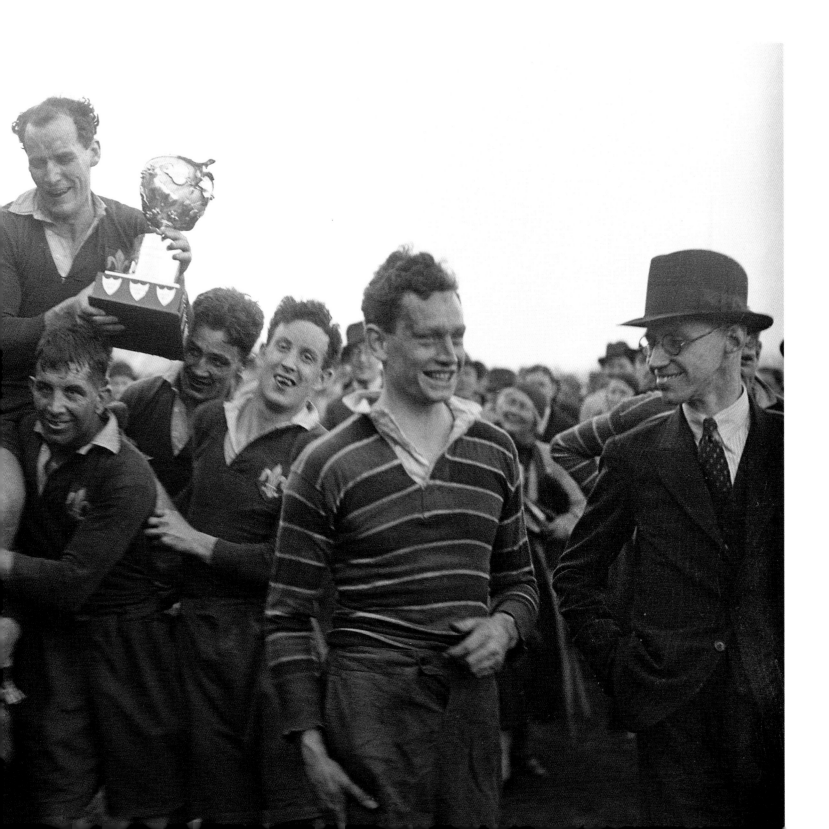

PRINCE OF WINGERS

Prince Alex Obolensky (R) dives to make a tackle. Obolensky, a member of the Rurik Dynasty of Kievan Rus, gained British citizenship in 1936 and represented England a total of four times before his international career was cut short by the Second World War. On the outbreak of war, Obolensky joined the RAF and was killed during training in 1940. He was aged 24. He is perhaps best known for his international debut in 1936, during which he scored two tries in England's first ever victory over the All Blacks. His first try, a dazzling run of three-quarters of the length of the pitch, was regarded as the greatest try of the time.

Date: **5th November, 1937**
Venue: **Unknown**

BILLY'S CABBAGE PATCH

C.S. Bongard (L), RFU Committee member, and Billy Williams, the purchaser of the land on which Twickenham was built, on their way to watch Harlequins v Richmond and Blackheath.

Date: **10th November, 1945**

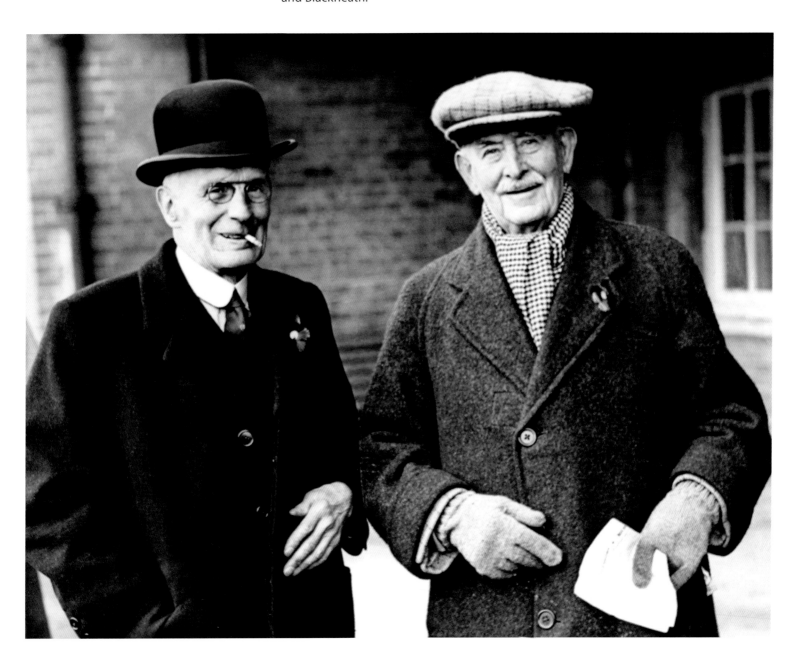

FULL TO THE RAFTERS

England and Scotland line up for the pre-match playing of *God Save The King* before their Five Nations encounter. England dominated the game and ran out 24–5 winners. The 1947 championship, won by Wales on points difference from England, marked the return of France to the Five Nations after a 16-year absence.

Date: **15th March, 1947**
Venue: **Twickenham, London**

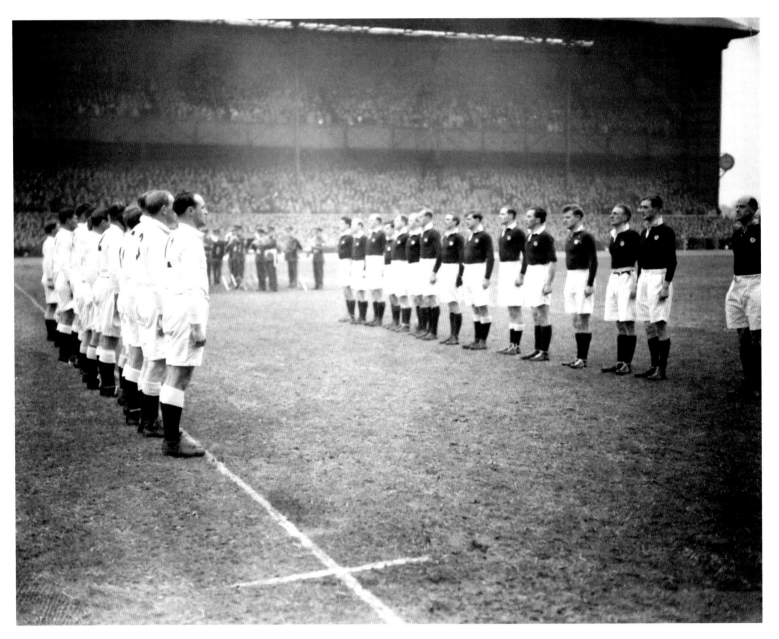

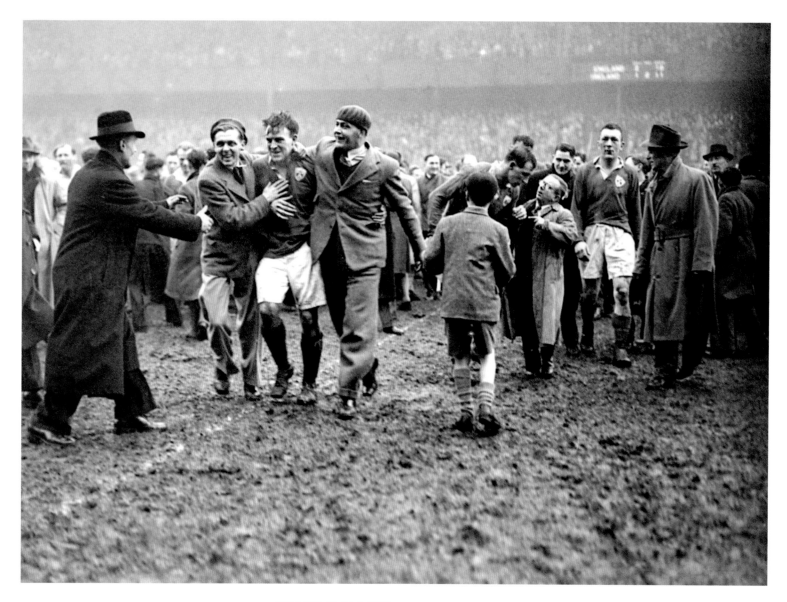

GRAND SLAM JOY

The Ireland players are mobbed by jubilant fans at the final whistle, after they had held off England 11–10 in a thrilling encounter. The Irish won all four of their matches in the 1948 Five Nations Championship, securing a Grand Slam, a feat they would not repeat until 2009.

Date: **14th February, 1948**
Venue: **Twickenham, London**

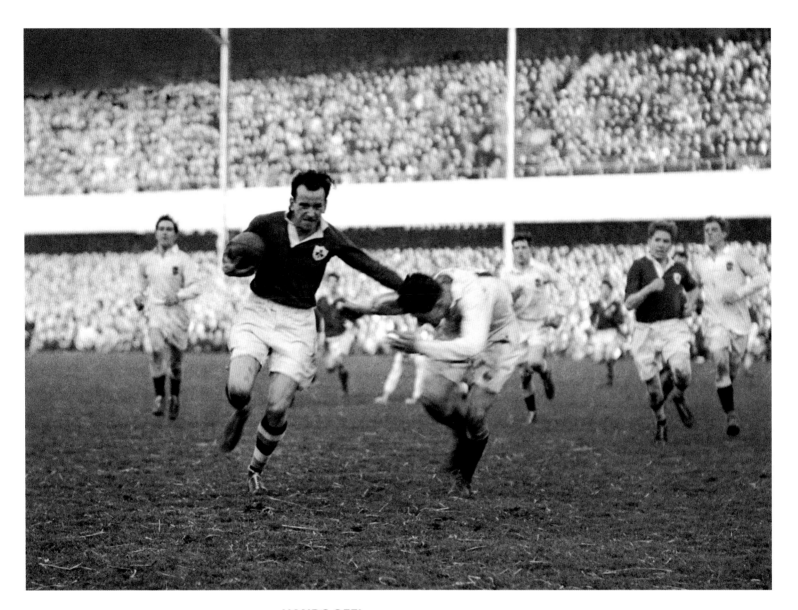

HANDS OFF!

Ireland's Mick Lane (L) evades a tackle from England's Barry Holmes during the 1949 Five Nations Championship. Ireland triumphed 14–5 and went on to retain the championship they had won the previous year. A solitary defeat at home to France cost them the chance to secure back-to-back Grand Slams.

Date: **12th February, 1949**
Venue: **Lansdowne Road, Dublin, Ireland**

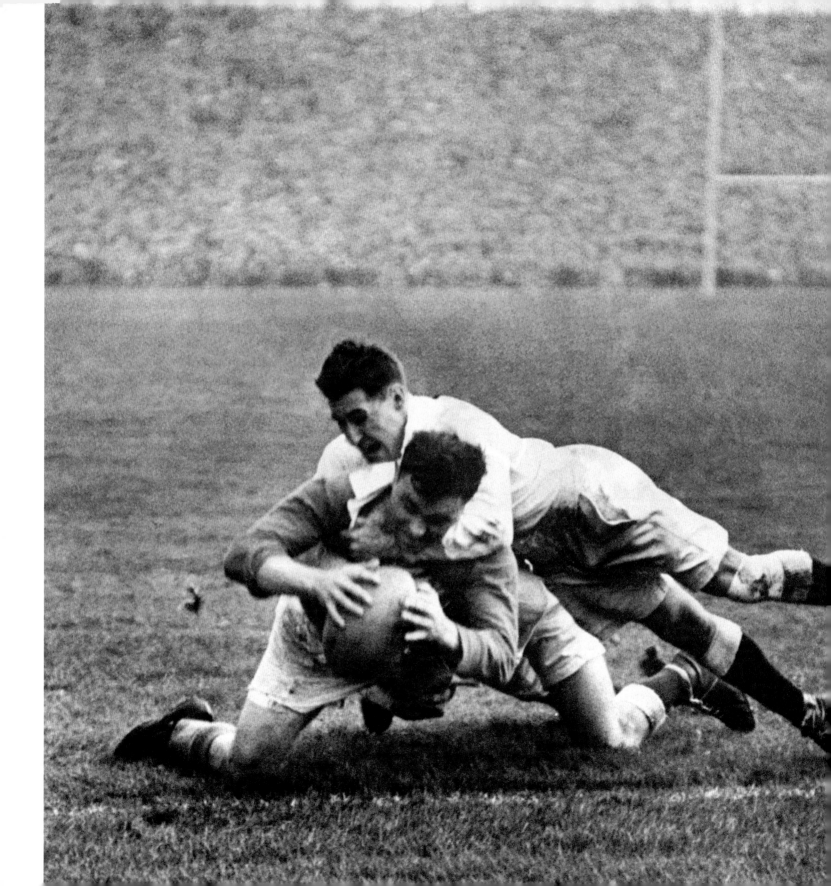

CROSSING THE LINE

Cliff Davies of Wales (L) scores Wales's first try, despite a desperate last-ditch tackle by Gordon Rimmer of England. Davies, a short, combative prop, played for Cardiff and represented his country on 16 occasions. He was selected for the British Lions tour of Australia and New Zealand, but played in only one game.

Date: **21st January, 1950**
Venue: **Twickenham, London**

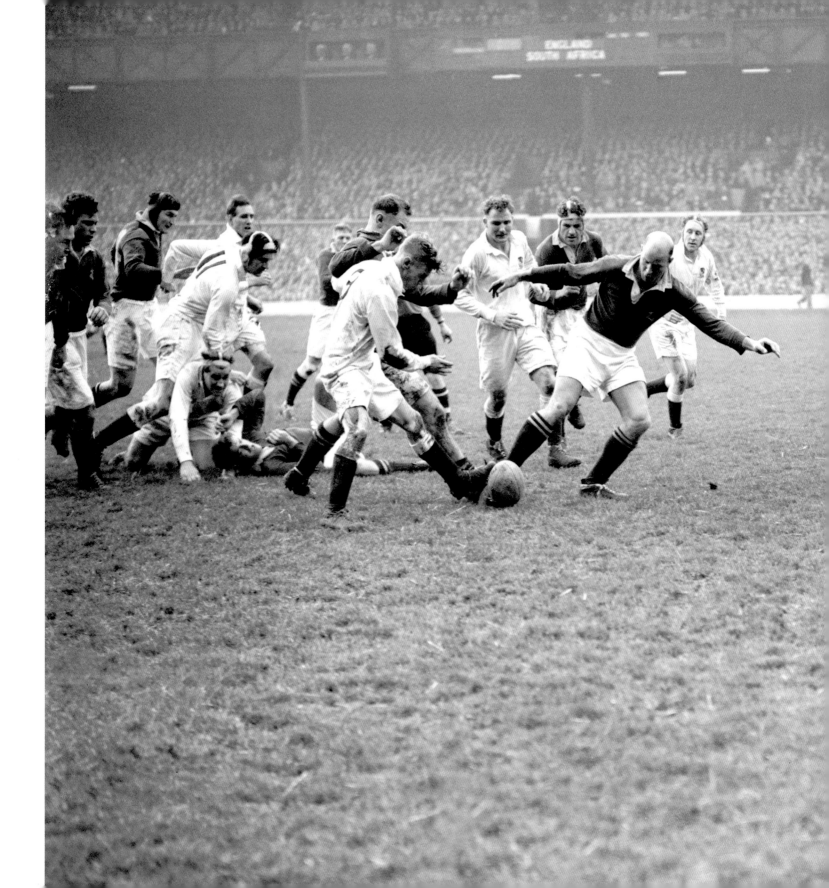

PUTTING BOOT TO BALL
South Africa's Basie van Wyk (C) demonstrates his football skills as he kicks the ball on during a Test Match against England. The South African team of 1951–52 is considered one of the finest Springbok line-ups of all time, losing just one match (against London Counties) out of 31 on their tour of Britain and France.

Date: **5th January, 1952**
Venue: **Twickenham, London**

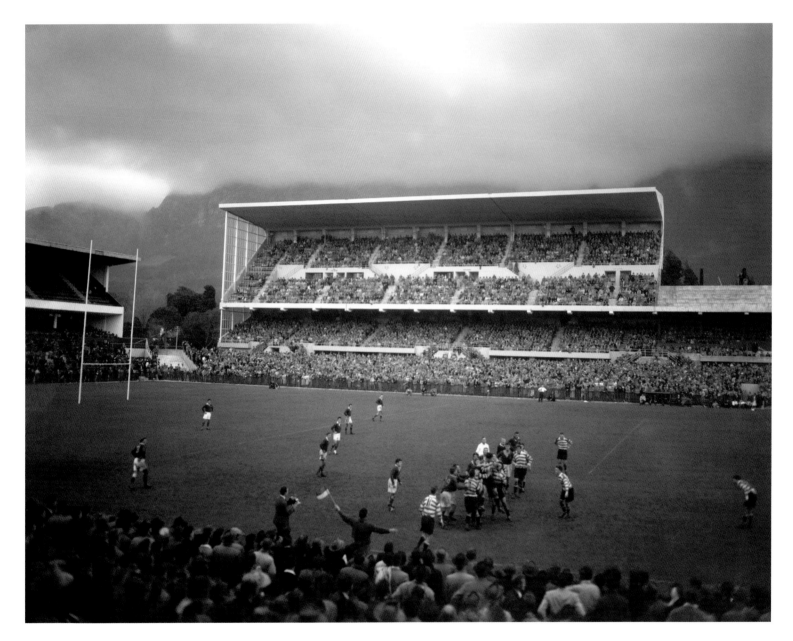

BENEATH TABLE MOUNTAIN

Low cloud obscures the summit of Table Mountain as Western Province take on the touring Australian side. The 1953 tour to South Africa would be disappointing for Australia, who lost the four-match test series 3–1. Their one victory over South Africa was secured at Newlands in Cape Town, where they emerged 18–14 winners in a tight encounter.

Date: **26th July, 1953**
Venue: **Newlands, Cape Town, South Africa**

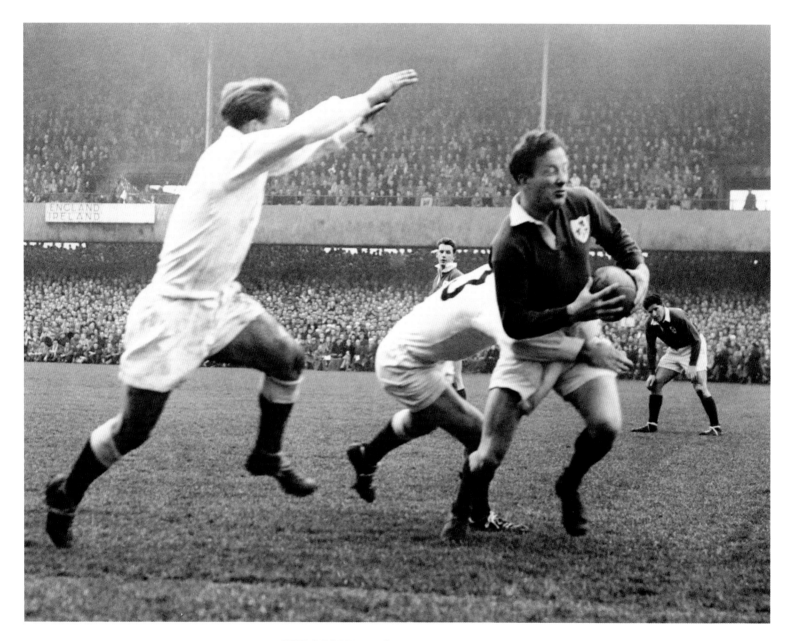

JEEPS IN THE FAST LANE
England's Dickie Jeeps (L) flies in to add his weight as team-mate Jeff Butterfield (C) tackles Ireland's Jackie Kyle. England ran out 6–0 winners and went on to secure a Grand Slam.

Date: **9th February, 1957**
Venue: **Lansdowne Road, Dublin, Ireland**

CHAMPAGNE MOMENT

French fans spray champagne on their cockerel mascot on the Twickenham pitch before the game against England. France secured a crucial draw at the home of English rugby on their way to a maiden Five Nations Championship title.

Date: **28th February, 1959**
Venue: **Twickenham, London**

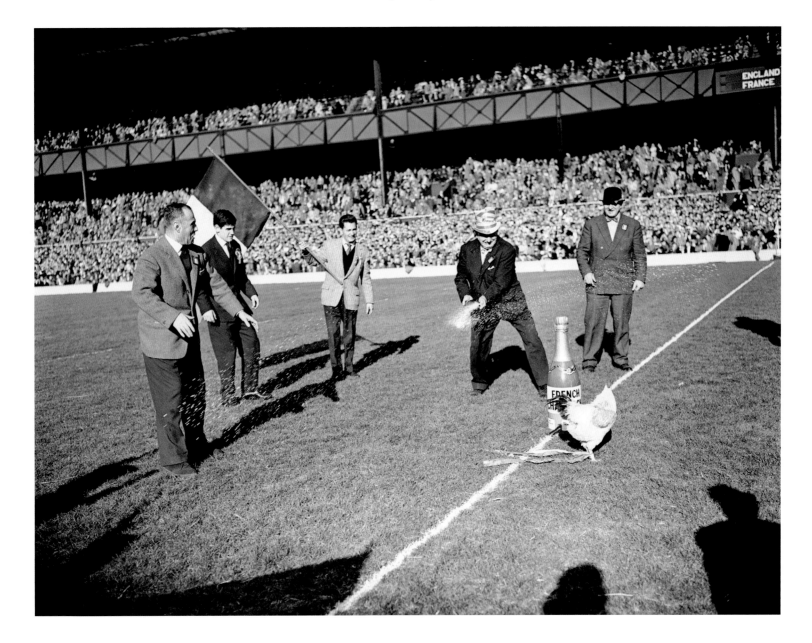

ALLEZ LES BLEUS

France's Antoine Labazuy (C) kicks a penalty to score France's only points in a 3–3 draw with England, watched by team-mate Christian Darrouy (R). The kick would prove vital, with France securing their first Five Nations Championship by a single point. In a particularly low-scoring championship, France were the only team to achieve double figures in 1959, beating Wales 11–3 in Paris.

Date: **28th February, 1959**
Venue: **Twickenham, London**

EMERGING TALENT

Wales's Phil Bennett (R) is tackled by England's R.E. Smith during a Schoolboy International. Bennett went on to represent his country at senior level 29 times at fly-half, scoring 166 points, and delighting crowds with his skill and agility. He played club rugby for 16 seasons with Llanelli, and was inducted into the International Rugby Hall of Fame in 2005.

Date: **11th March, 1964**
Venue: **Twickenham, London**

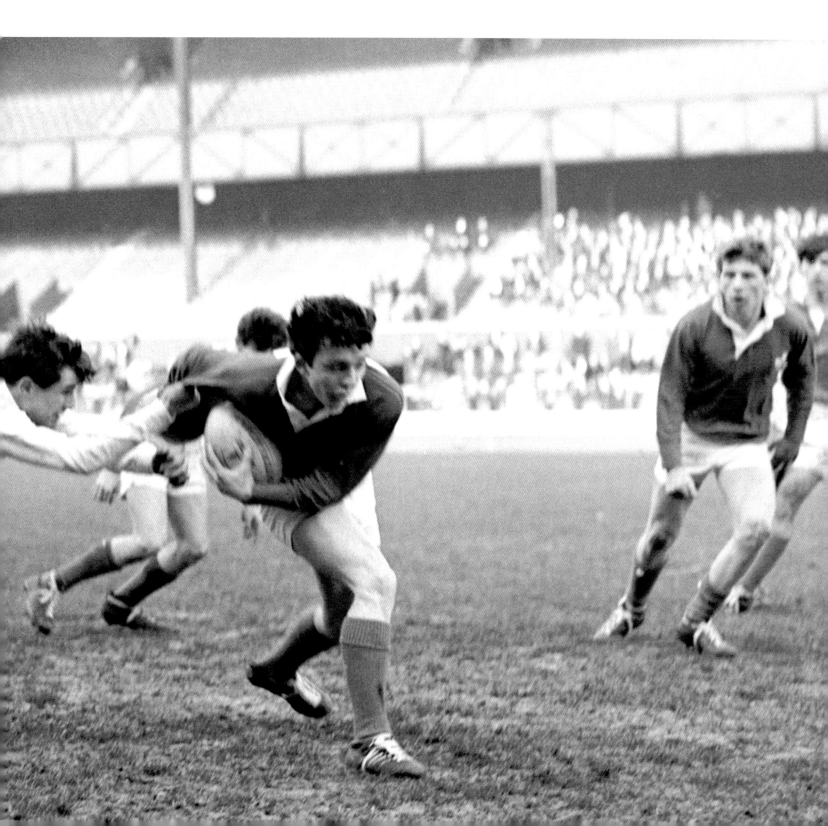

STUDENTS OF THE GAME

Oxford University's John Coker (dark shirt, on ground, R), the first black African to 'win a Blue', is bundled into touch just short of the line in the Varsity Match against Cambridge University. The game ended in a draw, one of fourteen contests to end all square since the first match in 1872.

Date: **7th December, 1965**
Venue: **Twickenham, London**

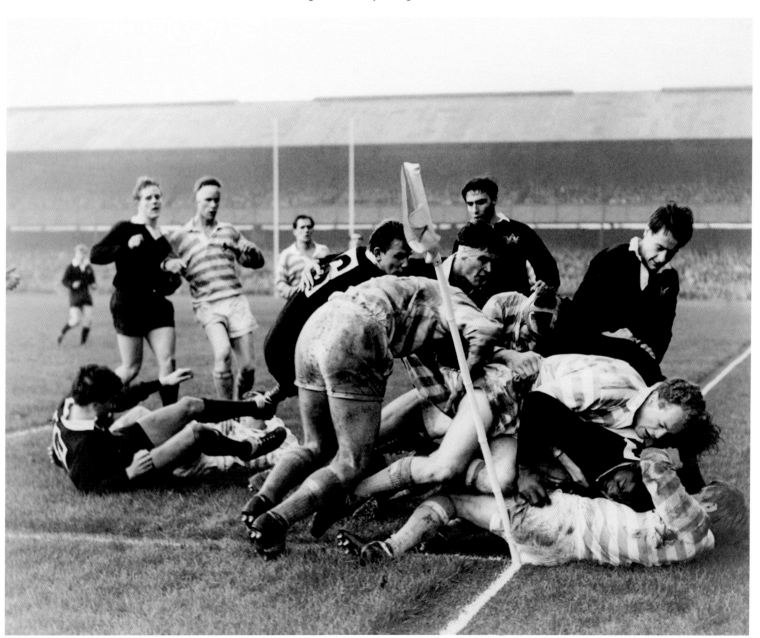

HOMEWARD BOUND

New Zealand captain Brian Lochore (L) leads his team-mates in a farewell *haka* before boarding the plane home. The All Blacks won the three Test Matches they played on British soil, and the tour was part of New Zealand's 17-match Test winning streak between 1965 and 1970, the longest winning run by any rugby nation at the time. South Africa equalled the achievement between 1997 and 1998, and Lithuania surpassed it in 2010, when they secured their 18th straight victory with a win over Serbia.

Date: **18th December, 1967**
Heathrow Airport, London

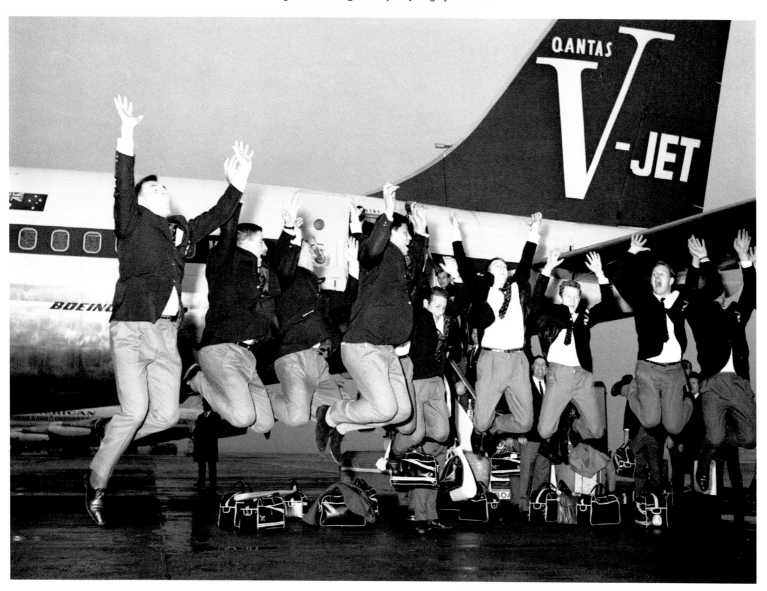

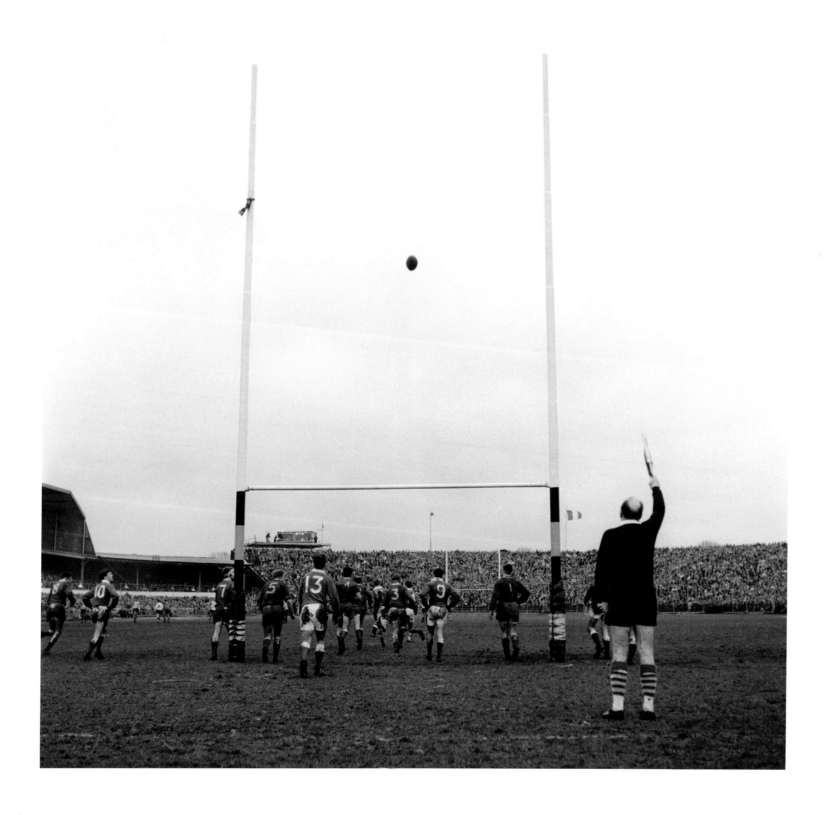

BISECTING THE UPRIGHTS

The ball sails between the posts as France's Guy Camberabero converts his team's second try against Wales in the Five Nations Championship. The game finished 14–9 to France, securing them a Grand Slam and their fifth Five Nations Championship title.

Date: **23rd March, 1968**
Venue: **The Arms Park, Cardiff**

TRUE LEADER

Making his 56th appearance for his country, a world record at the time, Ireland captain Willie John McBride leads his men out for the Five Nations Championship match against England. Ireland ran out 26–21 winners in an entertaining game, and secured their eighth Five Nations Championship title with a 9–6 win over Scotland in their final game.

Date: **16th February, 1974**
Venue: **Twickenham, London**

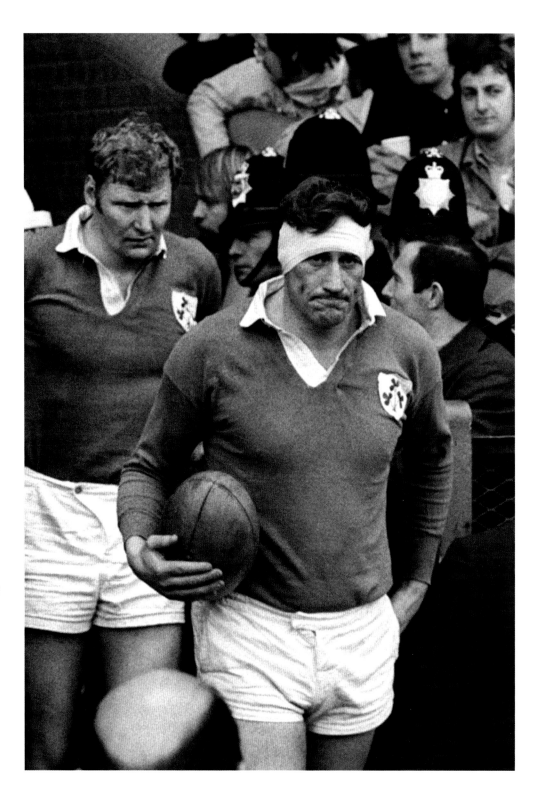

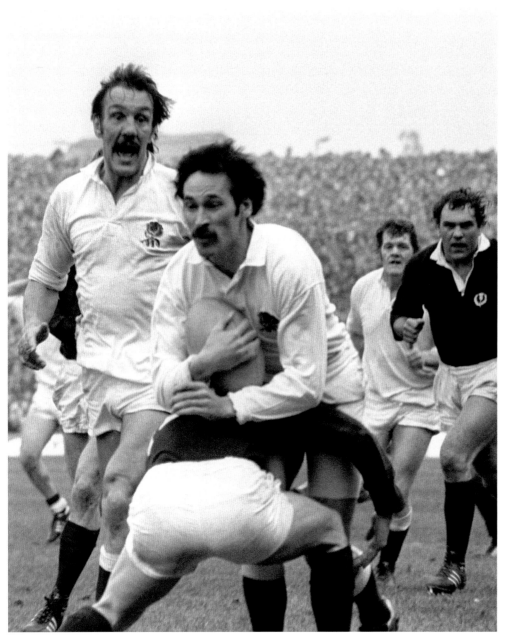

ENGLAND HALTED

England's Roger Uttley (L) looks on as team-mate Mike Slemen runs into the tackle of Scotland's Keith Robertson during the Calcutta Cup clash. England's 30–18 victory over the *auld* enemy clinched an 18th Five Nations Championship title and their first Grand Slam since 1957.

Date: **15th March, 1980**
Venue: **Murrayfield, Edinburgh**

WOODWARD CUTS THROUGH

England's Clive Woodward (C) touches the ball down to put his team ahead, before Scotland's James Calder (R) can tackle him. England triumphed 23–17 to secure the Calcutta Cup. William 'Dusty' Hare's kicking proved decisive in a close contest.

Date: **21st February, 1981**
Venue: **Twickenham, London**

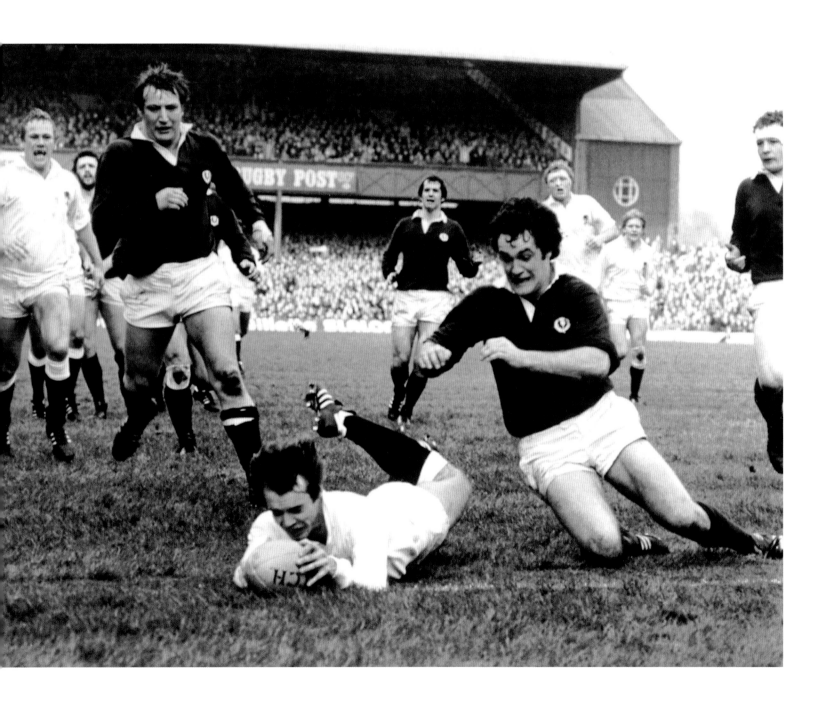

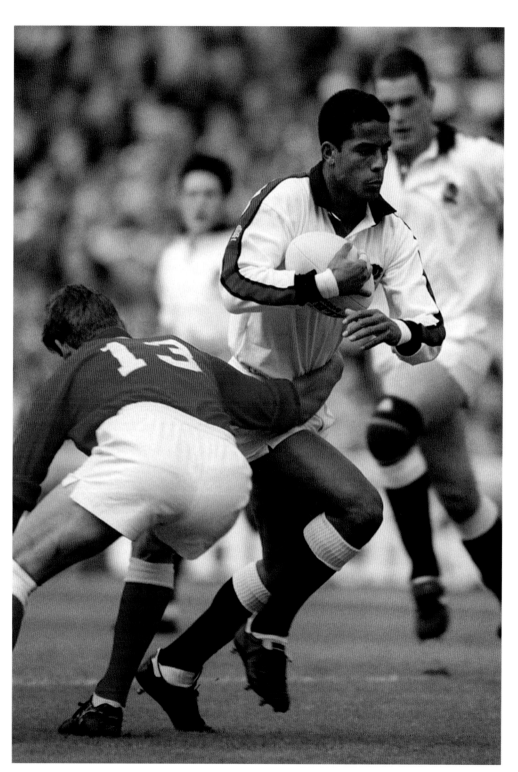

STYLISH GUSCOTT

Jeremy Guscott of England bursts through a Canadian tackle. The game was notable for being held at Wembley Stadium, the home of English football, while redevelopment work was being carried out at Twickenham.

Date: **17th October, 1992**
Venue: **Wembley Stadium, London**

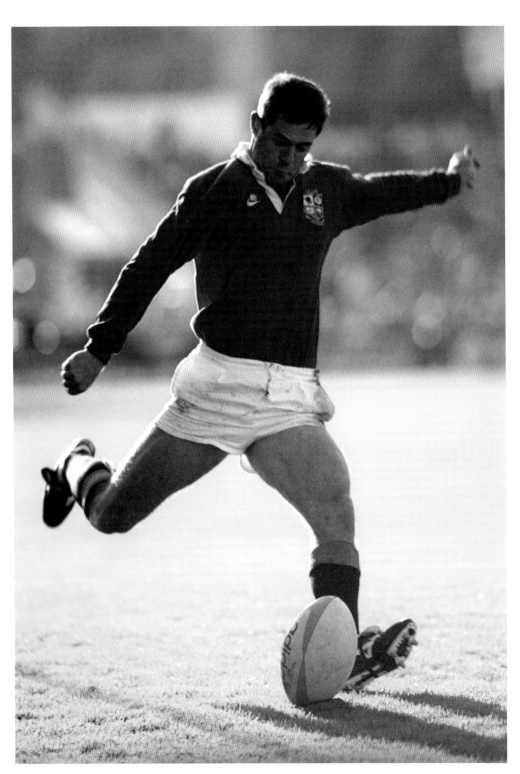

SCOTTISH LION

Gavin Hastings poised to kick for the British Lions in the tour match against Otago in New Zealand. The Lions lost the match 37–23 and lost the three-match test series against the All Blacks 2–1, with losses in Christchurch and Auckland. They won the second test match in Wellington.

Date: **5th June, 1993**
Venue: **Carisbrook, Dunedin, New Zealand**

COMMETH THE HOUR...

Francois Pienaar, the South African flanker and captain, talks to the pack during the opening match of the 1995 World Cup against Australia. The home nation ran out 27–18 winners, with tries from Joel Stransky and Pieter Hendriks. The South Africans went on to triumph in the final over New Zealand, leading to one of the most iconic trophy presentations in the history of sport. Nelson Mandela, wearing the Springbok shirt that had been the preserve of South Africa's white community, handed over the Webb Ellis Trophy to a delighted Pienaar.

Date: **25th May, 1995**
Venue: **Newlands, Cape Town, South Africa**

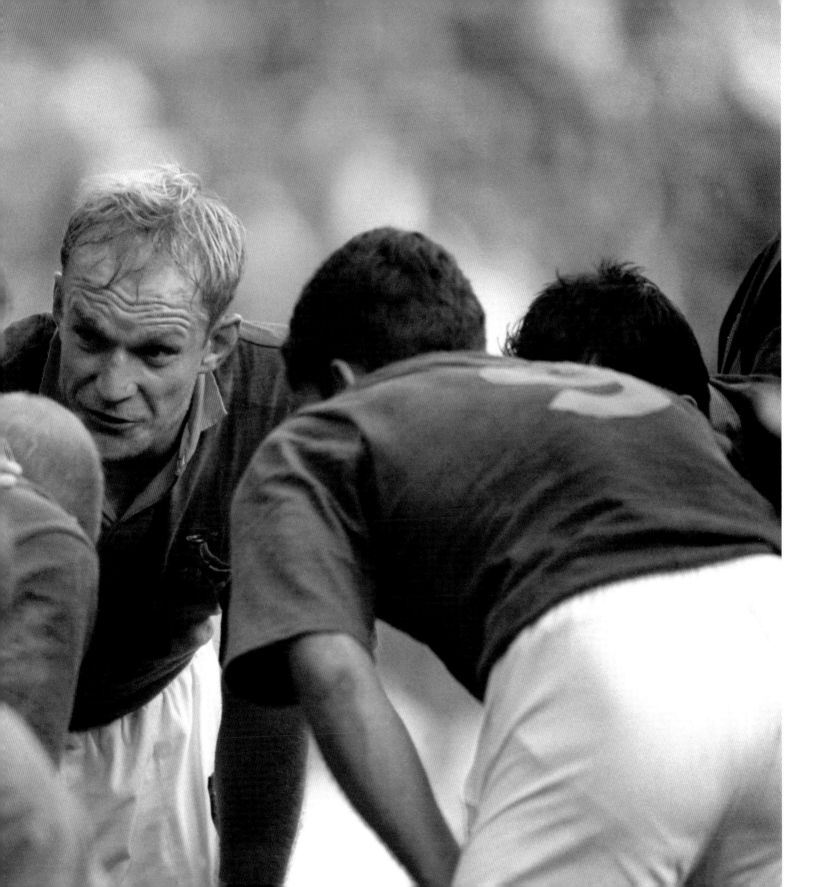

MAKING A SPLASH

All Black captain Sean Fitzpatrick runs
at Scotland's Doddie Weir (L) and Barry
Stewart (R) during a 36–12 triumph. It was
a repeat of the result in Dunedin a week
before, which saw the All Blacks run out
62–31 winners.

Date: **22nd June, 1996**
Venue: **Eden Park, Auckland, New Zealand**

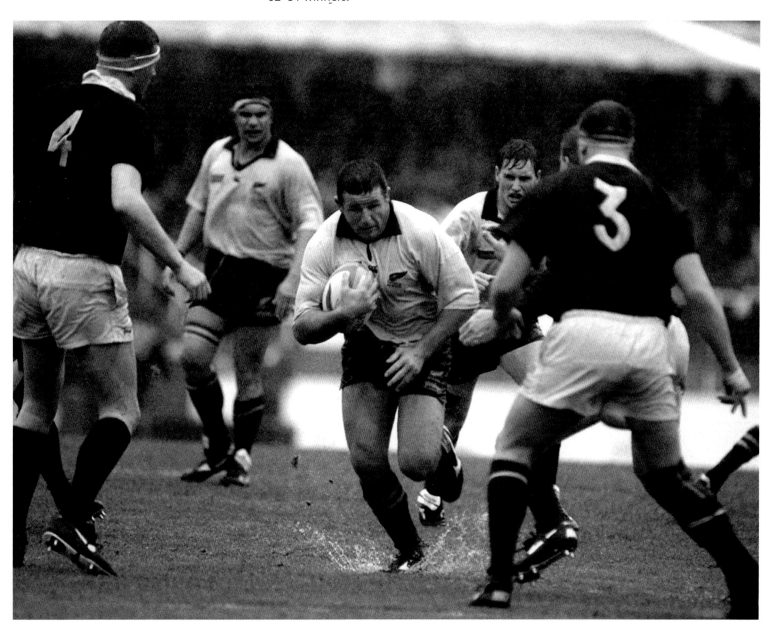

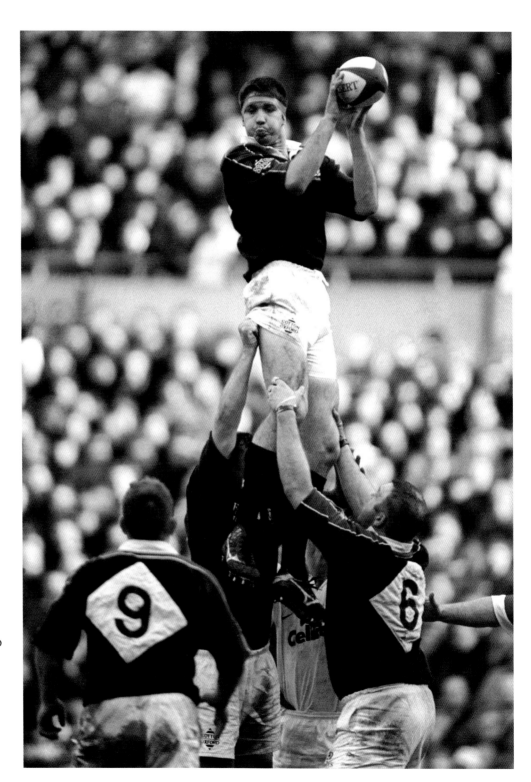

REACH FOR THE SKY

Scotland's Scott Murray wins the line-out ball with a little help from his team-mates in the Five Nations Championship match against England. Despite a thrilling 24–21 victory for the English, Scotland went on to secure the title, notable for being the last Five Nations Championship; the following year, Italy joined the tournament, and the Six Nations Championship was born.

Date: **20th February, 1999**
Venue: **Twickenham, London**

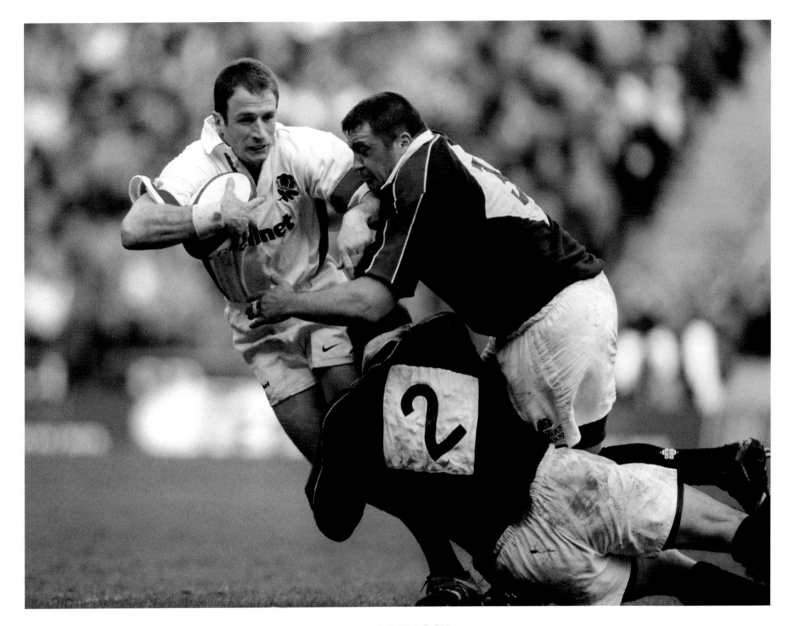

CATT RUNS INTO BULLOCH
England's Mike Catt (L) goes down under
the tackle of Scotland's Gordon Bulloch
(B) and Paul Burnell (T), during the Five
Nations Championship match.

Date: **20th February, 1999**
Venue: **Twickenham, London**

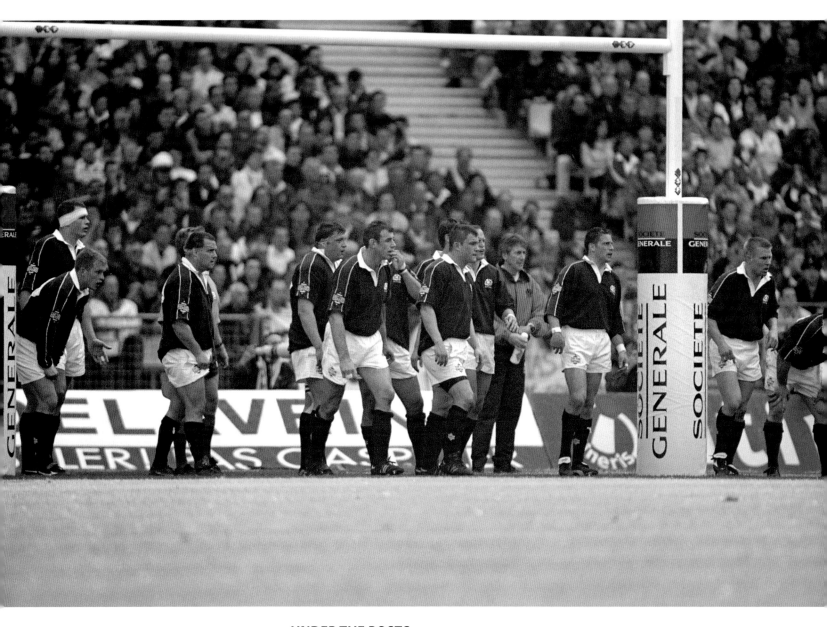

UNDER THE POSTS

The Scotland players wait on the goal line for a French conversion kick during the Five Nations Championship clash in Paris. (L–R) Cameron Murray (bent down), Stuart Grimes, David Hilton, Paul Burnell, Stuart Reid, Gordon Bulloch, Gregor Townsend, Alan Tait, Glenn Metcalfe and Gary Armstrong. The Scots ran out 36–22 winners to secure their 14th Five Nations Championship title.

Date: **10th April 1999**
Venue: **Stade de France, Paris, France**

IRISH EYES ARE SMILING

Leicester's versatile Irish back Geordan Murphy dives in to score a try against Swansea during their Heineken Cup Quarter-Final match. The English team ran away with the game, scoring 41 points to Swansea's 10.

Date: **28th January, 2001**
Venue: **Welford Road, Leicester**

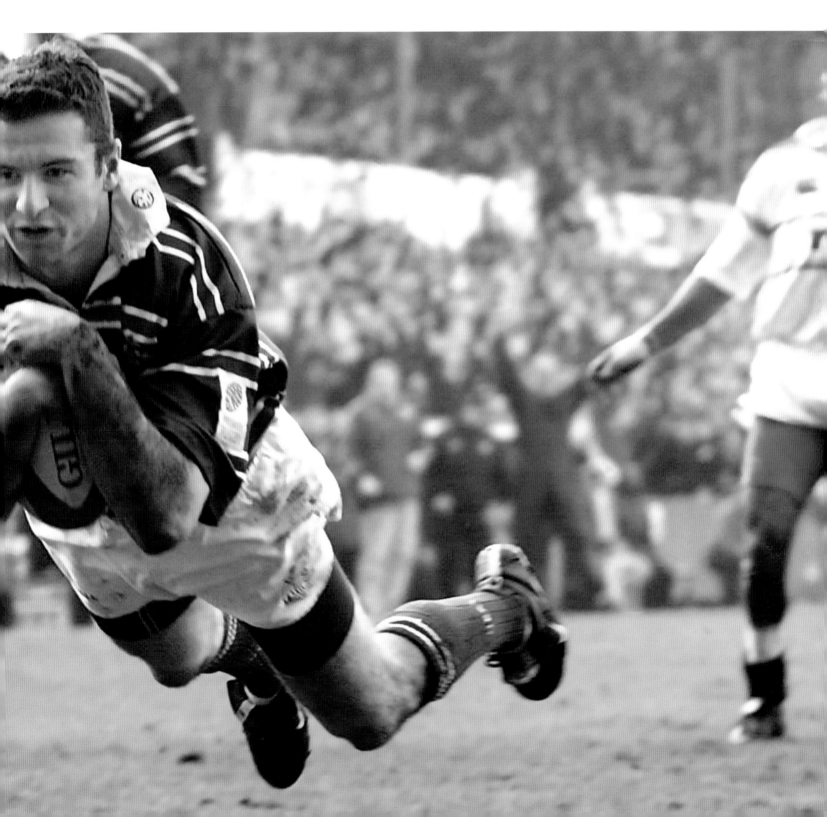

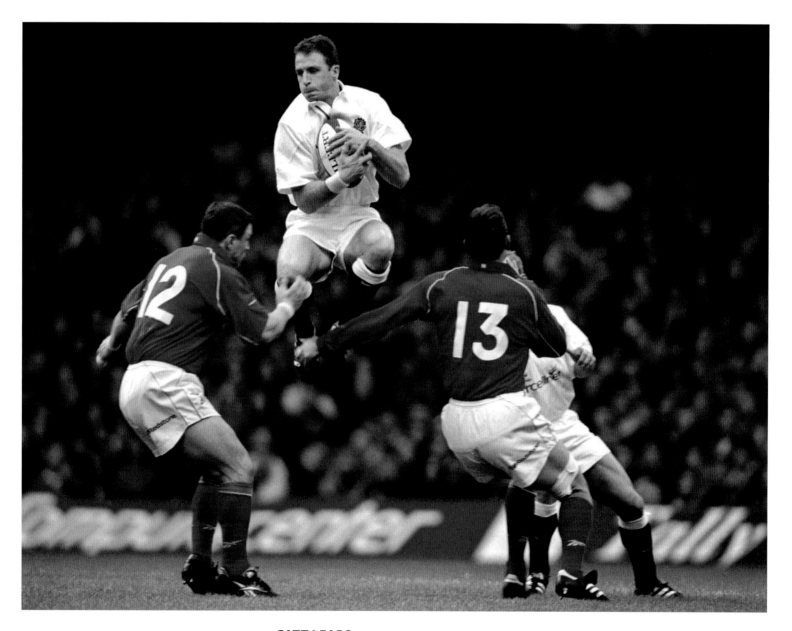

CATT LEAPS

Mike Catt catches a high ball from Wales's
Scott Gibbs (L) and Mark Taylor (R) during
England's comprehensive 44–15 victory in
the Six Nations Championship clash.

Date: **3rd February, 2001**
Venue: **Millennium Stadium, Cardiff**

EYE ON THE BALL

Australia's David Giffen takes the line-out ball against the British Lions in the First Test at Brisbane. The Lions won the match 29–13, with tries from Jason Robinson, Dafydd James, Brian O'Driscoll and Scott Quinnell. The Lions couldn't capitalise on this excellent start, Australia taking the final two matches to clinch the series 2–1.

Date: **30th June 2001**
Venue: **The Gabba, Brisbane, Australia**

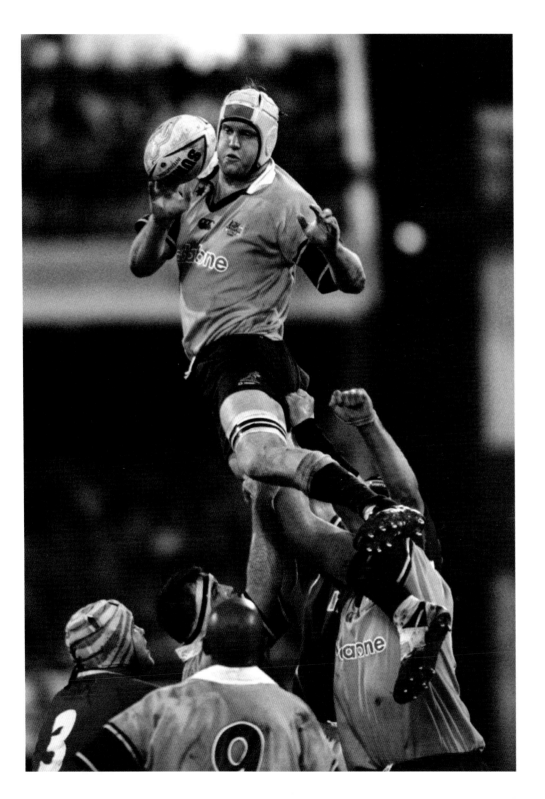

SIDE STEP

France's captain Fabien Galthie on the break
against Ireland in a 44–5 French victory.

Date: **6th April, 2002**
Venue: **Stade de France, Paris, France**

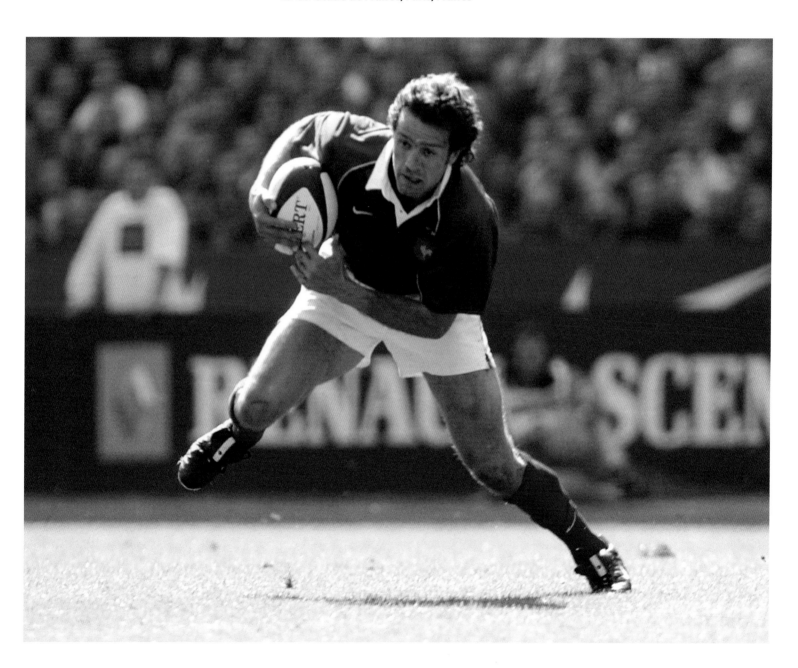

HIGH PRESSURE
Steam rises from the scrum during the
Powergen Cup Sixth Round clash between
London Wasps and Bath.

Date: **21st December, 2002**
Venue: **Adams Park, High Wycombe**

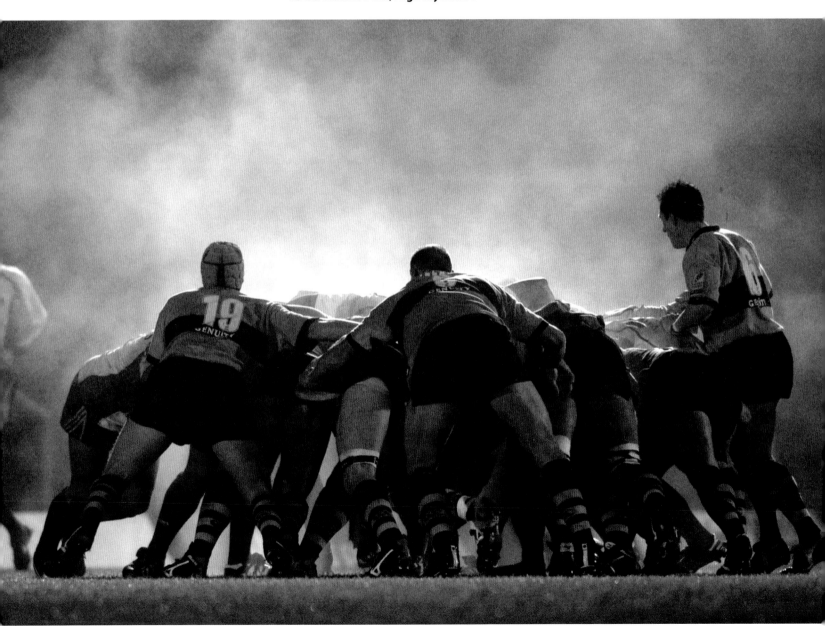

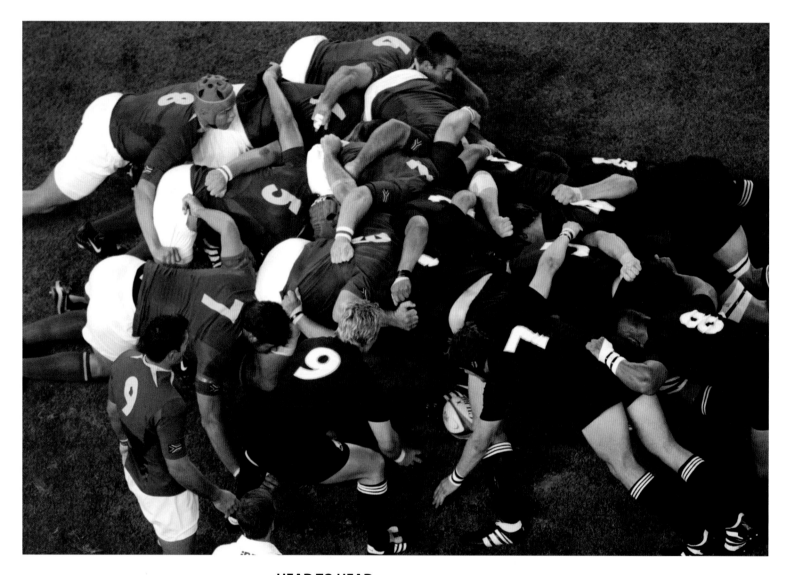

HEAD TO HEAD

A scrum during the Rugby World Cup Quarter-Final match between South Africa and New Zealand in Australia. Tries from Leon MacDonald, Keven Mealamu and Josevata Rokocoko helped the All Blacks to a convincing 29–9 victory. The South Africans were restricted to three penalties.

Date: **8th November, 2003**
Venue: **Telstra Dome, Melbourne, Australia**

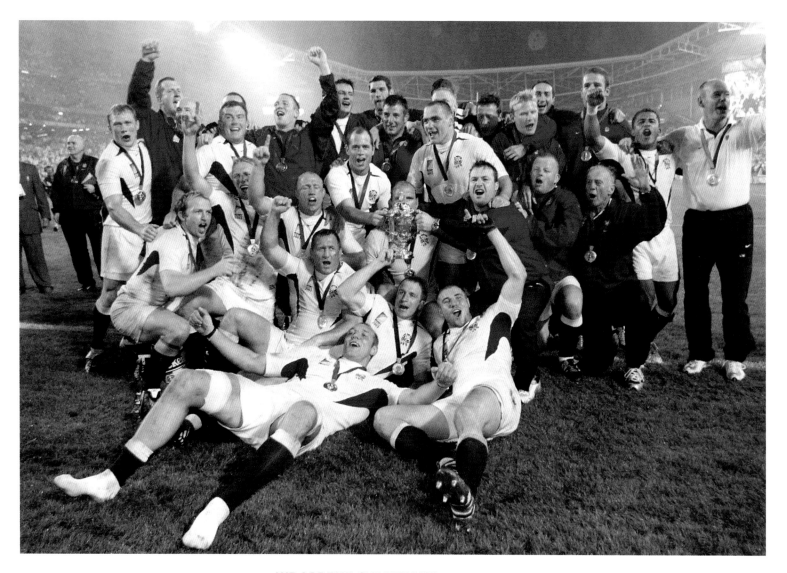

WE ARE THE CHAMPIONS
The joyous England squad with the Webb
Ellis Trophy after beating Australia in the
Rugby World Cup Final. The architect of
the victory, manager Clive Woodward (R),
celebrates with try scorer Jason Robinson,
while Jonny Wilkinson and Martin Johnson
are missing from the group.

Date: **22nd November, 2003**
Venue: **Telstra Stadium, Sydney, Australia**

WRAPPED UP

Wales's Gareth Thomas is tackled by France's Yannick Jauzion during the Six Nations Championship match in Cardiff. France ran out 29–22 winners, their third victory of five in an impressive Grand Slam season.

Date: **7th March, 2004**
Venue: **Millennium Stadium, Cardiff**

CRUNCH

Ireland's Brian O'Driscoll (L) delivers a shattering tackle to Italy's Paul Griffen. The Irish won the game 19–3 through tries from O'Driscoll, Malcolm O'Kelly and Shane Horgan. Italy avoided the ignominy of the wooden spoon by beating Scotland 20–14 in Rome. It was the second season in a row that Italy had avoided finishing in last place, an improvement on their initial performances in the competition.

Date: **20th March, 2004**
Venue: **Lansdowne Road, Dublin, Ireland**

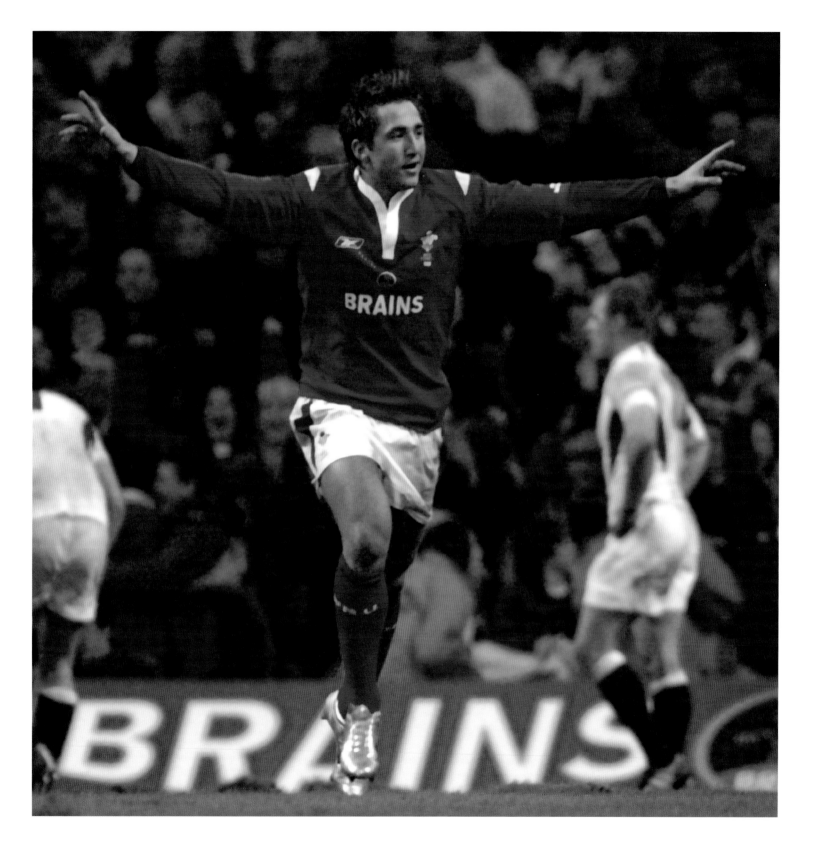

GAVIN'S JOY

Wales's match winner, Gavin Henson, celebrates at the final whistle after his long-range penalty against England in the Six Nations Championship pushed the score to 11–9. This victory proved to be the first of five in a Grand Slam winning season.

Date: **5th February, 2005**
Venue: **Millennium Stadium, Cardiff**

PRINCE'S DESPAIR

Prince William in obvious distress as he watches the British & Irish Lions go down to arguably their worst ever defeat, losing to New Zealand 48–18 in the Second Test.

Date: **2nd July, 2005**
Venue: **Westpac Stadium, Wellington, New Zealand**

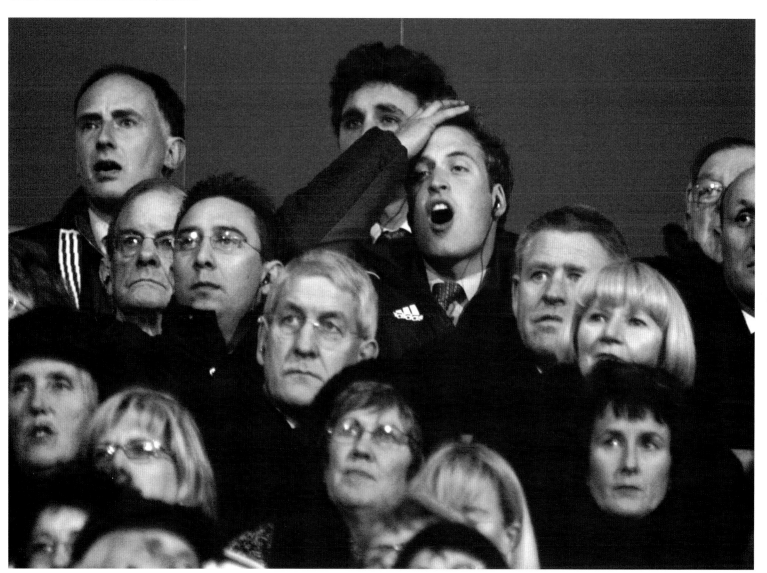

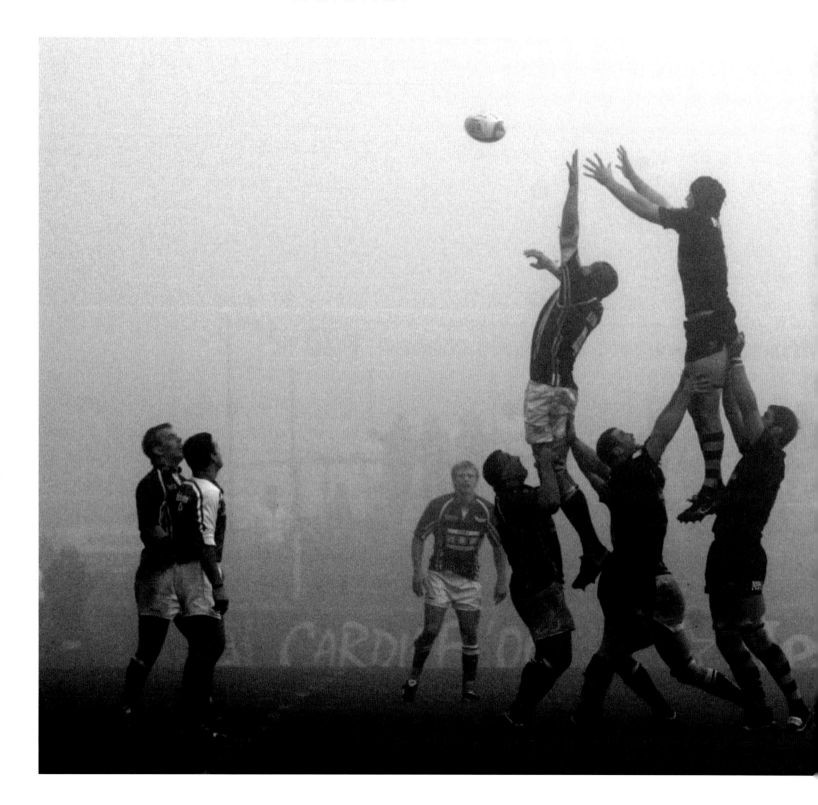

EMERGING THROUGH THE MIST
Mist descends in a Llanelli v Wasps
Heineken Cup match in south-west Wales.
The 21–13 win for the home side ensured
that Wasps would not progress beyond
the pool stage for the second successive
season. Llanelli also failed to qualify for the
knockout stage of the competition.

Date: **11th December, 2005**
Venue: **Stradey Park, Llanelli**

POWERING OVER

France's Aurelien Rougerie scores France's first try as Ireland's Geordan Murphy closes in. An Olivier Magne try, and two apiece from David Marty and Cédric Heymans secured a 43–31 victory in a high-scoring encounter in Paris. It would prove to be the decisive result in the 2006 Six Nations Championship, with France topping the final table from Ireland on points difference.

Date: **11th February, 2006**
Venue: **Stade de France, Paris, France**

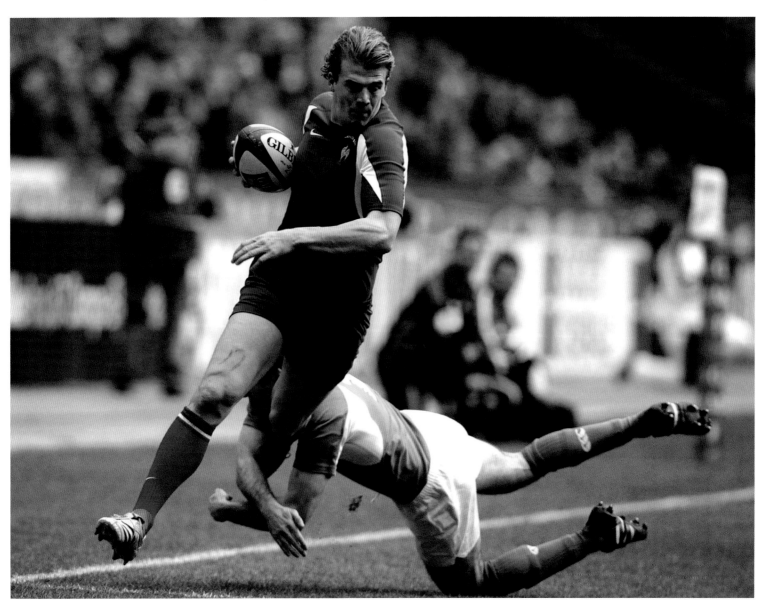

NOW BOYS...

Tempers flare between Northampton Saints and Bath players during a Premiership clash. The Saints finished bottom of the table and were relegated, while Bath reached mid-table. Leicester Tigers were crowned champions at the end of the 2006–07 season, with a 44–16 win in a one-sided final against Gloucester at Twickenham.

Date: **16th September, 2006**
Venue: **Franklin's Gardens, Northampton**

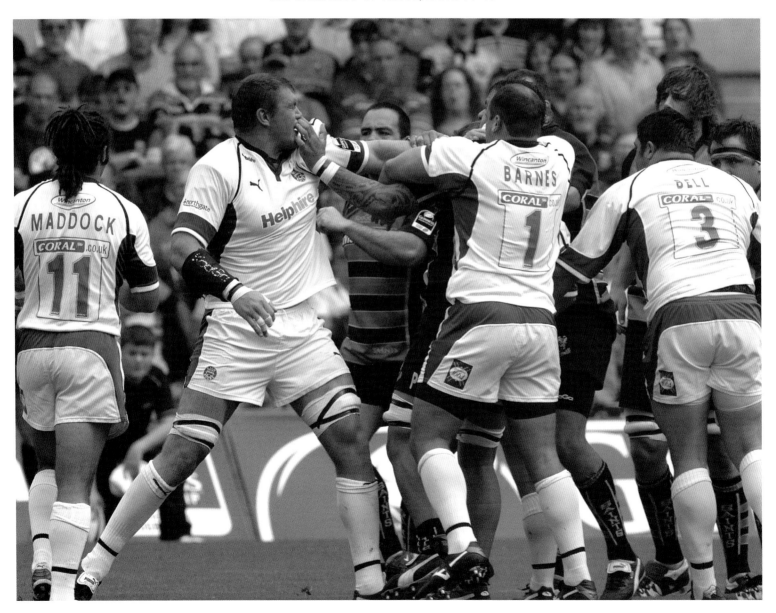

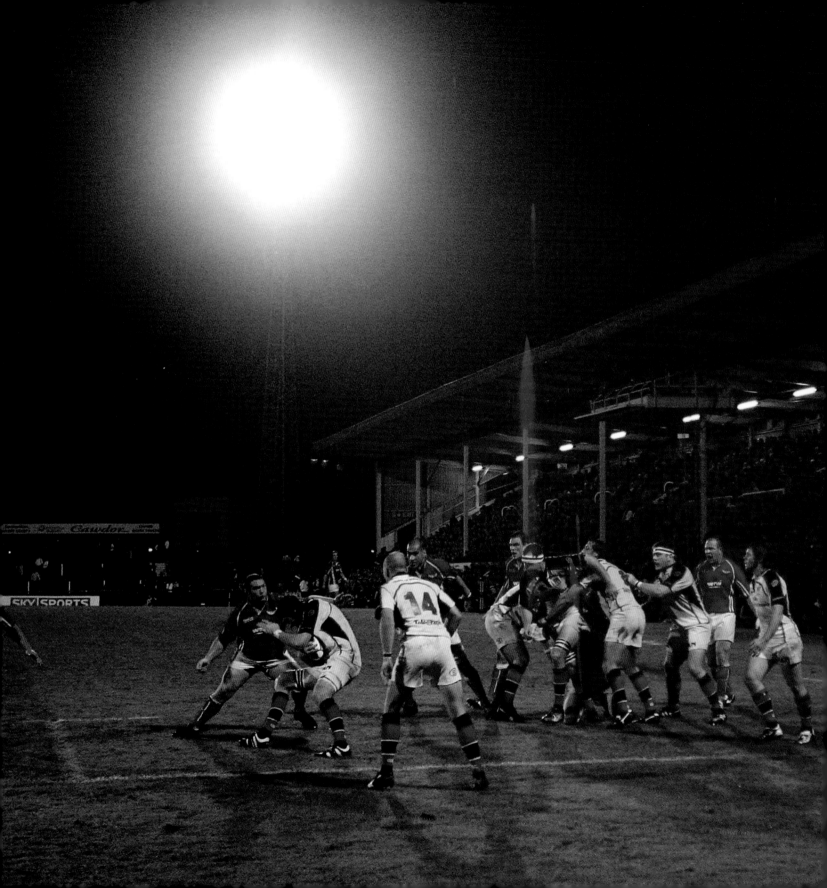

IN THE SPOTLIGHT
Ulster defend their line from Llanelli's attack during the Heineken Cup Pool Five match in Wales. Llanelli won all six of their pool games to top the table and qualify for the knockout stage of the competition. They defeated Munster in the quarter-final, but lost 33–17 in the semi-final against Leicester.

Date: **27th October, 2006**
Venue: **Stradey Park, Llanelli**

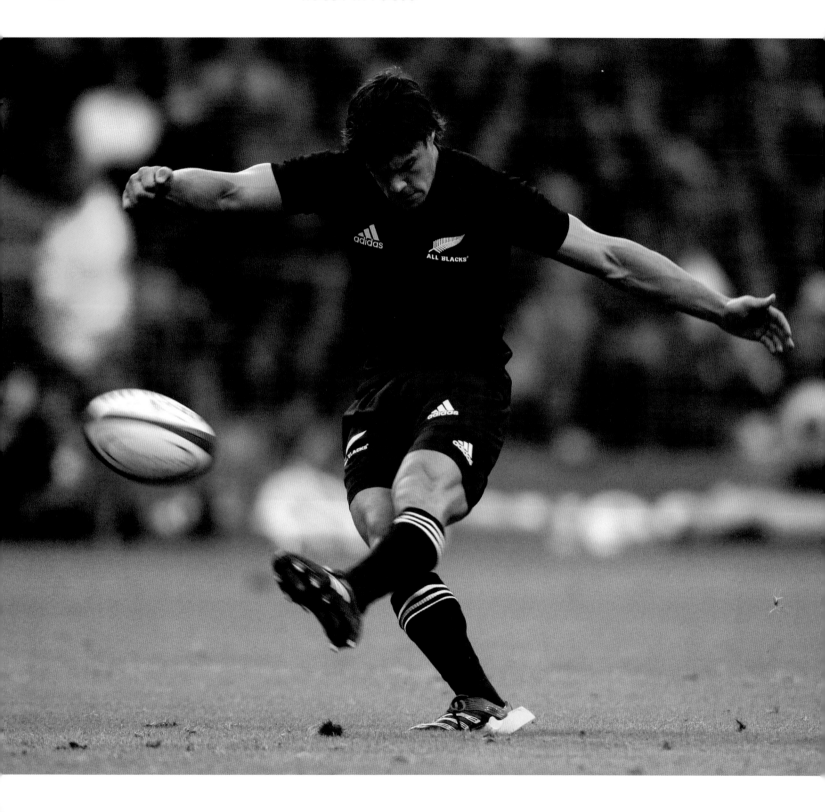

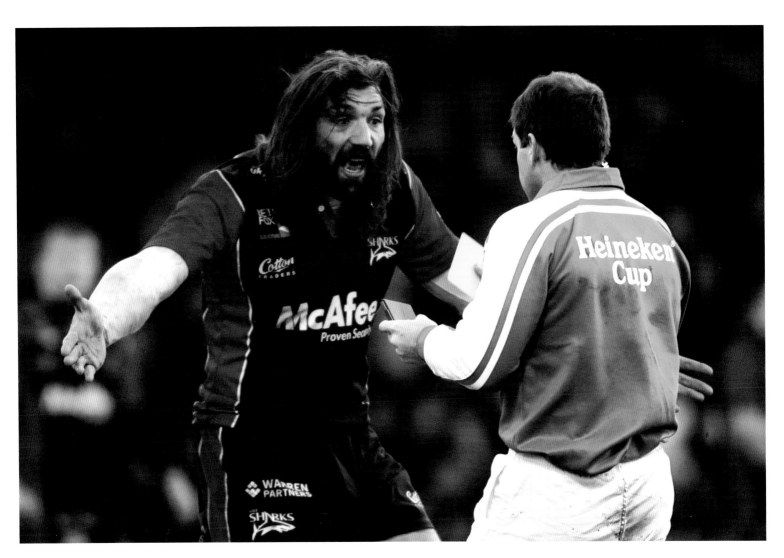

IN THE SPOTLIGHT
Ulster defend their line from Llanelli's attack during the Heineken Cup Pool Five match in Wales. Llanelli won all six of their pool games to top the table and qualify for the knockout stage of the competition. They defeated Munster in the quarter-final, but lost 33–17 in the semi-final against Leicester.

Date: **27th October, 2006**
Venue: **Stradey Park, Llanelli**

WHO, MOI?
Sale's French forward, Sébastien Chabal, pleads his innocence to referee Rowland as he is shown a yellow card during the Heineken Cup Pool Three match against Ospreys. Both teams failed to make the knockout stage, losing out to Stade Français, who topped the table after securing four wins and a draw.

Date: **20th January, 2007**
Venue: **Edgeley Park, Stockport**

IRELAND'S TEMPORARY HOME

Ireland take on France in the Six Nations Championship match. The game was significant for being the first rugby international held at Croke Park, the home of Gaelic games. The stadium had been built with the intention of playing host to indigenous Irish sports, and there was significant controversy when it was announced that Ireland would play their home Six Nations matches at the stadium while redevelopment work took place at Lansdowne Road. At the end of the day, Ireland could not mark the historic occasion with a win, after conceding a last-minute converted try and losing to the French 20–17.

Date: **11th February, 2007**
Venue: **Croke Park, Dublin, Ireland**

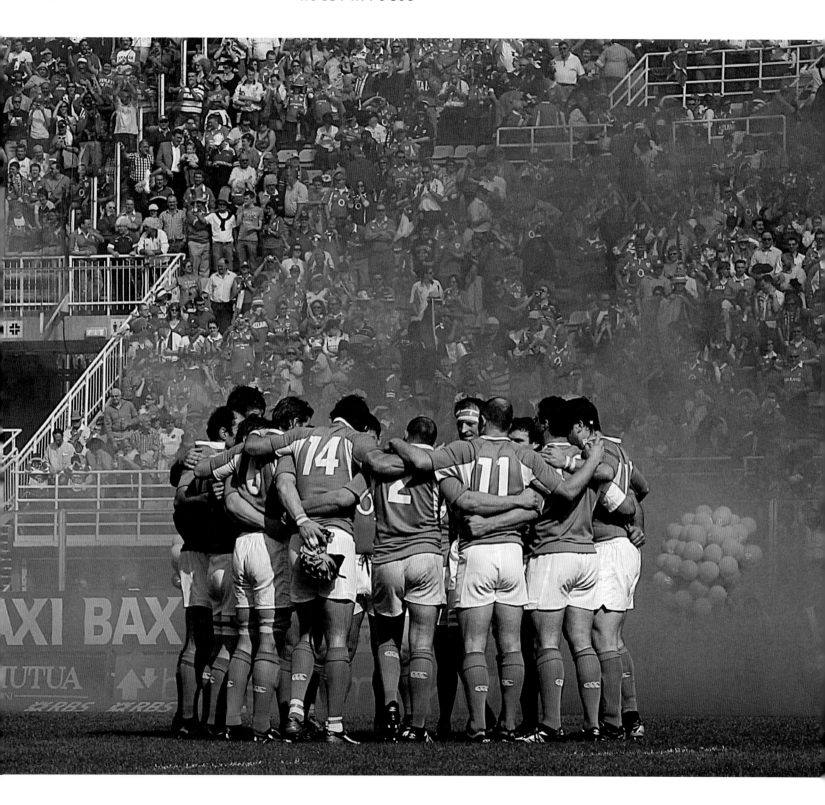

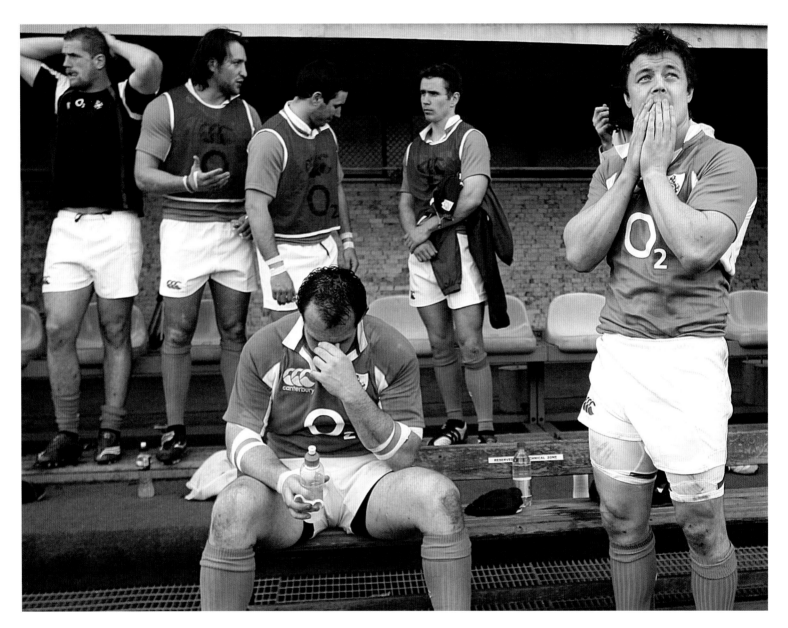

TEAM TALK

Ireland hold a team huddle during the Six Nations match in Rome, on the last day of an enthralling championship.

Date: **17th March, 2007**
Venue: **Stadio Flaminio, Rome, Italy**

SO NEAR...

Ireland's Brian O'Driscoll (R) looks at the scoreboard after a late Italian try during the Six Nations Championship match in Rome. It would prove a crucial score, as it meant that France had to win their match against Scotland by 23 points rather than 30 points to clinch the title. In a dramatic denouement in Paris, the French scored an injury-time converted try to seal a 27-point win over the Scots and secure their 16th title.

Date: **17th March, 2007**
Venue: **Stadio Flaminio, Rome, Italy**

74

MAN OF THE MATCH

Wales's James Hook kicks one of four penalties during a memorable Six Nations match against England. Switched to fly-half for the final fixture of the campaign, Hook scored 22 points (completing his first 'full house' – a drop goal, penalty, try and conversion) and was named man of the match in a 27–18 win.

Date: **17th March, 2007**
Venue: **Millennium Stadium, Cardiff**

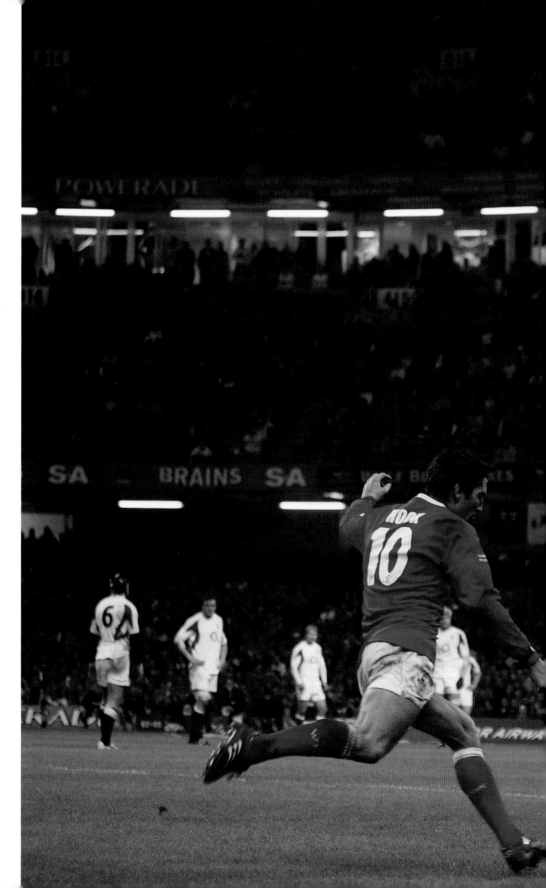

WASPS STUNG

London Wasps' James Haskell (B) gets to grips with Leinster's Felipe Contepomi (C) and Shane Horgan (T) during a Heineken Cup Quarter-Final match. The Wasps ran out comfortable 35–13 winners to set up an all-English semi-final against Northampton Saints.

Date: **31st March, 2007**
Venue: **Adams Park, High Wycombe**

A CONTENTED SWARM

London Wasps celebrate with the trophy following their Heineken Cup Final win against Leicester Tigers. In a brilliant 25–9 win, in which they dominated both the tactical and physical battles, the Wasps proved their doubters wrong and showed once again their ability to raise their game when it really matters. Their tackling intensity and their bossing of the breakdown forced a number of uncharacteristic errors from Leicester.

Date: **20th May, 2007**
Venue: **Twickenham, London**

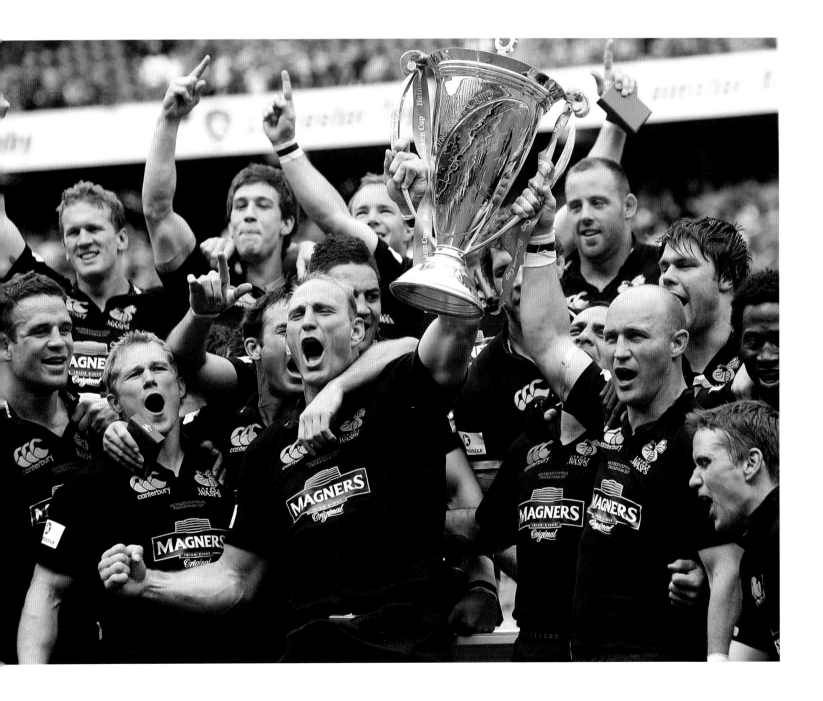

ENTENTE CORDIALE

England mascot Mr England, Pete Cross (R) and his French counterpart wave to the crowd before a World Cup warm-up game in Marseille. England's dismal away record continued with a 22–9 defeat at the hands of *Les Bleus*, meaning they had won just one of their previous 16 games on the road. England would gain revenge a couple of months later, however, with a 14–9 win over the French in the World Cup Semi-Final.

Date: **18th August, 2007**
Venue: **Stade Vélodrome, Marseille, France**

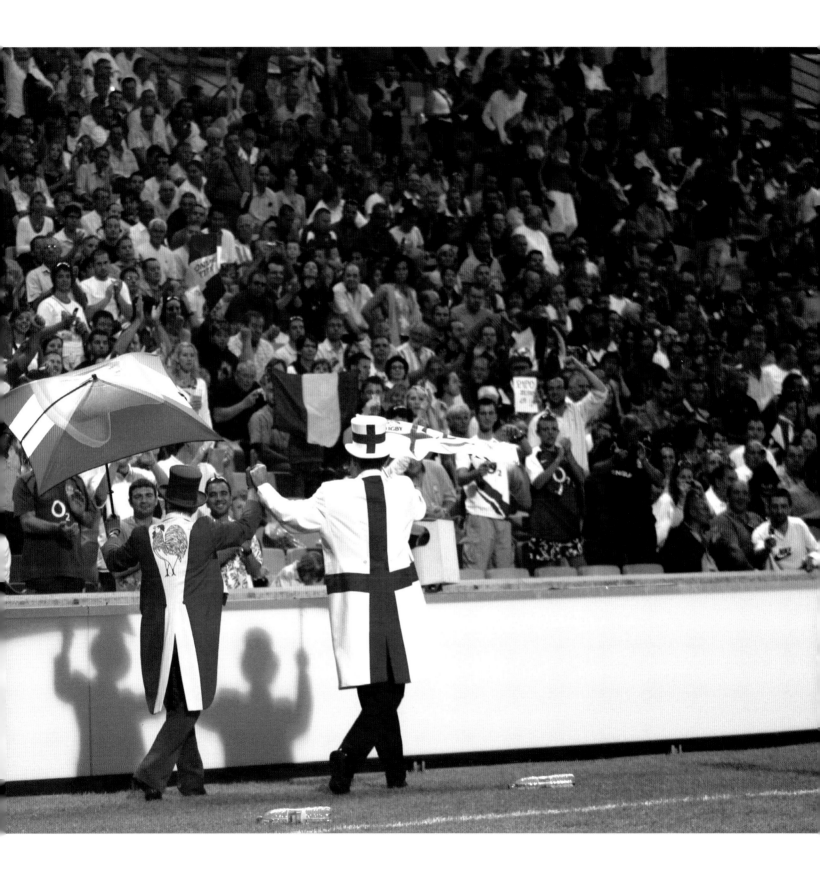

AUSSIE ENDEAVOUR 1

Waratahs' (Australia) Matt Dunning (R) tackles Hurricanes' (New Zealand) Tamati Ellison during the opening match of the Super 14 season, the biggest club rugby competition in the southern hemisphere, being contested by four teams from Australia, five from New Zealand and five from South Africa. The Waratahs made it to the final of the competition in 2008, but lost 20–12 to the Crusaders from New Zealand.

Date: **16th February, 2008**
Venue: **Sydney Football Stadium, Sydney, Australia**

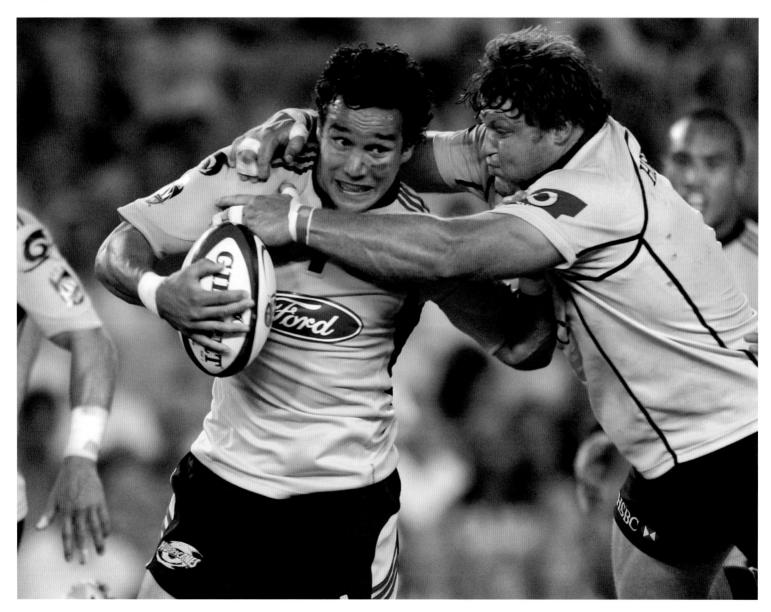

AUSSIE ENDEAVOUR 2
Highlanders' Adam Thomson is tackled during the Super 14 match against CA Brumbies, who won by 22 points to 20.

Date: **23th February, 2008**
Venue: **Canberra Stadium, Canberra, Australia**

SCOTS RAINBOW *(Overleaf)*
England and Scotland contest a line-out during Scotland's 15–9 victory in the Six Nations Championship.

Date: **8th March, 2008**
Venue: **Murrayfield, Edinburgh**

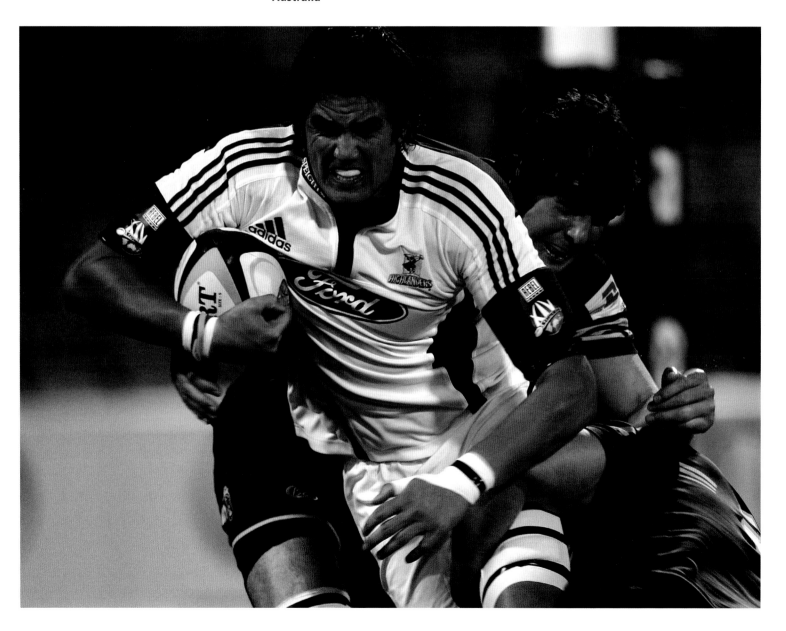

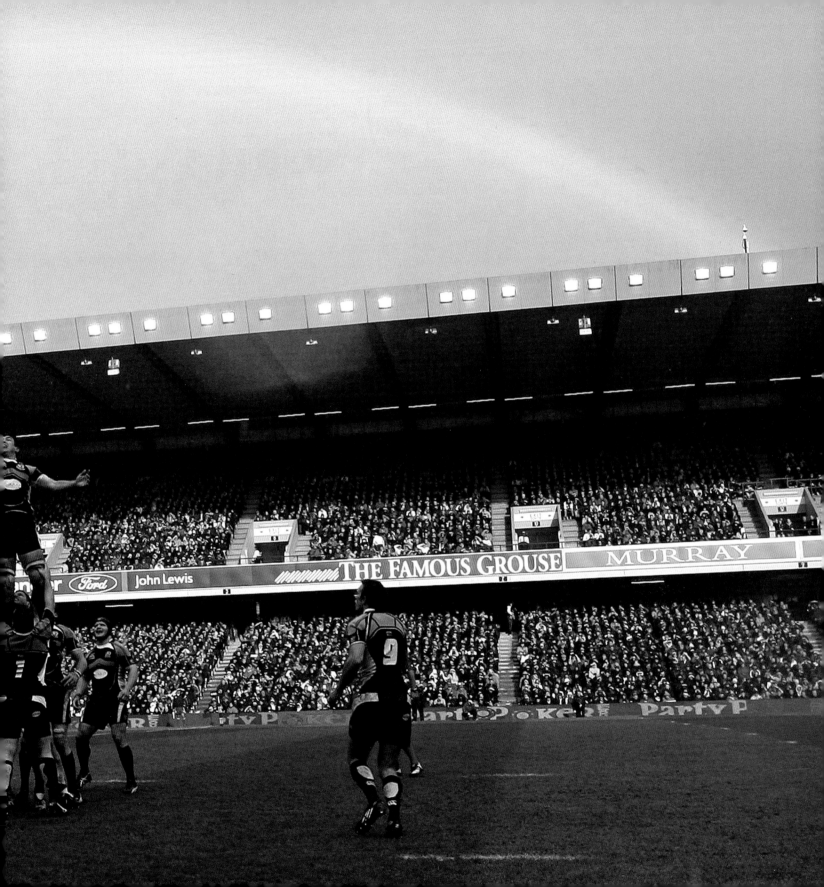

SCOTS HOLD THE CUP

Scotland's Nathan Hines (L) and Chris Paterson celebrate with the Calcutta Cup following the Six Nations Championship match against England. The 15–9 victory was Scotland's only win of the campaign. Despite the loss, the game was a significant personal landmark for England's Jonny

Wilkinson, whose three penalties made him the leading points scorer in the history of international rugby.

Date: **8th March, 2008**
Venue: **Murrayfield, Edinburgh**

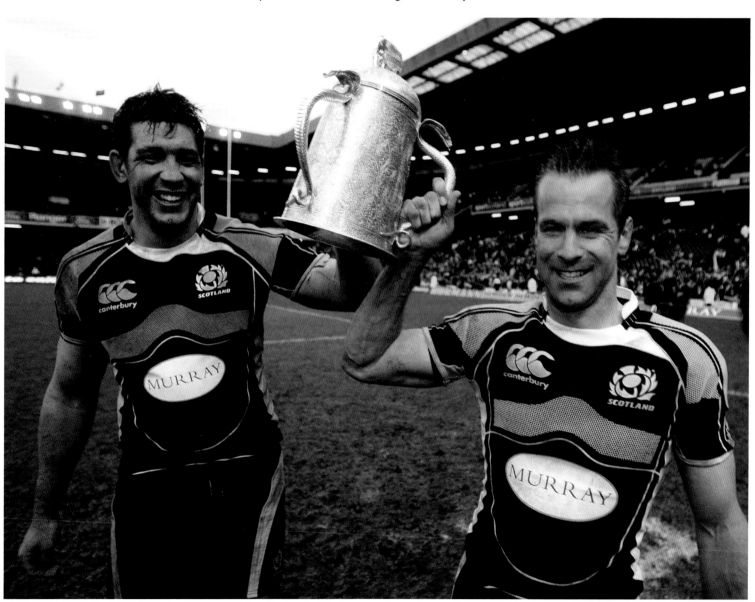

PRESENTING THE BALL

London Wasps' Lawrence Dallaglio finds himself at the bottom of a ruck during the Guinness Premiership Semi-Final against Bath. Wasps ran out 21–10 victors, setting up a final clash with Leicester Tigers, which the London side won 26–16 in front of 81,600 fans at Twickenham.

Date: **18th May, 2008**
Venue: **Adams Park, High Wycombe**

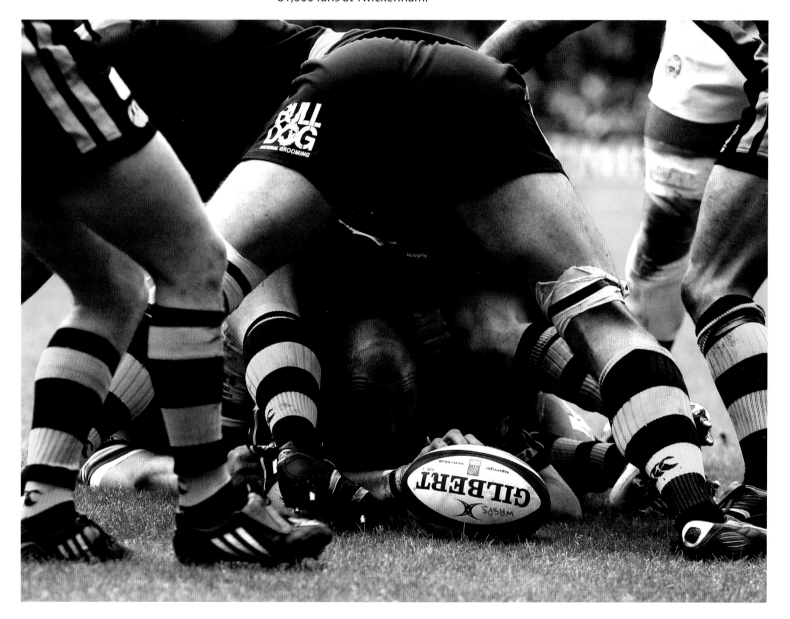

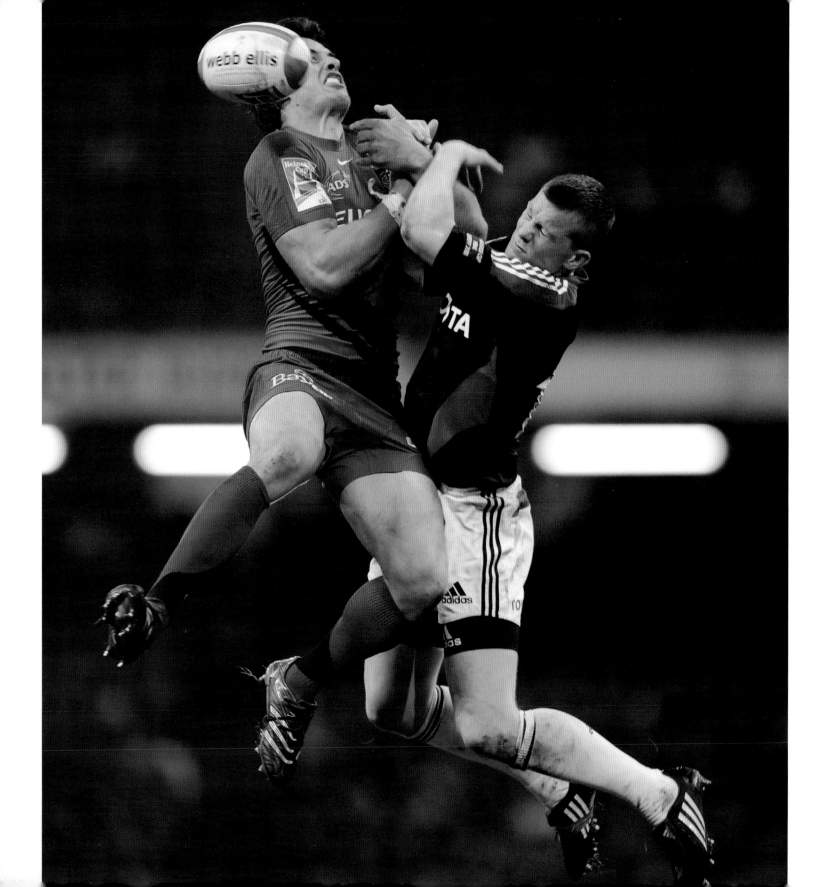

AERIAL CONTEST 1

Munster's Denis Hurley (R) and Toulouse's Yannick Jauzion compete for possession during the Heineken Cup Final. Three penalties and a conversion by Ronan O'Gara following a Denis Leamy try secured Munster a 16–13 victory and their second European triumph in three seasons. The match was the last as Munster's head coach for Declan Kidney, who had agreed to take on the Ireland job.

Date: **24th May, 2008**
Venue: **Millennium Stadium, Cardiff**

AERIAL CONTEST 2

Ireland and the Barbarians contest a line-out during an international match at Gloucester. Two tries apiece from Shane Horgan and Jamie Heaslip, and a try from Tommy Bowe helped an under-strength Ireland to a 39–14 win. South African Pedrie Wannenburg and All Black Craig Newby touched down for the 'Baa-Baas'.

Date: **27th May, 2008**
Venue: **Kingsholm Stadium, Gloucester**

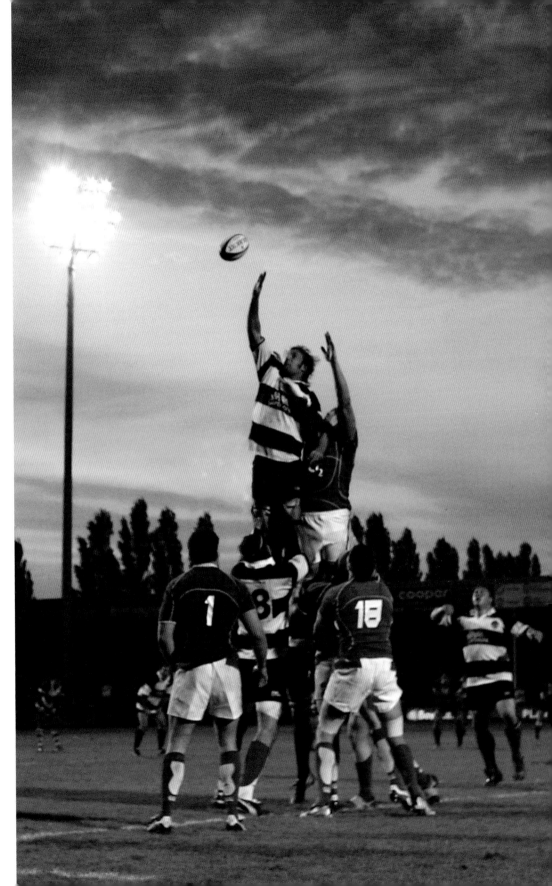

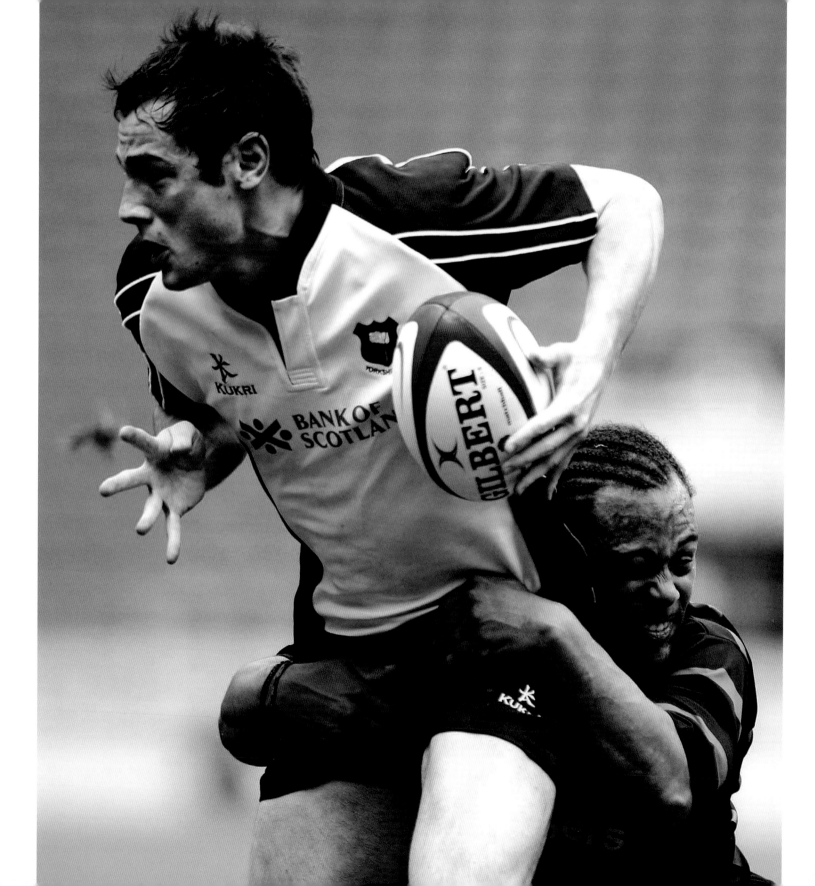

NO WAY THROUGH

Yorkshire's Steve Parsons tries to escape a tackle from Devon's Liam Gibson during the Bill Beaumont Cup Final, which the team from the north won 33–13. The competition, named in honour of the former England and British Lions captain, was known as the County Championship until it was restructured in 2007.

Date: **1st June, 2008**
Venue: **Twickenham, London**

THE SERGE v THE SAINT

Northampton Saints' Chris Ashton (C) and London Wasps' Serge Betsen (R) during a Guinness Premiership clash.

Date: **20th September, 2008**
Venue: **Franklin's Gardens, Northampton**

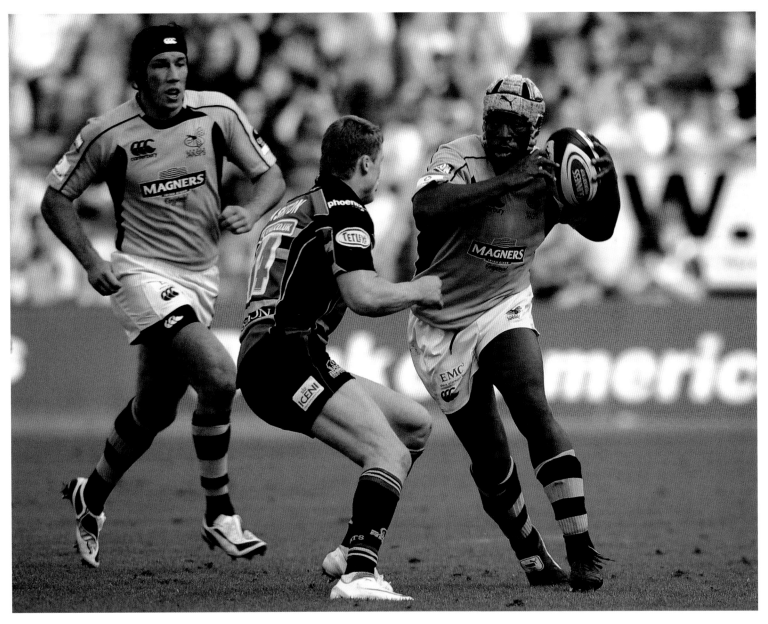

GLOUCESTER FLYER

James Simpson-Daniel dives to score Gloucester's first try during a Heineken Cup match against Biarritz. Both teams failed to qualify for the knockout stage of the competition, finishing behind an impressive Cardiff Blues team, who won all six of their pool games.

Date: **11th October, 2008**
Venue: **Kingsholm Stadium, Gloucester**

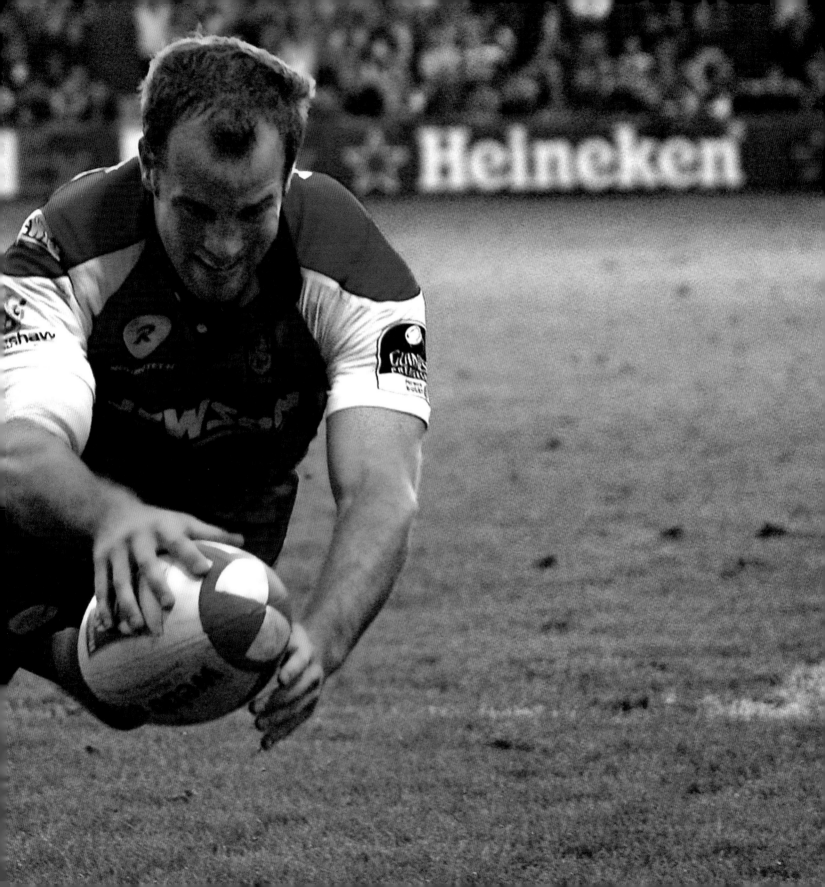

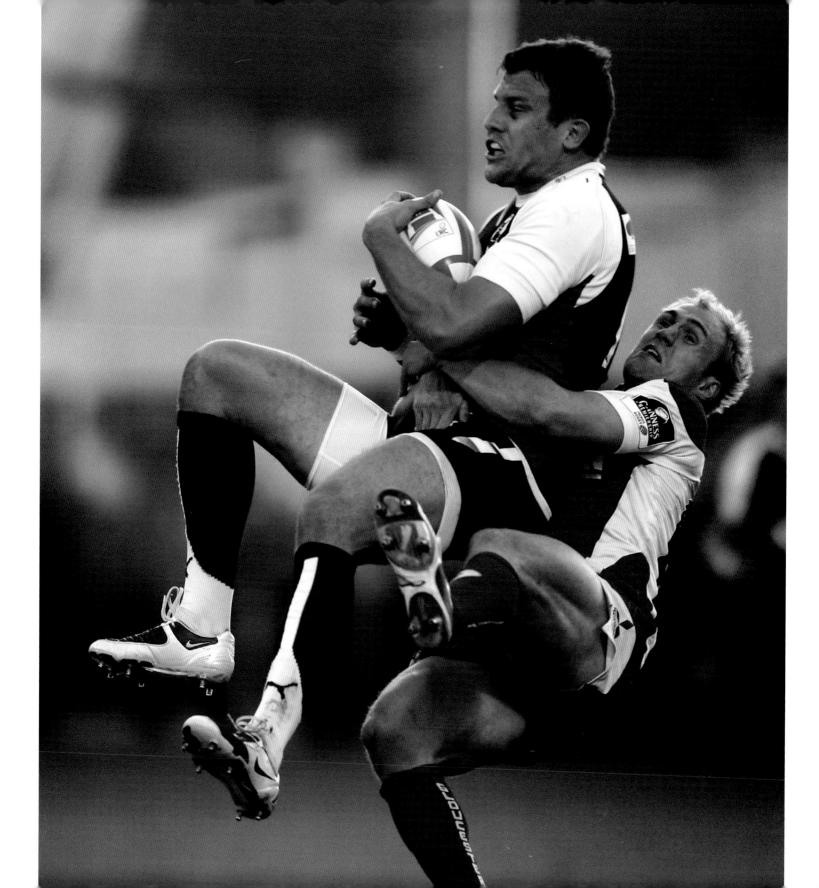

HOLD TIGHT

Biarritz's Damien Traille is tackled by Gloucester's Olly Morgan during a Heineken Cup pool match. A try from James Simpson-Daniel and four penalties from the boot of Olly Barkley helped the West Country team to a 22–10 win over their French opponents.

Date: **11th October, 2008**
Venue: **Kingsholm Stadium, Gloucester**

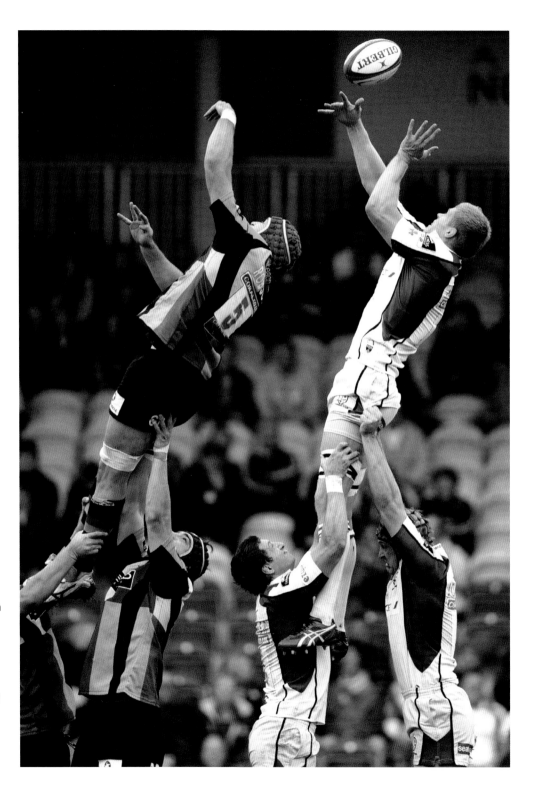

LINE-OUT LEAP

Harlequins' George Robson and London Irish's James Hudson in a line-out during an EDF Energy Cup match. Leading 17–5 early in the second half, 'Quins' looked firm favourites to wrap up the win, but a sudden and unexpected resurgence from Irish, who scored 27 unanswered points, turned the game on its head. Peter Hewat, Adam Thompstone and James Bailey crossed in a six-minute spell, and Hewat went over for a second time late on.

Date: **25th October, 2008**
Venue: **Twickenham Stoop Stadium, London**

FLYING WINGER

New Zealand's winger Ma'A Nonu scores his side's third try during the Investec Challenge Series match at Twickenham.

Date: **29th November, 2008**
Venue: **Twickenham, London**

HEAD LOCKED

New Zealand's Joe Rokocoko (C) is tackled by England's James Haskell (L) and Tim Payne during the Investec Challenge Series match.

Date: **29th November, 2008**
Venue: **Twickenham, London**

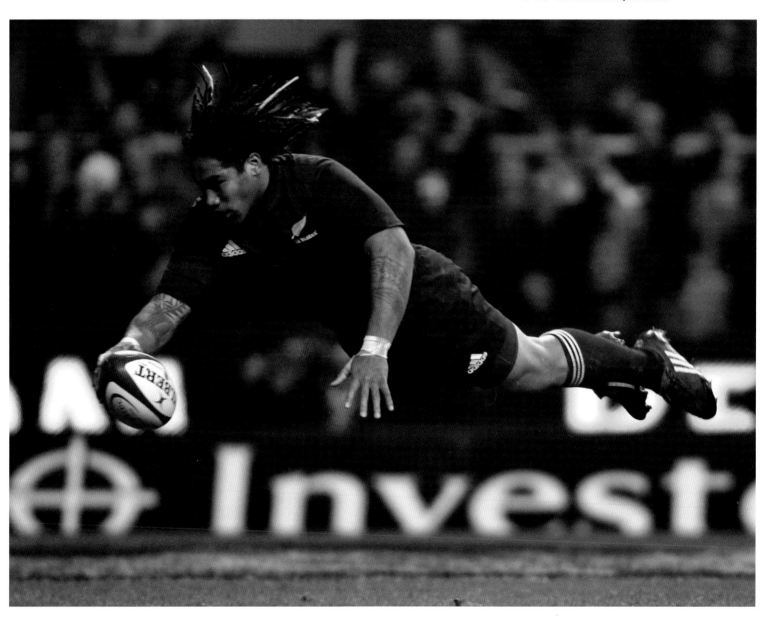

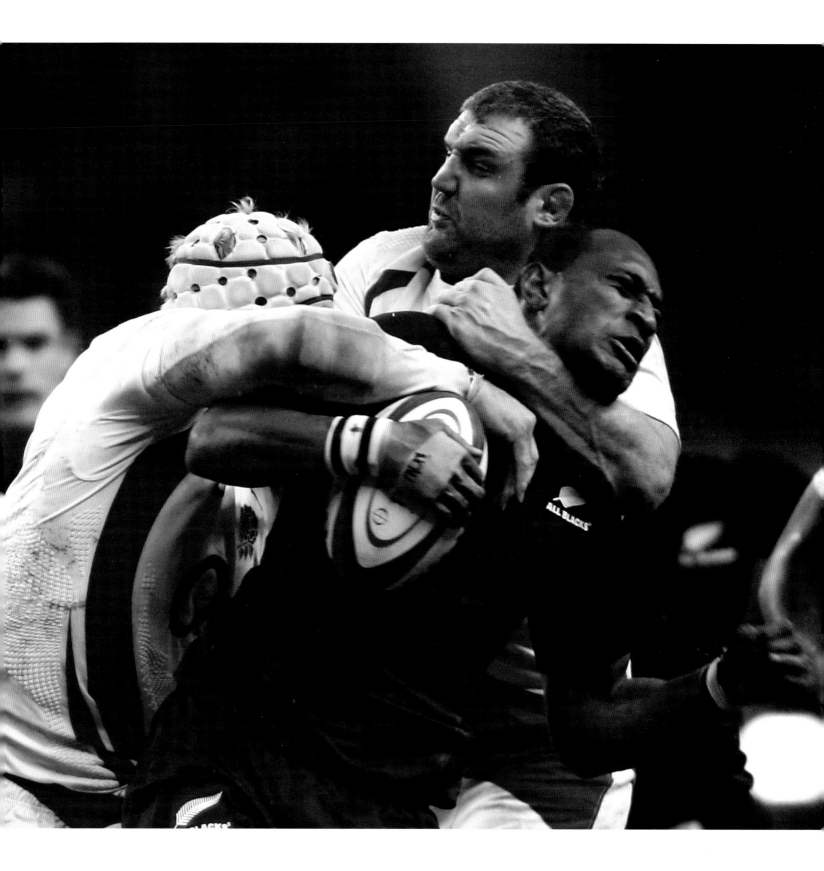

THE ART OF EVASION 1

London Irish's Sailosi Tagicakibau evades the tackle of Bristol's Shaun Perry to go on and score his team's first try during a Guinness Premiership clash. Winger Tagicakibau and fly-half Shane Geraghty scored one try apiece to seal a comeback win for the London side.

Date: **30th November, 2008**
Venue: **Memorial Ground, Bristol**

THE ART OF EVASION 2

Barbarians' Bryan Habana escapes the clutches of Australia's Adam Freier during the BOA Centenary Celebration match in London. The match was staged as part of the British Olympic Association's programme of events to celebrate the centenary of the 1908 London Olympic Games. Australia won 18–11 in the first rugby union match held at the newly redeveloped Wembley Stadium.

Date: **3rd December, 2008**
Venue: **Wembley Stadium, London**

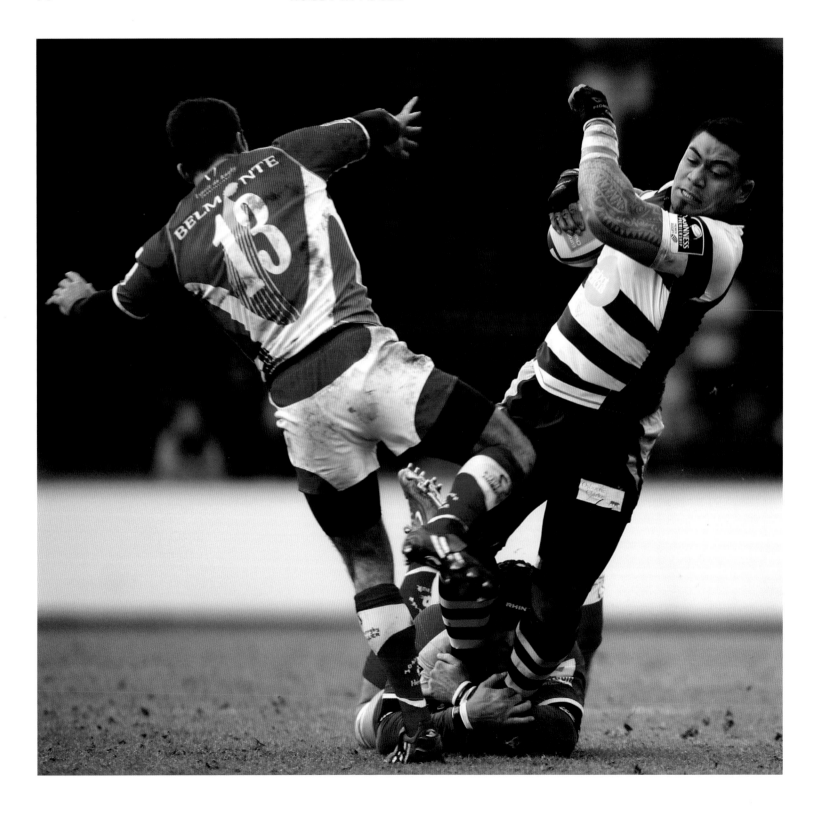

GOING NOWHERE

Bristol's Alfie To'oala (R) and Montpellier's Drickus Hancke (B) and Frikkie Welsh (L) in a European Challenge Cup pool match. Bristol ran out 25–14 winners, but failed to qualify for the knockout stage of the competition, finishing 15 points behind a dominant Northampton Saints.

Date: **25th January, 2009**
Venue: **Memorial Ground, Bristol**

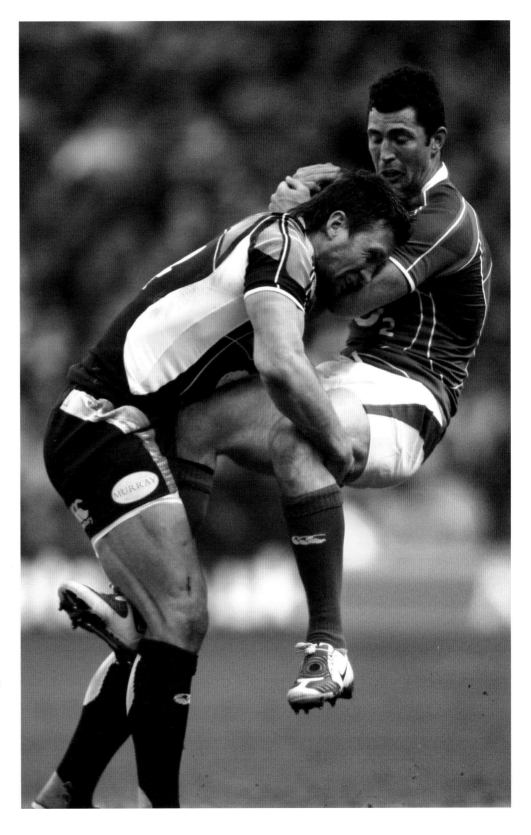

DRIVING THROUGH

Ireland's Robert Kearney (R) is tackled by Scotland's Simon Danielli during a Six Nations Championship match. A dominant second-half display and the unerring accuracy of Ronan O'Gara's kicking secured Ireland's fourth victory of the campaign, meaning that a win in the final fixture against Wales would seal a long-awaited Grand Slam.

Date: **14th March, 2009**
Venue: **Murrayfield, Edinburgh**

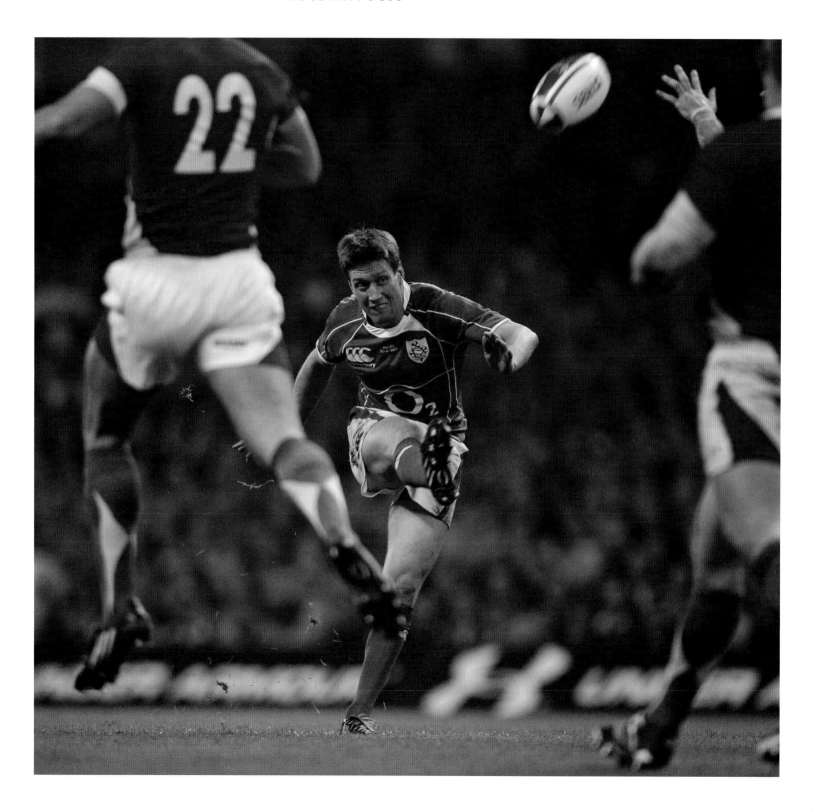

ON ITS WAY

Ireland's Ronan O'Gara kicks the match winning drop goal during his team's Six Nations Championship match against Wales on their home ground.

Date: **21st March, 2009**
Venue: **Millennium Stadium, Cardiff**

IRELAND'S DAY

Ireland's Brian O'Driscoll (L), flanked by Prince William and Irish President Mary McAleese, holds aloft the Six Nations trophy after his team beat Wales 17–15 in the Six Nations match in Cardiff to secure Ireland's first Grand Slam since 1948. In a thrilling climax to a fascinating championship, Ronan O'Gara scored a 78th-minute drop goal to put the Irish up 17–15. The Welsh had a chance to break Irish hearts with the last kick of the match, but fly-half Stephen Jones missed a 50-metre penalty, sparking joyous celebrations among the Irish players and the sizeable travelling support.

Date: **21st March, 2009**
Venue: **Millennium Stadium, Cardiff**

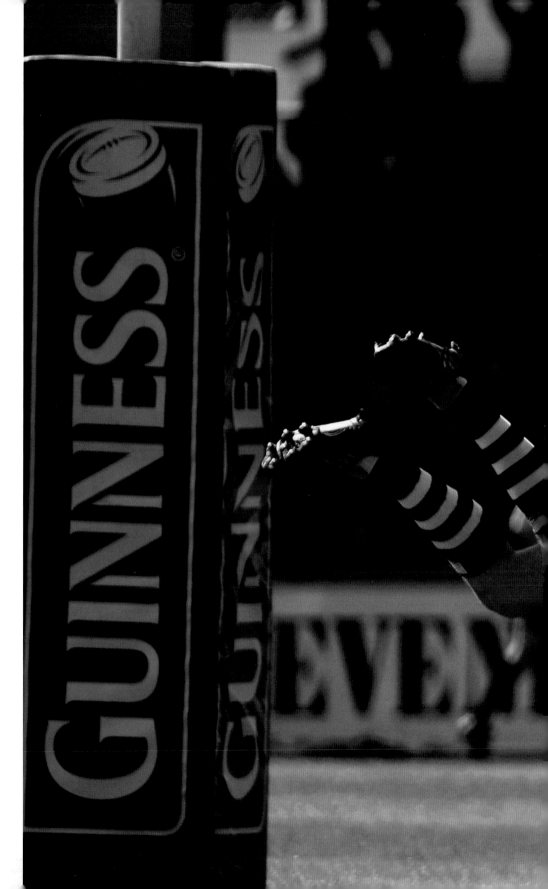

FIRST TRY

Bristol's Tom Arscott scores the opening try of the Guinness Premiership match against Worcester Warriors. Despite a convincing 37–18 win over fellow strugglers, Bristol finished the season bottom of the table and were relegated to the RFU Championship.

Date: **29th March, 2009**
Venue: **Memorial Stadium, Bristol**

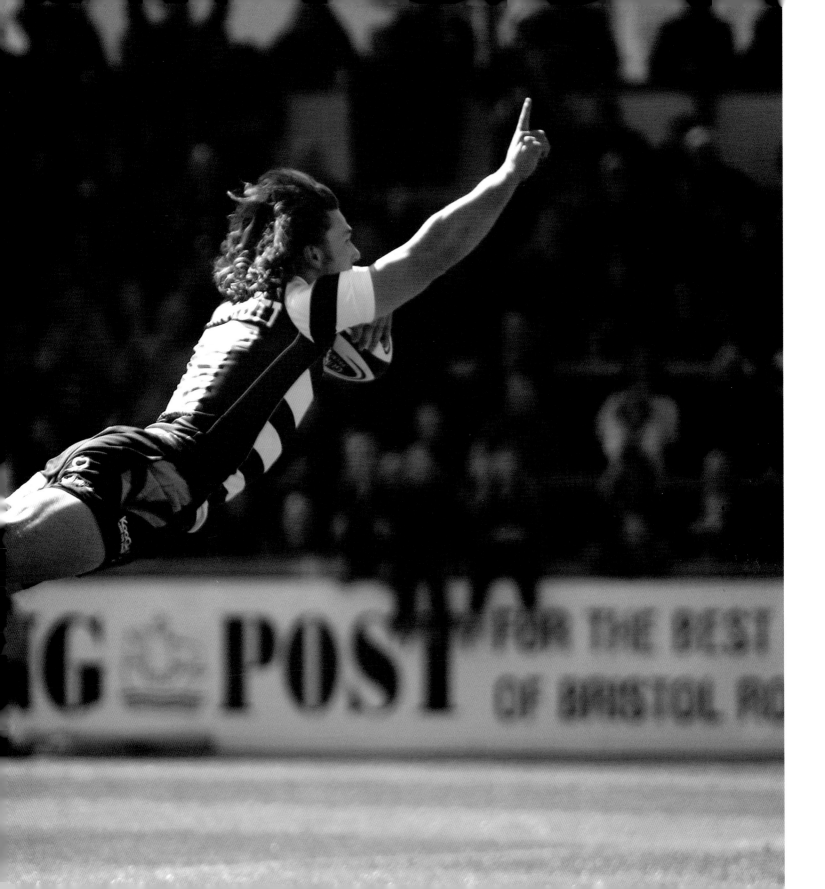

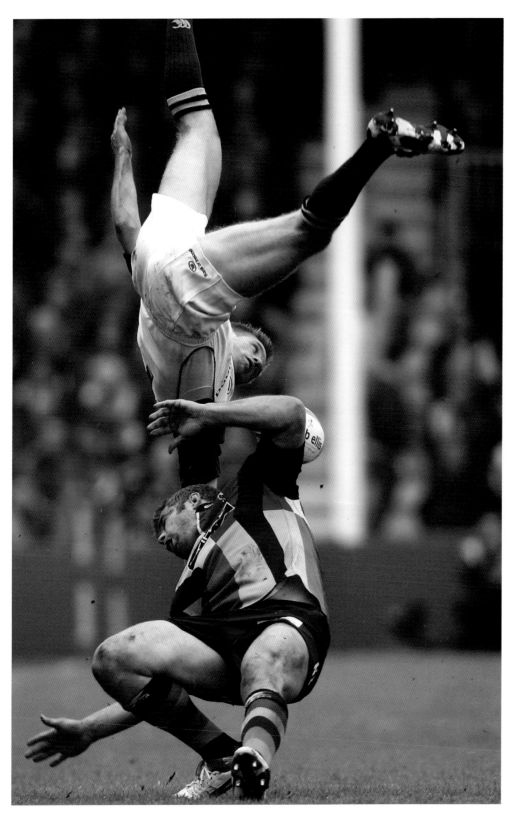

HEAD OVER HEELS

Leinster's Luke Fitzgerald collides in mid-air with Harlequins' Nick Easter during the Heineken Cup Quarter-Final match. The Irish team produced an epic defensive performance to shade the game 6–5 and put them through to an all-Irish semi-final against Munster, which they went on to win 25–6. They clinched their first title against Leicester Tigers with a nail-biting 19–16 victory.

Date: **12th April, 2009**
Venue: **Twickenham Stoop Stadium, London**

TAKE THE LIFT

Glasgow Warriors' Richie Gray (C) rises high to claim the ball from a line-out in a Magners League game against Connacht.

Date: **15th May, 2009**
Venue: **Firhill Stadium, Glasgow**

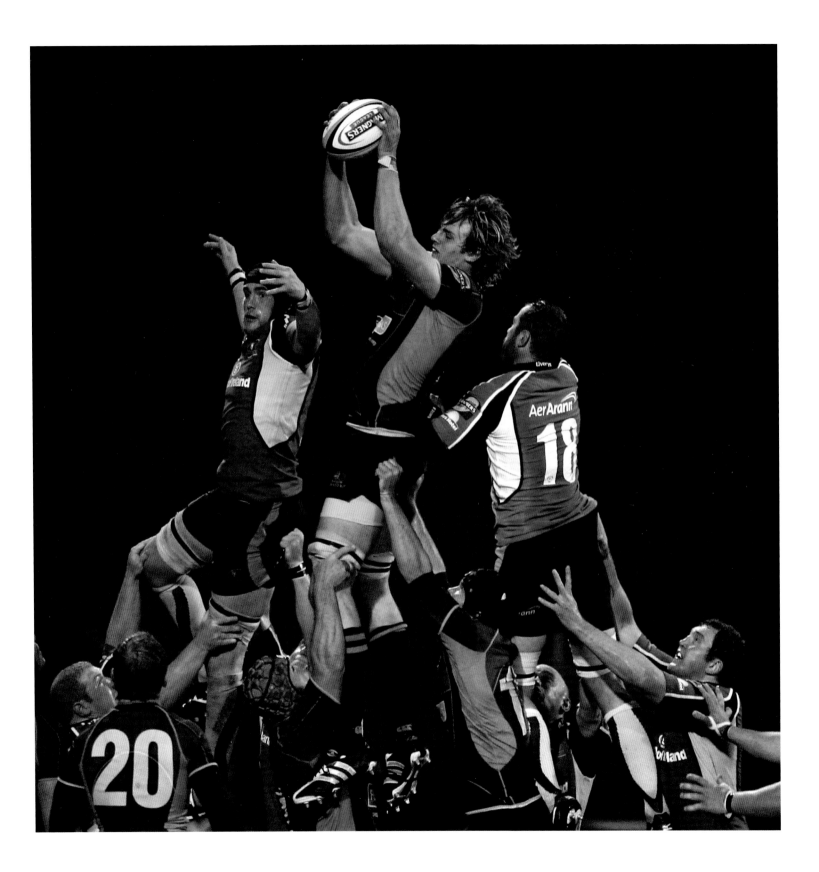

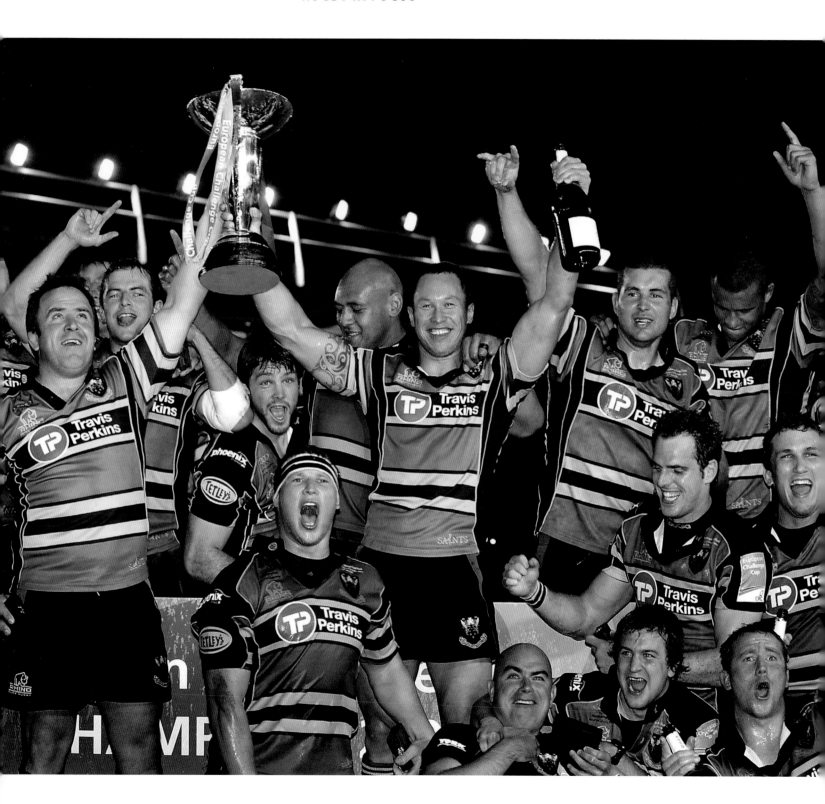

SAINTS IN HEAVEN

Northampton Saints captain Bruce Reihana (C) raises the cup after a 15–3 win in the European Challenge Cup Final against French side Bourgoin. In an open and often bad-tempered match, it was the boot of Stephen Myler that proved decisive – he kicked all of Saints' points.

Date: **22nd May, 2009**
Venue: **Twickenham Stoop Stadium, London**

AERIAL COMBAT

Gloucester's Olly Morgan (L) and Northampton's Ben Foden jump for a high ball during a Guinness Premiership match. The Saints ran out 27–14 winners after tries from Soane Tonga'uiha and Jon Clarke, as well as three penalties from Shane Geraghty and two from Bruce Raihana.

Date: **19th September, 2009**
Venue: **Kingsholm Stadium, Gloucester**

108

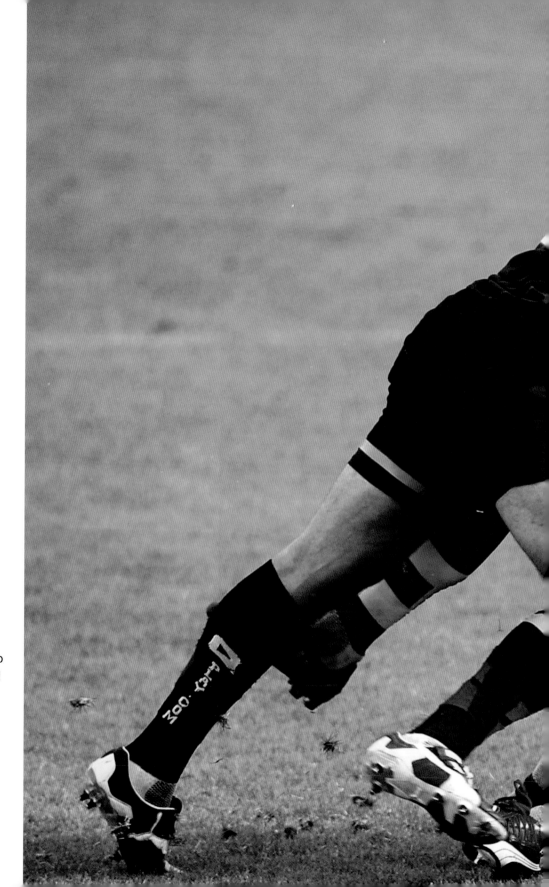

THIS WAY PLEASE

Gloucester's Nicky Robinson is tackled by Saracens' Mouritz Botha (L) and Justin Marshall (R) during a Guinness Premiership match. A 19–16 win for Saracens propelled them to the top of the table. They finished the season in third place, thereby qualifying for the play-offs, but lost out in the final to Leicester, who scored a 76th-minute converted try to seal a dramatic 33–27 victory.

Date: **27th September, 2009**
Venue: **Vicarage Road Stadium, Watford**

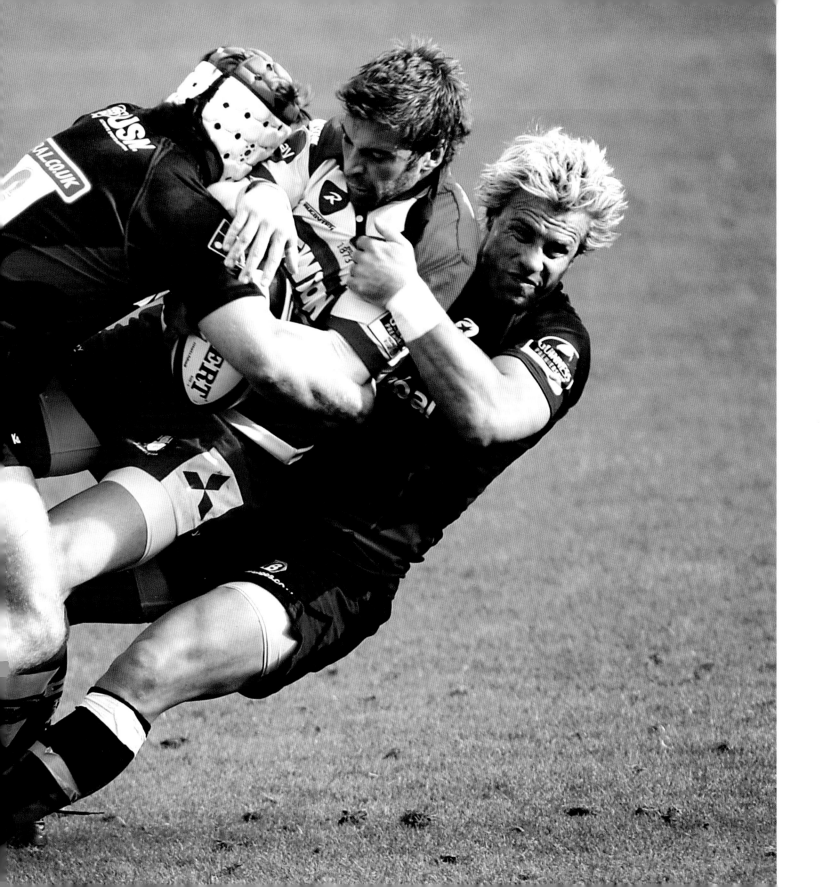

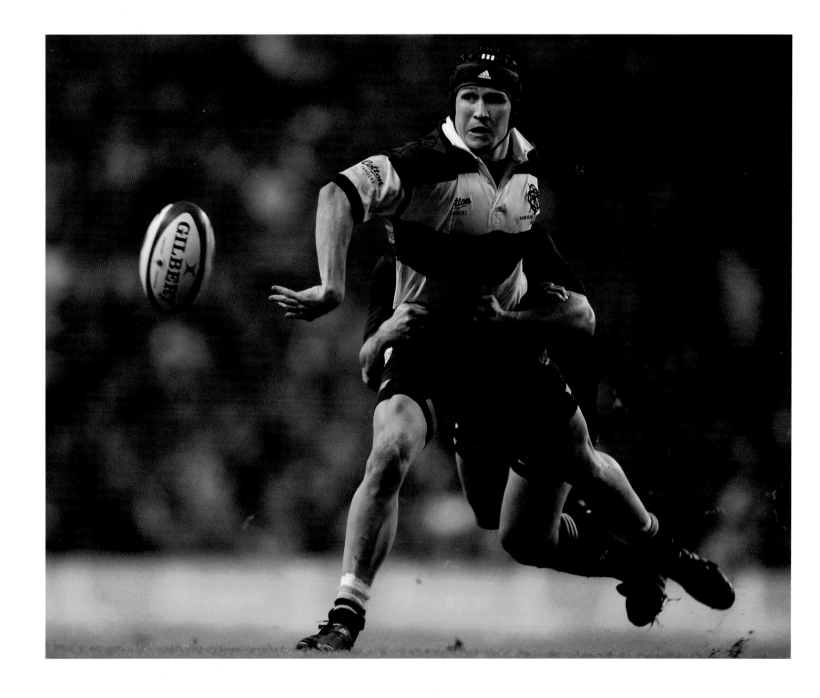

SLEIGHT OF HAND

Barbarians' Matt Giteau and New Zealand's Luke McAllister tussle for the ball during the inaugural Mastercard Trophy match. The 'Baa-Baas' won a thrilling game 25–18 with a hat trick of tries from scintillating South African winger Bryan Habana, whose pace and trickery delighted a large Twickenham crowd.

Date: **5th December, 2009**
Venue: **Twickenham, London**

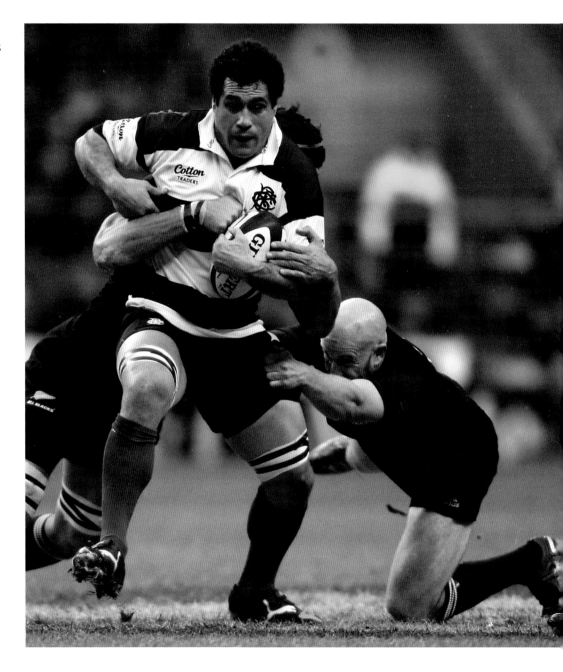

WRAPPED UP

Barbarians' George Smith (C) is tackled by New Zealand's Anthony Boric (L) and Brendon Leonard (R) during The MasterCard Trophy match.

Date: **5th December, 2009**
Venue: **Twickenham, London**

LOCAL RIVALS

Edinburgh's Chris Paterson (L) and David Callam (R) challenge Glasgow Warriors' Richie Vernon during a Magners League match. Dan Parks kicked a conversion, five penalties and a drop goal to help Glasgow to a 25–12 win and become the first player in Magners League history to 1,000 points.

Date: **27th December, 2009**
Venue: **Firhill Stadium, Glasgow**

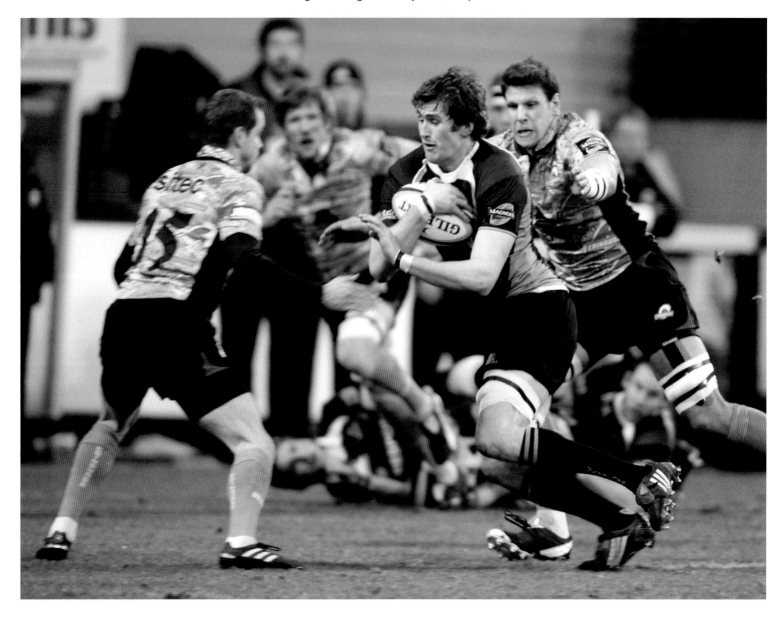

TRY TIME

Lesley Vainikolo celebrates as he scores Gloucester's first try during a Heineken Cup pool match against Biarritz. The French team went on to make it all the way to the final, where they lost a tight match against rivals Toulouse.

Date: **15th January, 2010**
Venue: **Kingsholm Stadium, Gloucester**

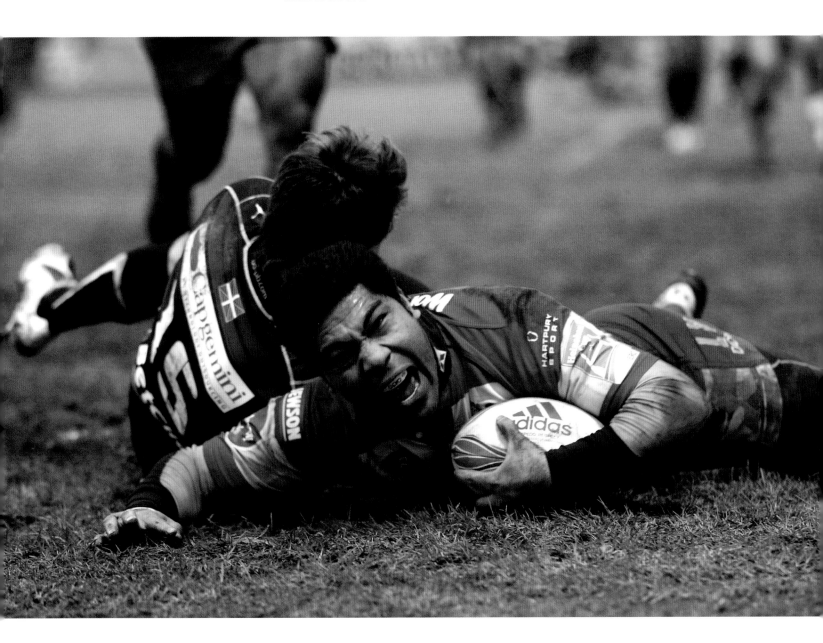

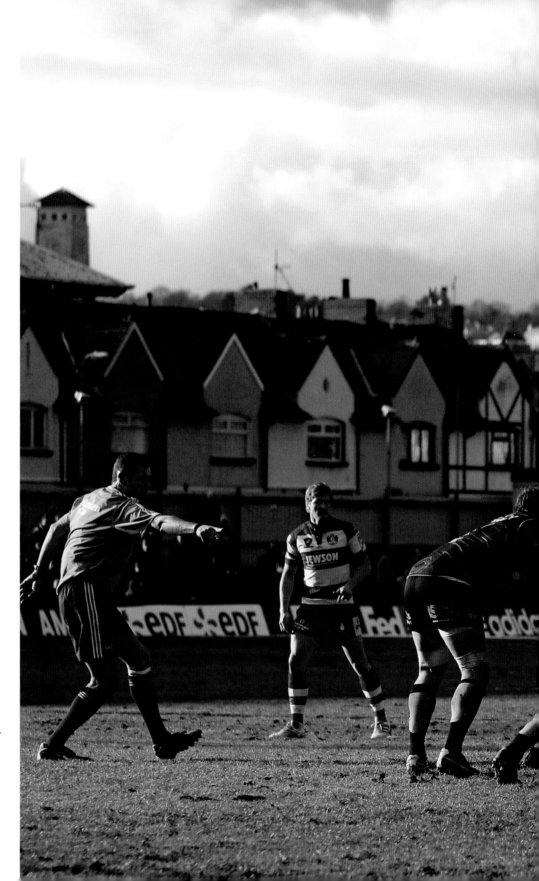

WELSH RUGBY HEARTLAND
The Newport-Gwent Dragons and Gloucester
Rugby contest a scrum during a Heineken
Cup pool game.

Date: **24th January, 2010**
Venue: **Rodney Parade, Newport**

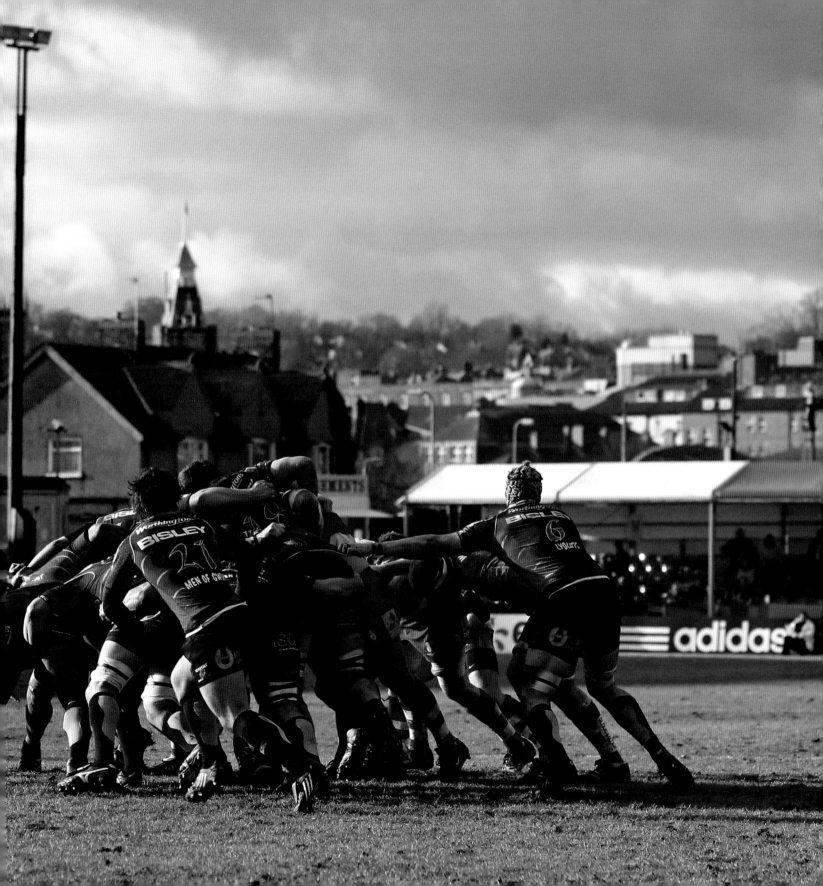

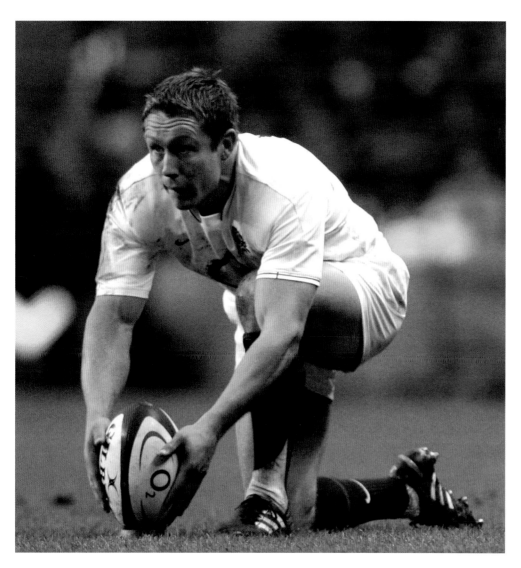

ALL LINED UP

Jonny Wilkinson lines up his attempt at goal during England's RBS Six Nations Championship match against Ireland. Ireland won by 20 points to 16.

Date: **27th February, 2010**
Venue: **Twickenham, London**

OVER THE LINE

Ireland's Keith Earls (C) is congratulated by his team mates after scoring his team's second try during the RBS Six Nations match against England. Tommy Bowe also scored twice as Ireland ran in three tries to England's one.

Date: **27th February, 2010**
Venue: **Twickenham, London**

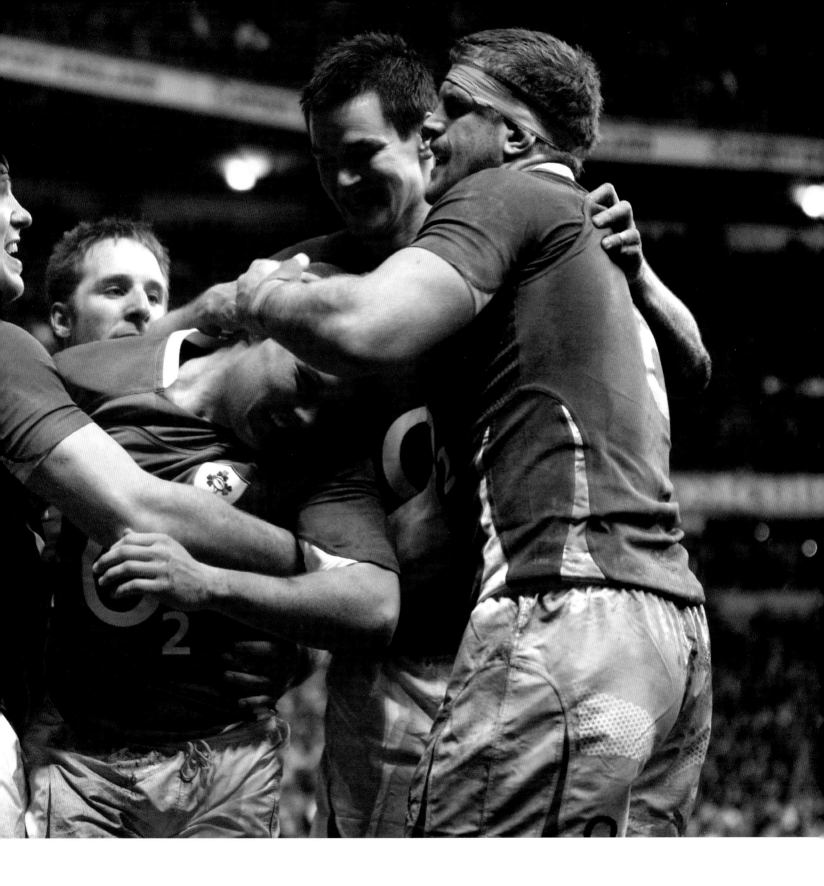

GETTING TO KNOW YOU

Northampton's Juandre Kruger (R) and Saracens' Mouritz Botha are sent to the 'sin bin' after a confrontation during the LV Cup Semi-Final match. The Saints came out on top 31–20 in a sometimes ill-tempered affair to set up a final against Gloucester.

Date: **14th March, 2010**
Venue: **Franklin's Gardens, Northampton**

CENTRE PARTNERS

Powerful French centres Mathieu Bastareaud (L) and Yannik Jauzion stand together during France's narrow two point victory over England that secured them the 2010 Six Nations Championship.

Date: **20th March, 2010**
Venue: **Stade de France, Paris, France**

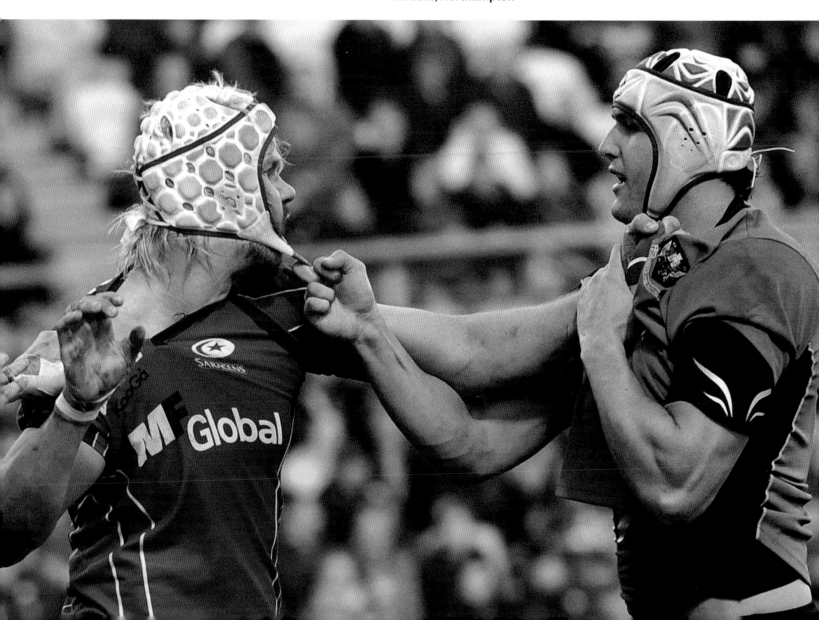

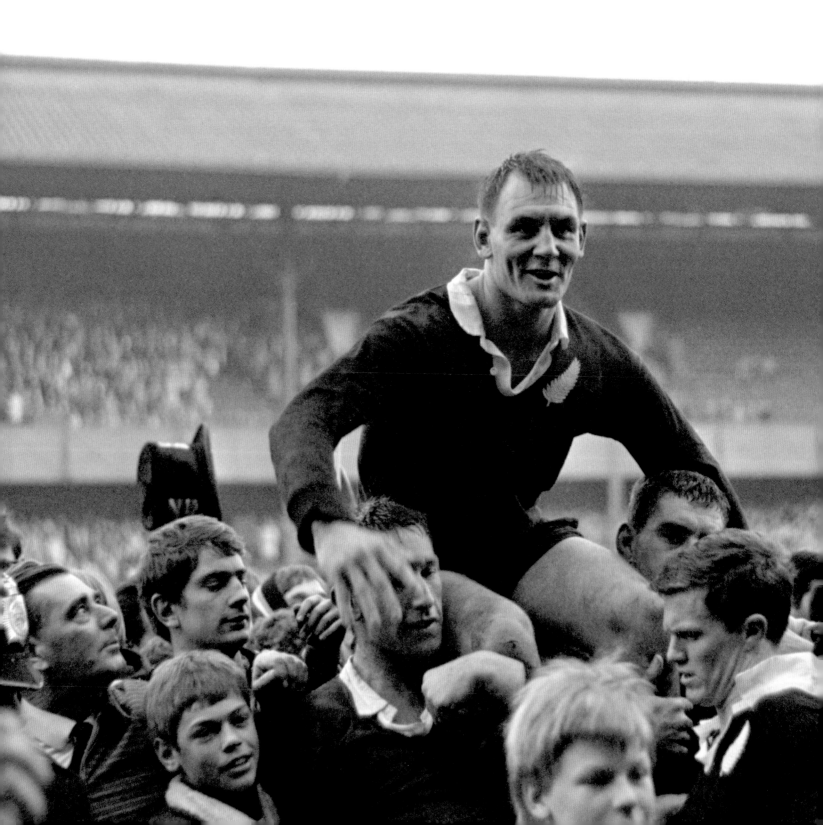

2 THE PLAYERS

Rugby is the team game *par excellence*, but the individual player can and does make a difference, illuminating games with moments of skill, determination and sheer courage.

The photographer picks out these instances and in doing so can capture the character of the man and the magic of the moment.

The names are evocative: Ernest 'General' Booth; Prince Alexander Obolensky; Wilson Whineray; Serge Blanco; Gareth Edwards; Nick Farr-Jones; Chester Williams; Martin Johnson. These and other legends of the game are shown in pictures that capture the concentration, the desire, the skill and self-belief of some true sporting icons.

FINAL TRIUMPH
New Zealand captain Brian Lochore is chaired off by his triumphant team-mates after leading his team to victory in the final game of the New Zealand Tour of Britain.

Date: **16th December, 1967**
Venue: **Twickenham, London**

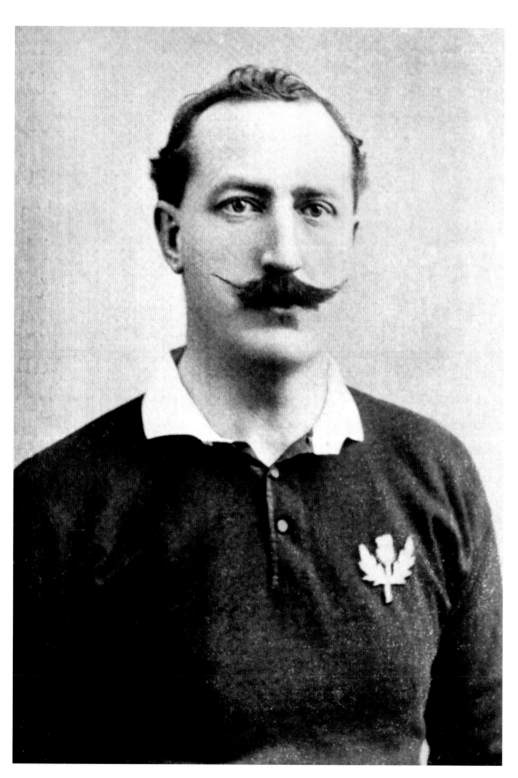

PROUD SCOTSMAN

Bill Maclagan, who played club rugby for London Scottish FC and international rugby for Scotland, was one of the most important figures in the early development of the game. Playing at both three-quarter and fullback, Maclagan represented his country for 13 seasons, earning 25 caps, making him one of the longest serving international players of his era. He led the first British Isles team on its 1891 tour of South Africa; this and his other contributions to the game were recognised in 2009 with his induction into the IRB Hall of Fame.

Date: **1st February, 1886**

ENGLAND RUGBY

The England team group before the Calcutta Cup match against Scotland in 1886. (back row L–R) A.E. Stoddard, Fred Bonsor, A. Teggin, E.B. Brutton. (second from back row L–R) C. Gurdon, A. Rotheram, W. G. Clibborn, N. Spurling, R. Robertshaw. (second from front row L–R) R.E. Inglis, E.T. Gurdon, E. Wilkinson, C.J.B. Marriott. (front row L–R) Charles Sample, G.L. Jeffery.

Date: **13th March, 1886**

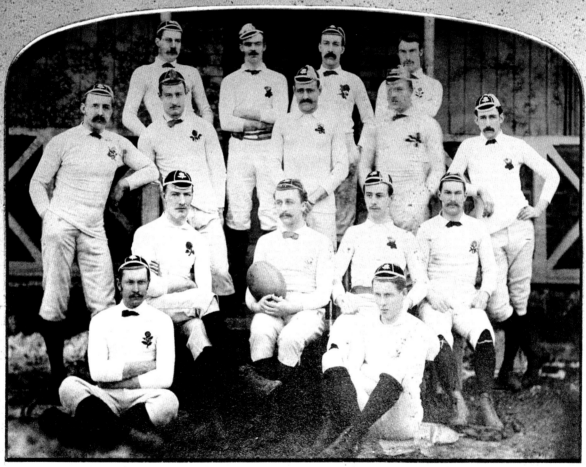

England v Scotland
March 13th 1886.

A. E. Stoddart	H. Bonsor	A. Teggin	E. B. Brutton	
C. Gurdon	A. Rotherham	W. G. Clibborn	N. Spurling	R. Robertshaw
E. E. Inglis	E. T. Gurdon	F. Wilkinson	C. J. B. Marriott	
C. H. Sample		G. L. Jeffery		

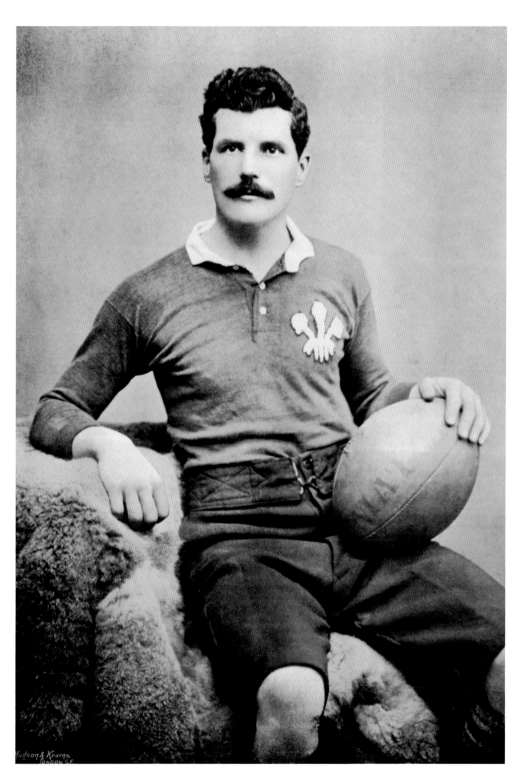

WELSH GOLD

Arthur Gould, who won 27 caps for Wales and led his nation as captain on 18 occasions, is considered by many to be the first superstar of Welsh rugby. He made two appearances at fullback, but he was more often utilised as a centre, in which position he employed his electric pace and agility to great effect. By 1896, Gould had played more first-class matches, scored more tries and dropped more goals than any other player on record. He was a legend in his own lifetime, and his funeral in 1919 (he died aged just 54 from an internal haemorrhage) was said to have been the biggest ever seen in Wales, until Lloyd George's death some 30 years later. Gould's legendary status lives on to this day: he was inducted into the Welsh Sports Hall of Fame in 2007.

Date: **1st September, 1895**

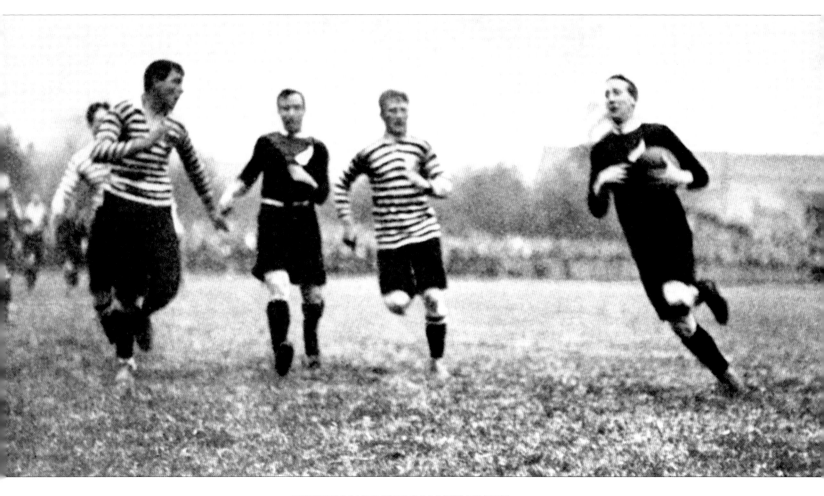

'GENERAL' BOOTH SALLIES FORTH

Ernest 'General' Booth (R), of The Original All Blacks, races forward with the ball during a match against Somerset. The Originals were the first New Zealand rugby team to tour outside of Australasia, visiting the British Isles, France and the United States of America in 1905–06. They played 35 matches, losing only once, by a narrow 3–0, to Wales. Booth made his international debut against France in January 1906 and went on to play three tests for the All Blacks.

Date: **21st October, 1905**
Venue: **Jarvis's Field, Taunton**

WAR HERO

Dave Gallaher, captain of the first touring New Zealand rugby team, known as The Original All Blacks. Gallaher played in 26 of the 35 matches on New Zealand's tour of the British Isles, France and the United States of America, proving to be an expert motivator and an astute tactician. Keen to fight in the First World War, he lied about his age, claiming he was three years younger. His deception was successful, but he was killed in the Passchendaele offensive in 1917. Today, New Zealand and France compete for the Dave Gallaher Trophy, which is awarded to the winner of the first Test Match between the two nations in any given year.

Date: **1st November, 1905**

SPIRIT OF WALES

Jehoida Hodges, one of the most influential players in the early history of Welsh rugby. Along with fellow Welsh internationals George Boots and George Travers, Hodges is credited with bringing a greater tactical sophistication to forward play. Blessed with great strength, Hodges is remembered particularly for the forward resistance he showed in Wales's famous 3–0 victory over The Original All Blacks in 1905, but he was an all-round player who was equally as comfortable on the wing.

Date: **10th January, 1908**

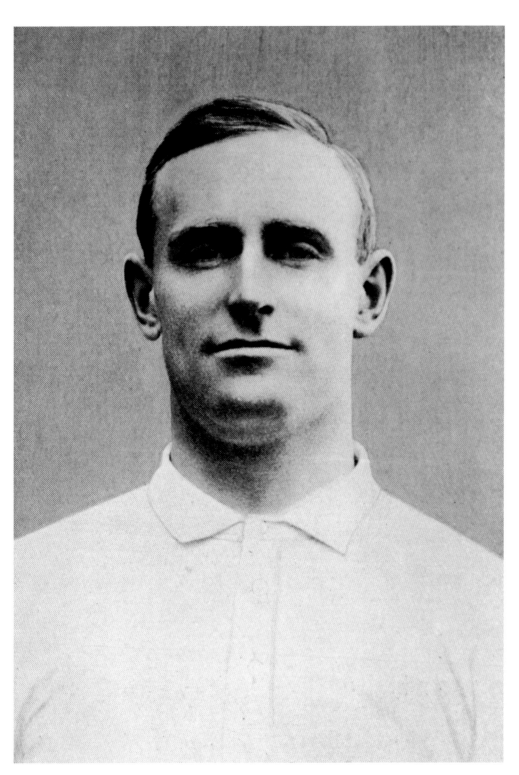

UNBEATEN RECORD

Ronald Poulton-Palmer, captain of England and one of the finest players of his generation. Considered by many of his contemporaries to be the greatest ever attacking three-quarter, Poulton-Palmer scored a remarkable five tries for Oxford in the Varsity match of 1909, still a record to this day, and led his country in the unbeaten season of 1914. Commissioned as a lieutenant in the Army during the First World War, he was killed by a sniper's bullet in 1915.

Date: **1st February, 1914**

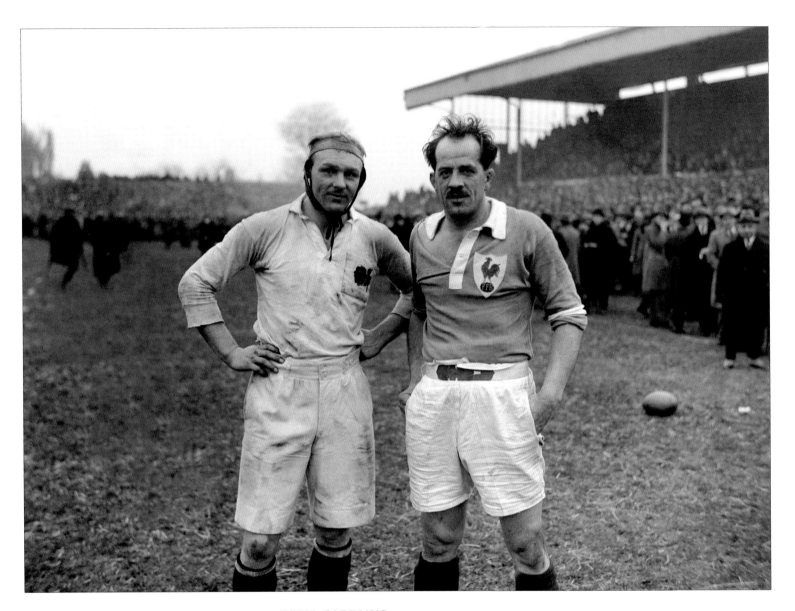

RIVAL CAPTAINS

Wavell Wakefield (L) and Aimé Cassayet-Armagnac, captains of England and France respectively, after an international match between the two nations. On retiring from rugby, Wakefield became a prominent politician. Tragically, Cassayet-Armagnac died in 1927, at the age of just 34, after a short illness.

Date: **23rd February, 1924**
Venue: **Twickenham, London**

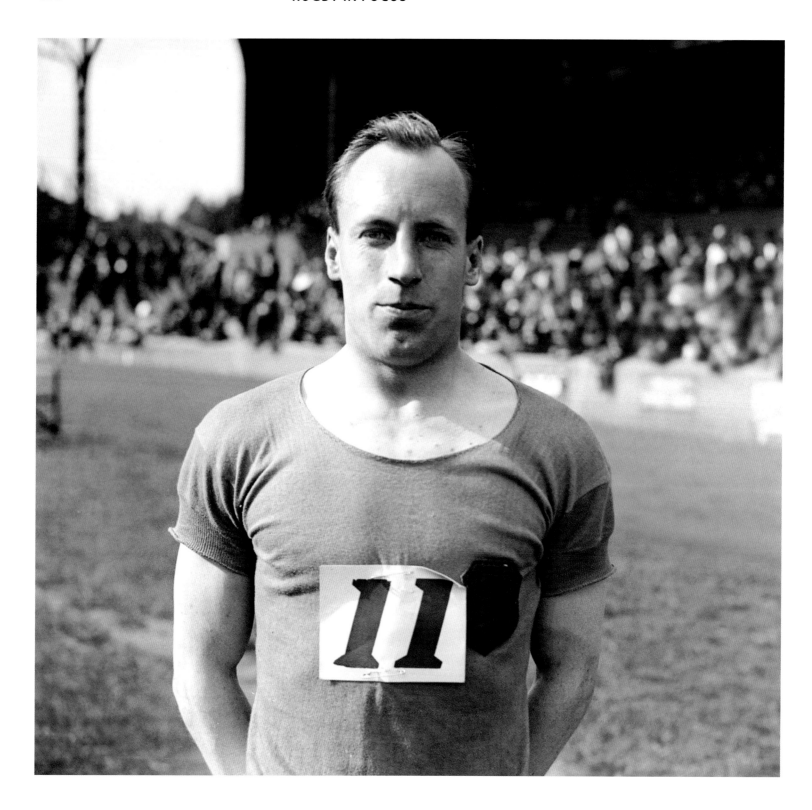

SCOTLAND'S SUPERSTAR

Eric Liddell, the Scot who won Gold in the 400 metres at the 1924 Olympic Games in Paris, was immortalised by the film *Chariots of Fire*. After quitting athletics, he became a Christian missionary in China, but was captured by the Japanese. He died in a prisoner-of-war camp in 1945, just three months before the end of the Second World War. Although he is best known for his athletics career and his missionary zeal, Liddell also played international rugby for Scotland, winning six caps for his country.

Date: **1st July, 1924**

MAORI SUPERSTAR

George Nepia, a member of the 1924–25 New Zealand rugby team who toured the British Isles, France and Canada. Nepia is remembered as an exceptional fullback and one of the greatest Maori players of all time. He played in all 32 matches of the tour, scoring 77 points, which helped the team to remain unbeaten, a feat that led to them being named 'The Invincibles'. Regarded by some as New Zealand's first true rugby superstar, in 2004 Nepia was selected as number 65 by the panel of *New Zealand's Top 100 History Makers* television programme.

Date: **1st December, 1924**

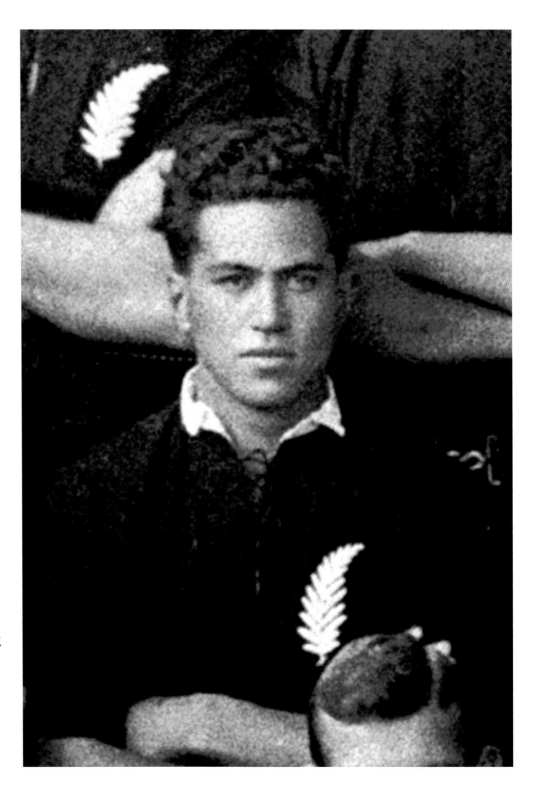

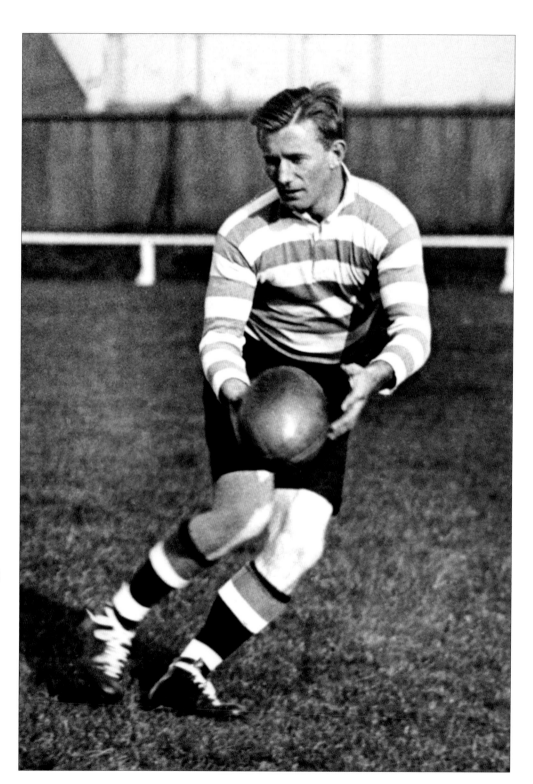

SPRINGBOK SKIPPER

South African captain Bennie Osler training during the Springboks' 1931–32 tour to the British Isles. Osler's men became the second South African team to win the Grand Slam against the home nations, with wins over England, Scotland, Wales and Ireland. Osler's accuracy when kicking for territory allowed South Africa to play ten-man rugby, a forward orientated style of play.

Date: **22nd September, 1931**

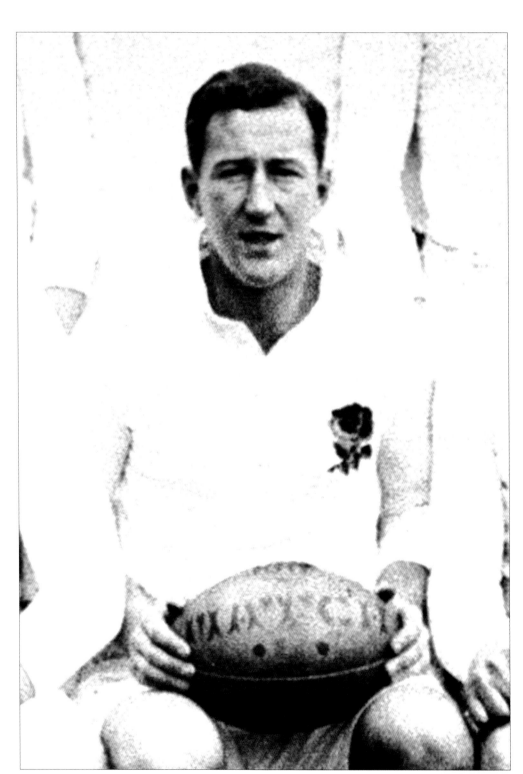

ENGLAND CAPTAIN

Scrum-half and captain Bernard Gadney before England's international match against New Zealand. England's 13–0 victory became known as 'Obolensky's Game', thanks to the exploits of Prince Alexander Obolensky, who scored two tries, the first of which was regarded at the time as the greatest ever scored. Gadney played 14 times for his country, captaining the team on eight occasions, and has the enviable record of never having lost an international match.

Date: **4th January, 1936**
Venue: **Twickenham, London**

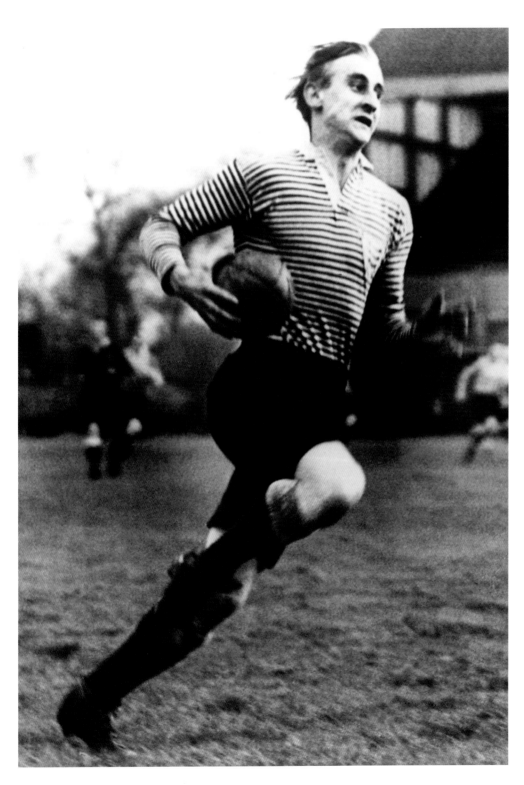

PRINCE AMONG WINGERS

Prince Alexander Obolensky, a member of the exiled Kievan Rus Rurik dynasty, in action. Obolensky, popularly known as 'The Prince' by rugby fans, played four times for England in the years leading up to the Second World War. He is best remembered for his debut performance against New Zealand, when he scored two tries in a 13–0 win. His first, recorded by Pathé News and shown in cinemas across the nation, was regarded by his contemporaries as the greatest ever scored. Obolensky was killed in a flying accident while training for the RAF in 1940.

Date: **1st October, 1937**
Venue: **Unknown**

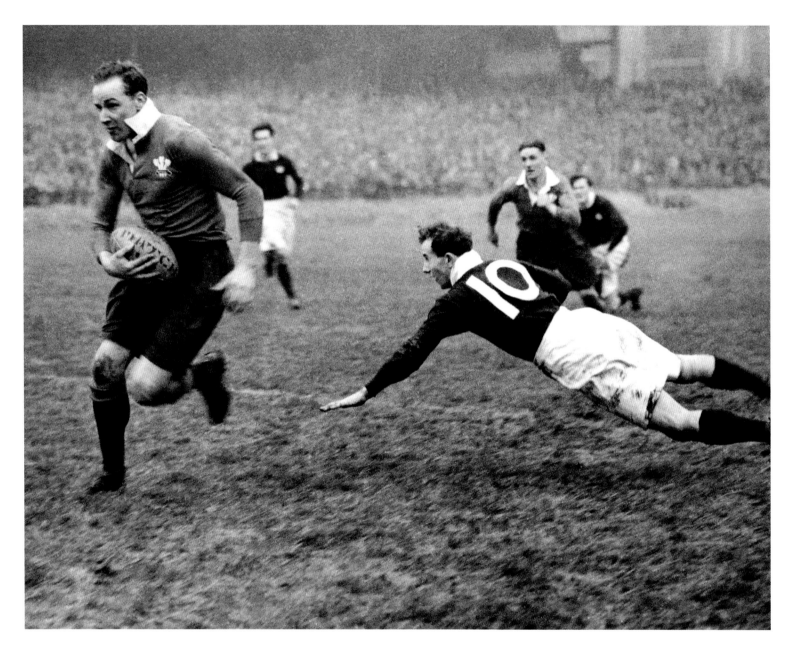

WOOLLER BREAKS THE LINE
Wales's Wilf Wooller (L) dodges a tackle
from Scotland's John Craig during a Five
Nations Championship match.

Date: **4th February, 1939**
Venue: **The Arms Park. Cardiff**

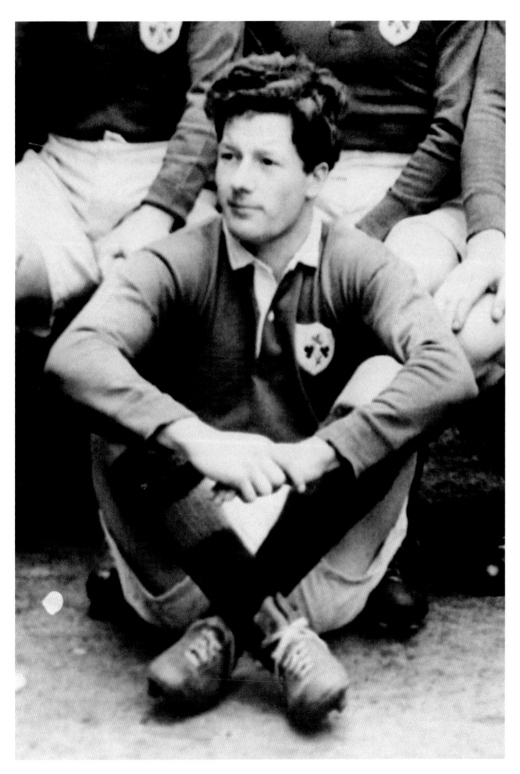

GRAND SLAM JOY

Ireland's Jack Kyle before a Five Nations Championship Match against England. Playing at fly-half, Kyle made 46 full appearances for his country between 1947 and 1958, scoring 24 points. He is perhaps best known for his superb performances during Ireland's 1948 Grand Slam winning season; in 2002, he was named the 'Greatest Ever Irish Rugby Player' by the Irish Rugby Football Union.

Date: **8th February, 1947**
Venue: **Lansdowne Road, Dublin**

LEADING BY EXAMPLE

Hennie Muller, captain of South Africa, during a tour match against London Counties. The Tourists lost this match at Twickenham by 9 points to 11. Muller, considered one of South Africa's greatest ever players, is perhaps best known for his performances in the 1951–52 tour to the British Isles and France. Victories over the four Home Nations were followed by a 25–3 win against the French, ensuring a Grand Slam for the Springboks.

Date: **15th December, 1951**
Venue: **Twickenham, London**

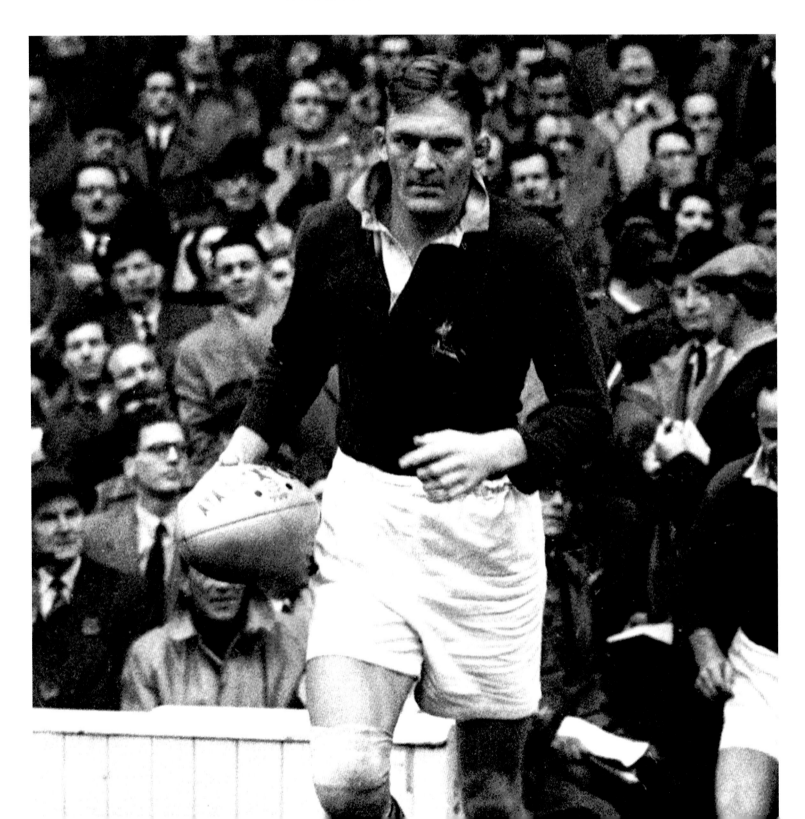

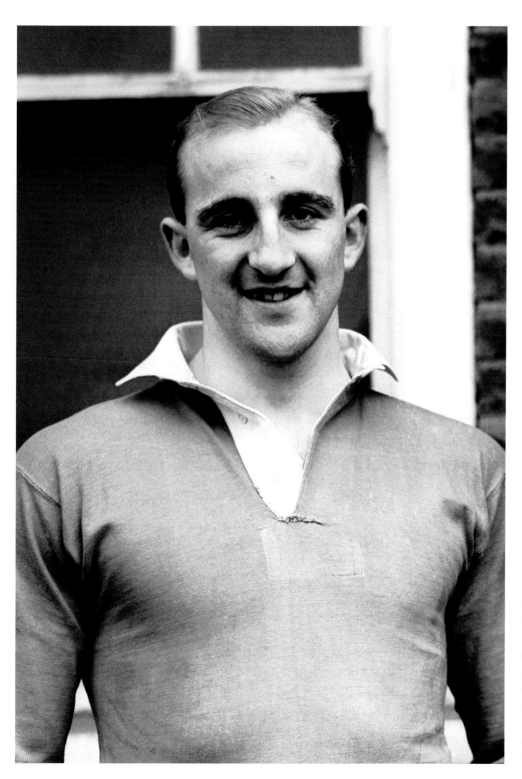

SWAPPING THE CODES

Lewis Jones, hailed by some as the greatest attacking back Wales ever produced, poses in his Llanelli shirt. Played variously at fullback, centre and wing, Jones's devastating acceleration, top speed and trickery made him one of the greatest stars of the game in the 1950s. Shortly after this photograph was taken, Jones signed for Leeds rugby league club, where he achieved a club record of over 1,000 goals, a feat that survived until equalled in 2009 by Kevin Sinfield.

Date: **10th November, 1952**
Venue: **Stradey Park, Llanelli**

FRENCH FAVOURITE

France's captain, Jean Prat, leads his team out to face England in a Five Nations Championship match, a game that the English went on to win 11–0. Prat played over 50 times for his country, scoring 139 points, and as captain laid the foundations for France to become a major force in world rugby.

Date: **28th February, 1953**
Venue: **Twickenham, London**

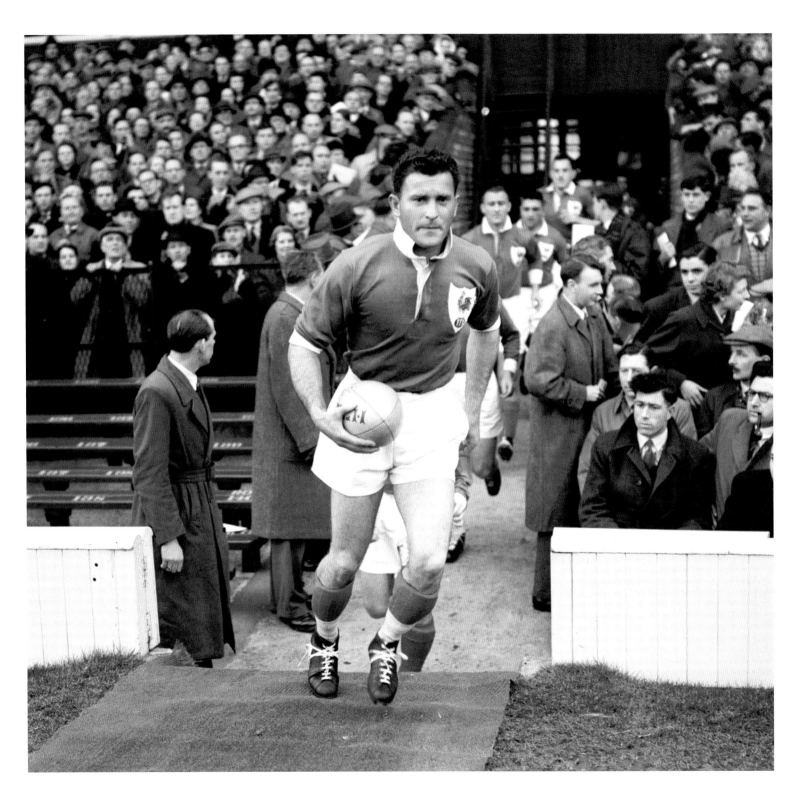

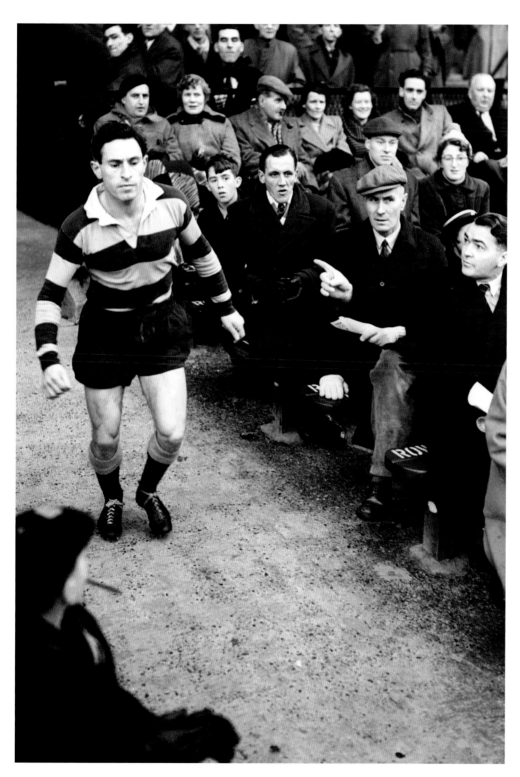

FAMOUS FLY HALF

A spectator points out Cardiff's Cliff Morgan as he emerges from the Twickenham tunnel to face Harlequins. Playing at fly-half, Morgan's acceleration, strength and astute kicking earned him 29 caps for Wales between 1951 and 1958, as well as four caps for the British Lions during the drawn test series against South Africa in 1955.

Date: **10th December, 1955**
Venue: **Twickenham, London**

TWICKENHAM PRELIMINARIES

HRH The Duke of Gloucester (C) talks to England captain Eric Evans before the match against Australia, a game that the home team shaded 9–6. Evans made 30 appearances for England, captaining his country on 13 occasions.

Date: **1st February, 1958**
Venue: **Twickenham, London**

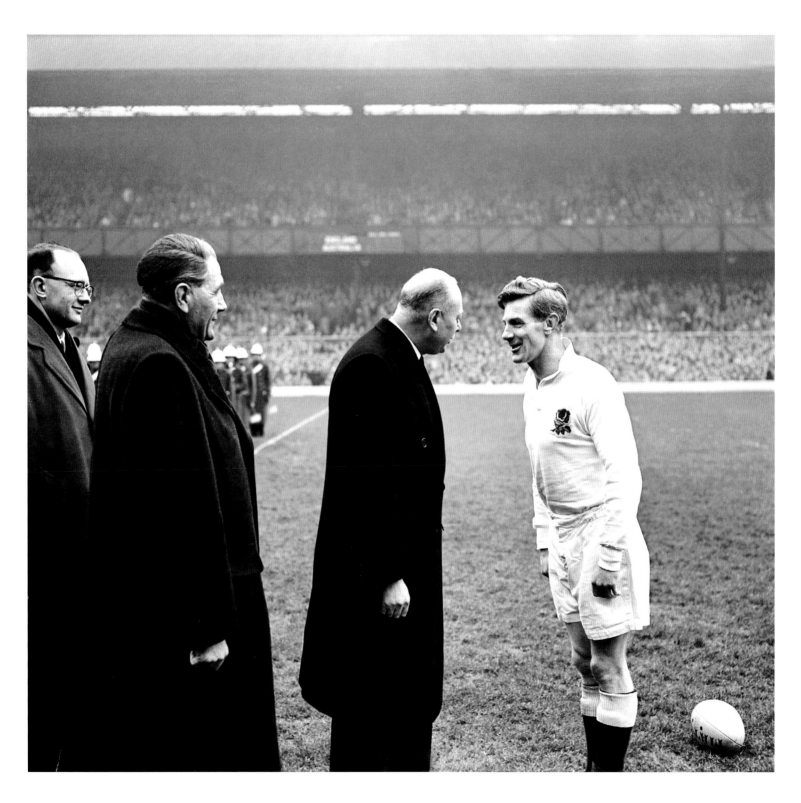

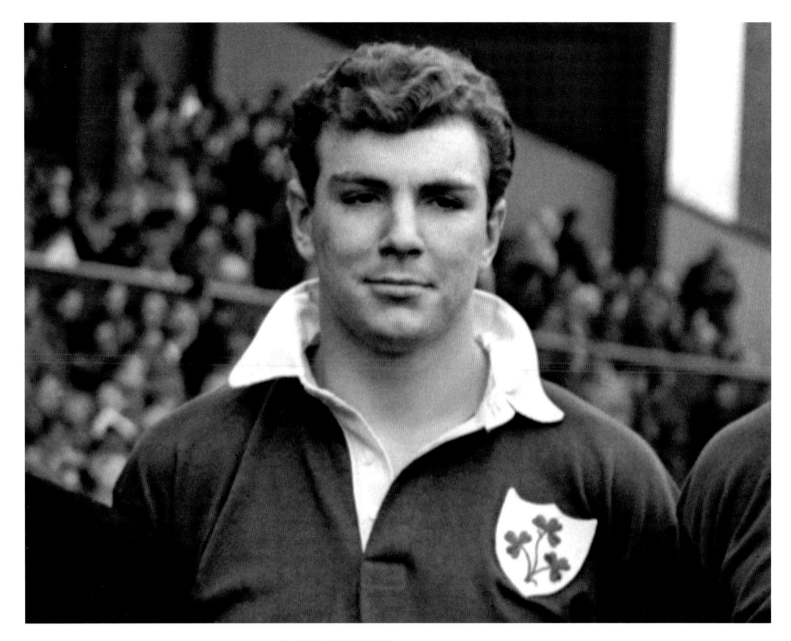

FLYING IRISHMAN

Ireland winger Tony O'Reilly lining up before a Five Nations Championship match against England. O'Reilly won 29 caps for the Irish, scoring 12 points; he also gained 18 points in 10 appearances for the British Lions.

Date: **8th February, 1958**
Venue: **Twickenham, London**

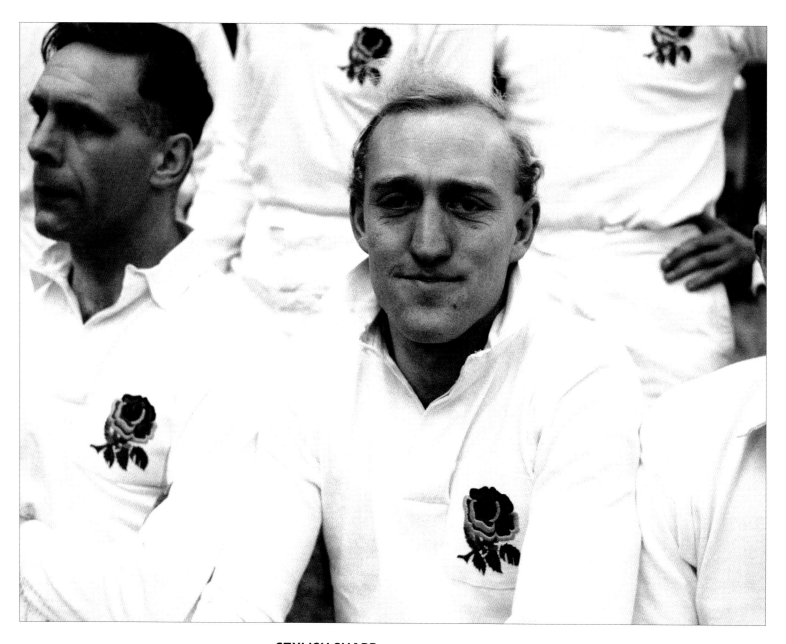

STYLISH SHARP

England captain Richard Sharp during a Five Nations Championship match against France, a game edged by the English 6–5. Playing at fly-half, Sharp made 14 appearances for England and is best known for leading his country to a Five Nations Championship title in 1963. A 0–0 draw against the Irish in Dublin cost England the Grand Slam.

Date: **23rd February, 1963**
Venue: **Twickenham, London**

ENGLAND'S FINEST

Budge Rogers during a training session prior to England's tour to the southern hemisphere. Rogers played 34 times for his country, captaining the team on seven occasions, and was a regular pick for the British Lions.

Date: **9th May, 1963**
Venue: **Twickenham, London**

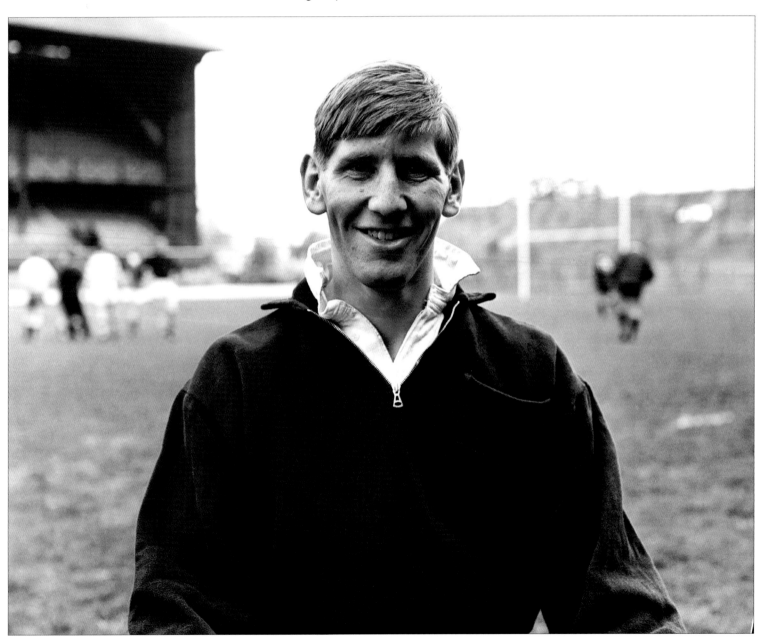

GOOD ATTENDANCE

England prop Ron Jacobs during a break from training prior to the tour to Australia and New Zealand. Jacobs won 29 caps for England, captaining his country for his final two appearances in 1964. He holds the appearance record for Northampton, having played 470 times over a 17-year period.

Date: **9th May, 1963**
Venue: **Twickenham, London**

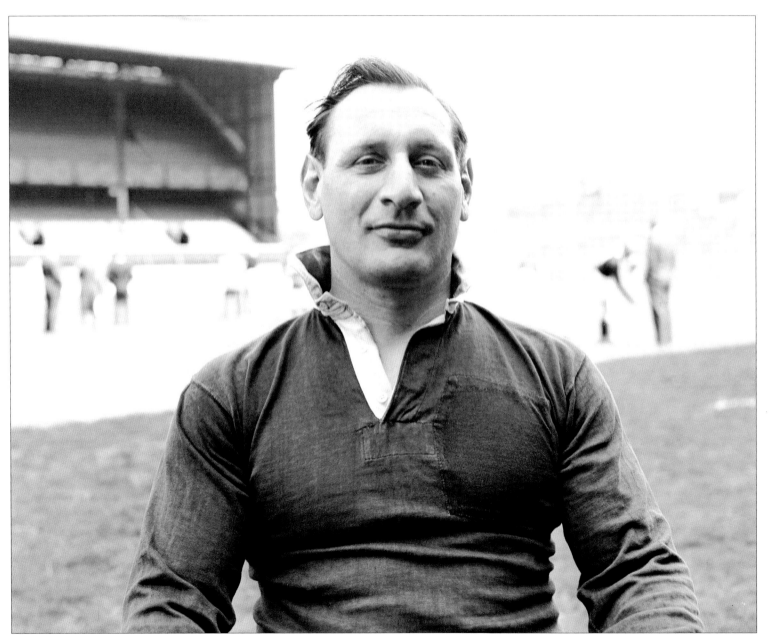

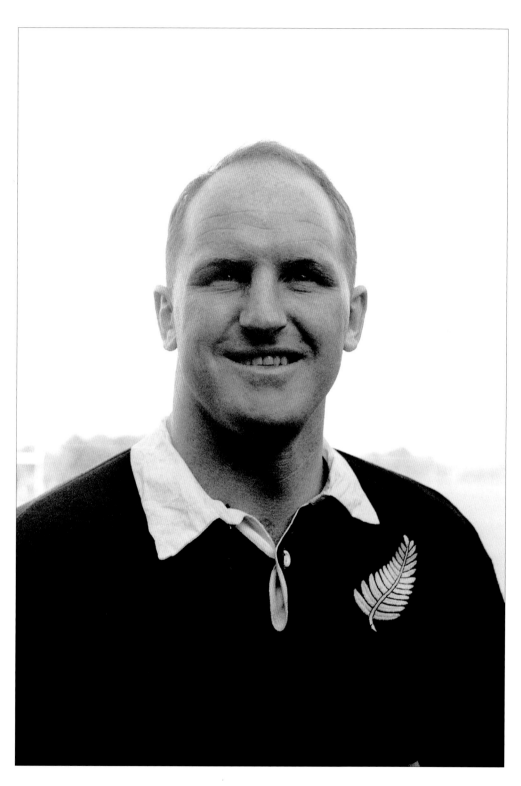

LONG SERVICE

New Zealand captain Wilson Whineray during New Zealand's tour to the British Isles. Whineray played in 32 test matches for the All Blacks, captaining them on 30 occasions, which makes him the longest serving captain in New Zealand history.

Date: **20th October, 1963**

STRENGTH AND BRAVERY

The Barbarians' Ian Clarke tackles New Zealand's Colin Meads during a tour match. Playing most often at lock forward, Meads took part in 55 test matches for New Zealand between 1957 and 1971, and is considered to be one of the greatest players in the history of the game. A combative player who once completed a game despite suffering a fracture to his arm, Meads was renowned for his strength and bravery. His desire to win was so great that sometimes it clouded his judgment, and he was involved in some controversial incidents during his career. Despite this, he was voted New Zealand's Player of the Century at the New Zealand Rugby Football Union Awards in 1999.

Date: **15th February, 1964**
Venue: **The Arms Park, Cardiff**

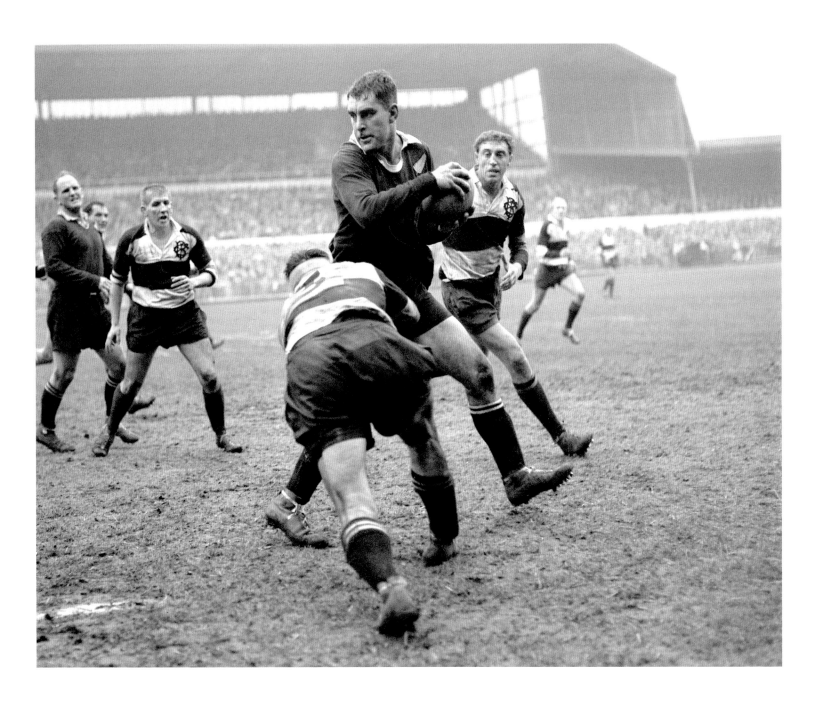

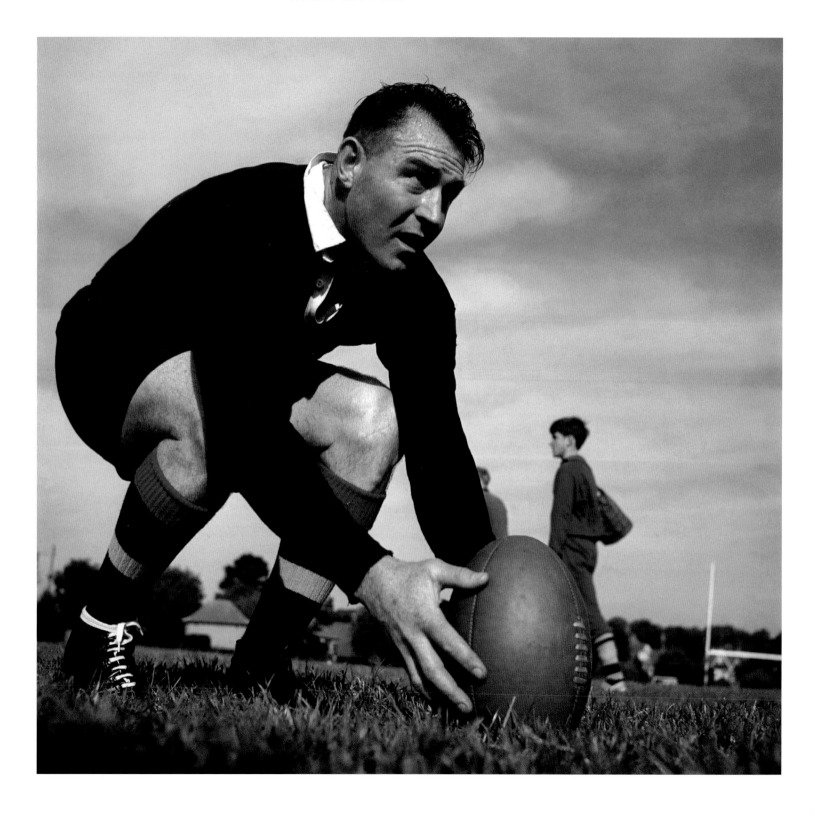

CLARKE'S PRACTICE

Don 'The Boot' Clarke, of New Zealand, earned his sobriquet for his superb goal kicking ability, which contributed the vast majority of the 781 points he scored during his All Black career.

Date: **14th May, 1965**

HOMEWARD BOUND

Ken Catchpole in 'civvies' during Australia's tour to the northern hemisphere. Considered to be one of the greatest scrum-halves ever to have played the game, Catchpole appeared in 27 Test Matches for the Wallabies, captaining them on 13 occasions. His career ended in controversial circumstances, however, when New Zealand's Colin Meads wrenched his leg while it was pinned down by other players in the ruck. The resulting injury was so severe that Catchpole never played again.

Date: **12th April, 1966**

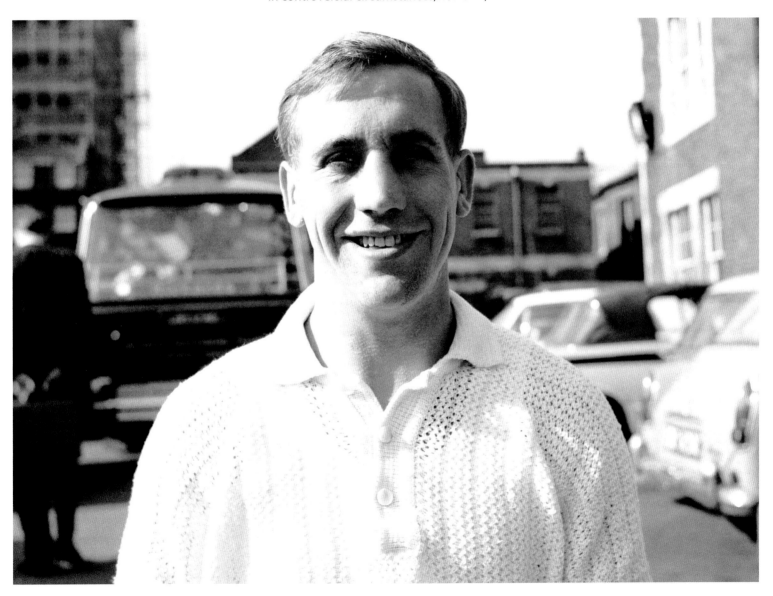

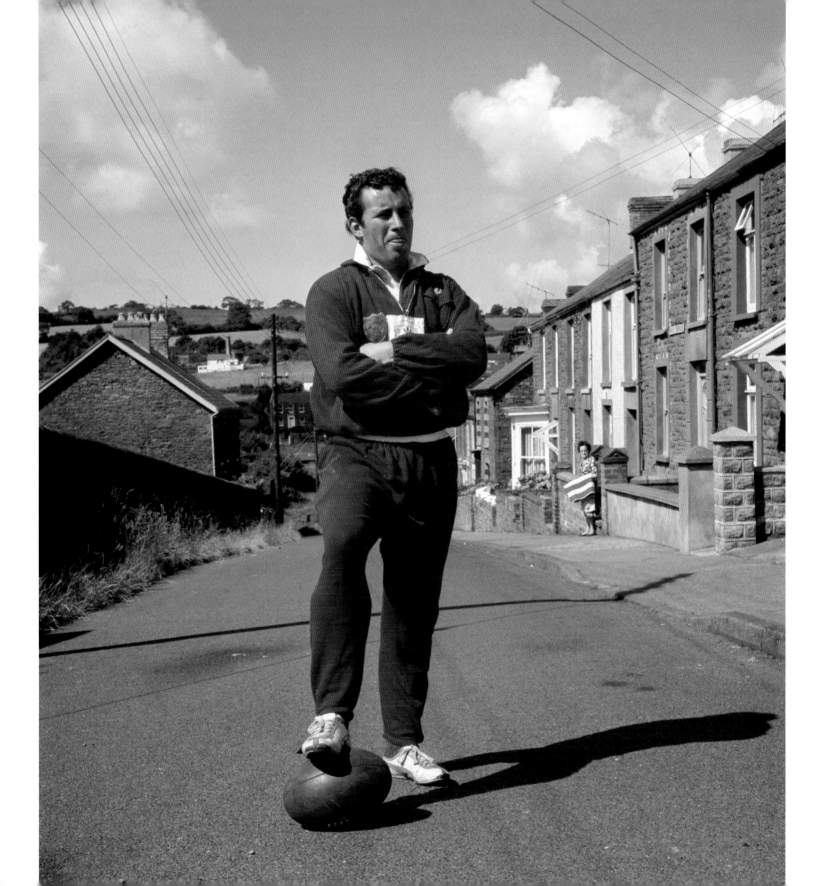

GREEN GREEN GRASS OF HOME

Terry Price, of Llanelli and Wales, in a typical south Wales street. Playing at fullback, Price made eight appearances for Wales before switching to rugby league in 1967. A master of both codes, he also tried his hand, or more accurately his foot, at American football, playing as placekicker for New York's Buffalo Bills in the early 1970s.

Date: **1st July, 1967**

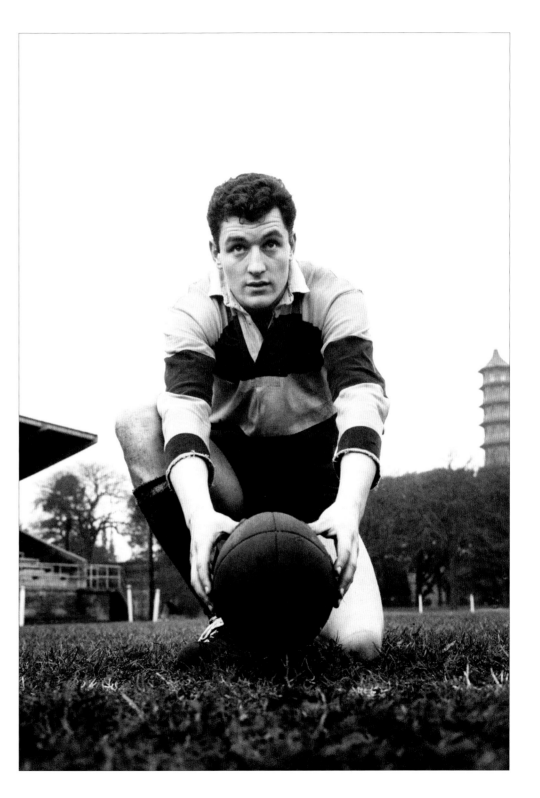

YOUNG GUN

Welshman Keith Jarrett lines up a kick during a training session in preparation for a Five Nations match against England. A precocious talent, Jarrett made his debut at the age of 18, scoring a stunning try after a break from his own 22-metre line, as well as making five conversions and two penalties. He made 10 appearances for Wales before switching codes, but his career was cut short at the age of just 25 after he suffered a stroke, which forced him to retire in his prime.

Date: **19th January, 1968**
Venue: **Old Deer Park, Kew, London**

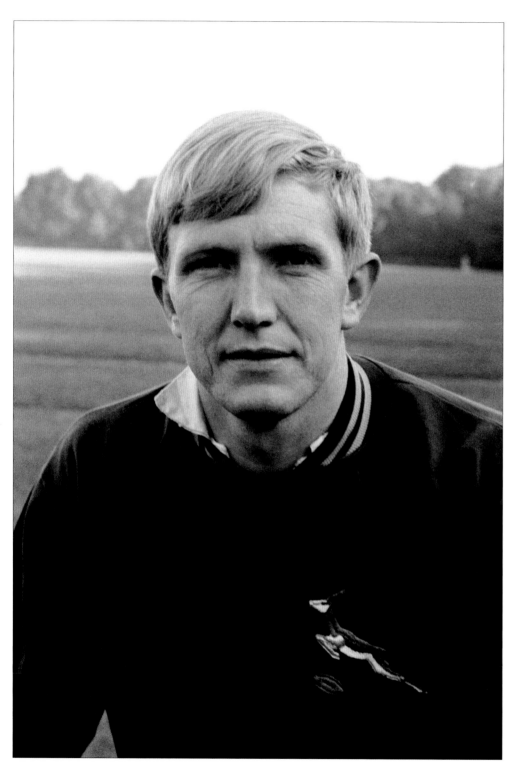

SPRINGBOK SCRUM-HALF
Dawie de Villiers during South Africa's tour of Great Britain. He played in 25 Test Matches for the Springboks, captaining the side on the tour to New Zealand in 1976.

Date: **1st November, 1969**

SPRINGBOK WITH A KICK
Springbok Frik Du Preez during the team's tour to Great Britain. He won 38 caps in a 10-year career, playing as lock and flanker. A superb all-rounder, Du Preez combined the athleticism and strength needed to play at lock with the turn of speed and kicking skills of a modern-day fullback.

Date: **1st November, 1969**

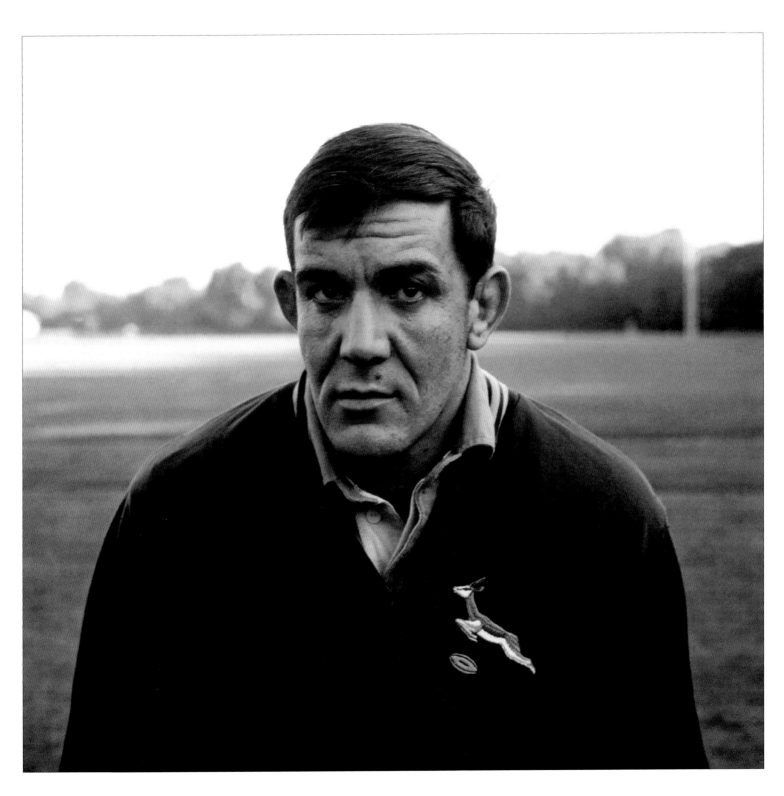

LIONS LEADER

Irishman Willie John McBride in the red of the British Lions during the 1971 tour to New Zealand. His selection for the tour had not been a foregone conclusion, some critics suggesting that he was past his best. He would prove the doubters wrong. He was made pack leader and played a crucial role in the Lions' 2–1 test series triumph, the first and so far only time a Lions team has won a series against the All Blacks.

Date: **1st May, 1971**

LIONS LOCK

Gordon Brown finds time for the camera during a break from training for the British Lions. Standing at 6ft 5in and weighing in at around 17 stone, Brown had the necessary physical attributes to play in the second row. Added to these natural endowments, he was more than capable in the loose, and was a determined and dedicated player with a strong will to win. Brown appeared 30 times for Scotland between 1969 and 1976, and won eight caps for the British Lions on three tours.

Date: **1st May, 1971**

WELSH FLY-HALF

Barry John, of Cardiff and Wales, was an extravagantly gifted player who is arguably the greatest kicker in the history of rugby. Playing at fly-half, John formed a formidable partnership with scrum-half Gareth Edwards in the great Welsh team of the late 1960s and early 1970s. Referred to by many as 'The King', John earned his nickname on the 1971 British Lions tour to New Zealand, where he scored 30 of the Lions' 48 points over the four tests.

Date: **1st May, 1971**

WELSH SCRUM HALF

Gareth Edwards, arguably the greatest player ever to don the famous red shirt of Wales and rated by many as the finest player of all time, during a British Lions training session. Edwards was one of 14 Welshmen in the tour party to New Zealand and Australia, where the Lions secured a historic series win over the All Blacks.

Date: **30th May 1971**

DUCKHAM MOTORS

England's David Duckham tries to outpace the opposition in the Rest of the World match. With John Spencer, he formed a solid and dynamic centre partnership during a difficult period for English rugby. Blessed with an ability to change direction at lightning speed, Duckham scored 10 tries in 42 appearances for England, and 11 tries in 16 games for the Lions, for whom he enjoyed more attacking freedom.

Date: **1st January,1972**
Venue: **Twickenham, London**

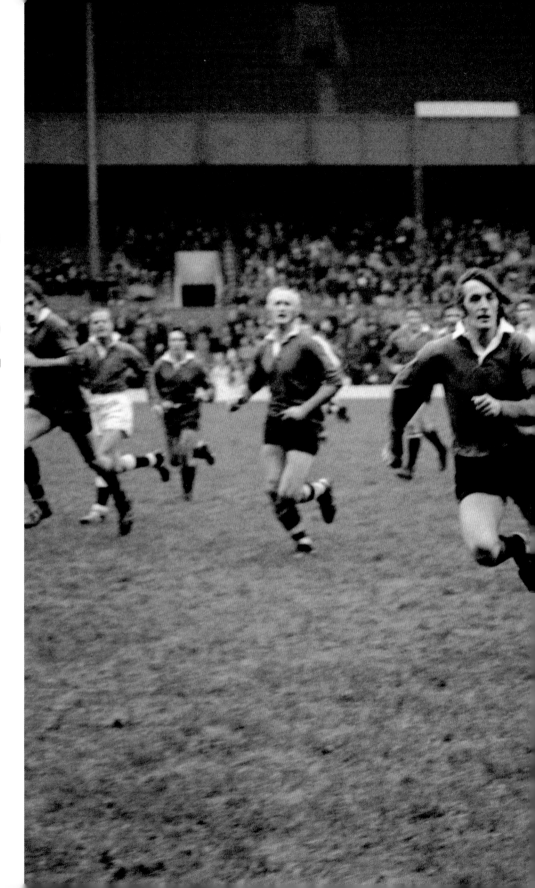

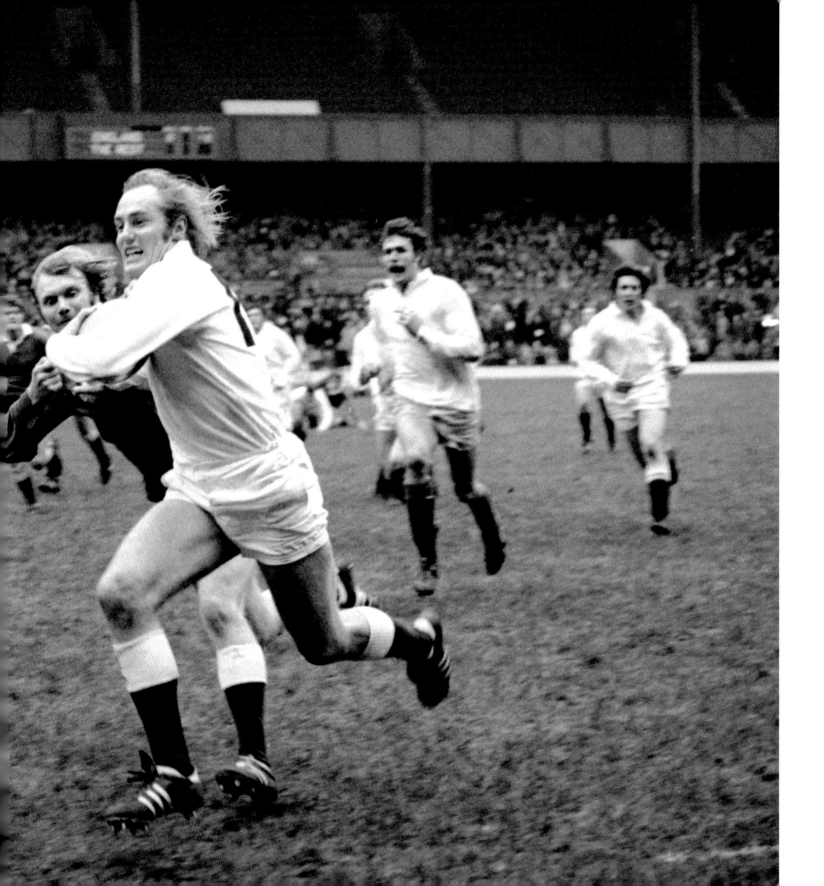

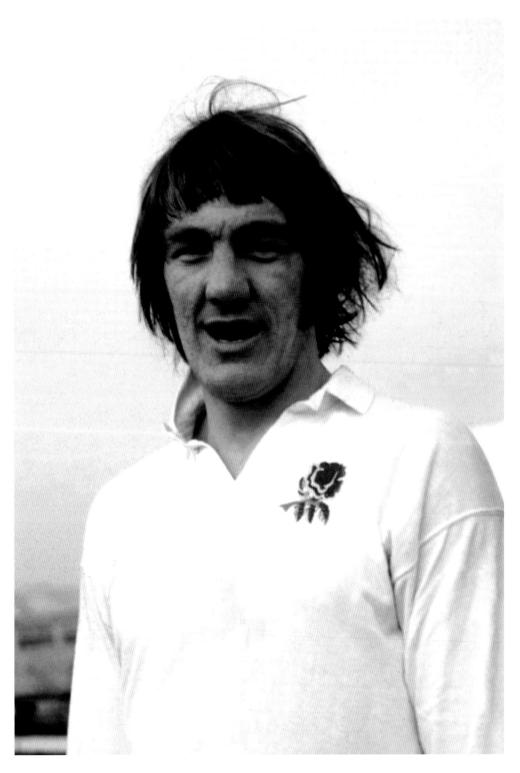

BIG ROGER
Roger Uttley of England during the build-up to the Five Nations Championship match against Wales. Uttley played 23 times for England, on five occasions as captain, and was selected in the back row for the four tests on the undefeated 1974 Lions tour to South Africa.

Date: **14th March, 1974**

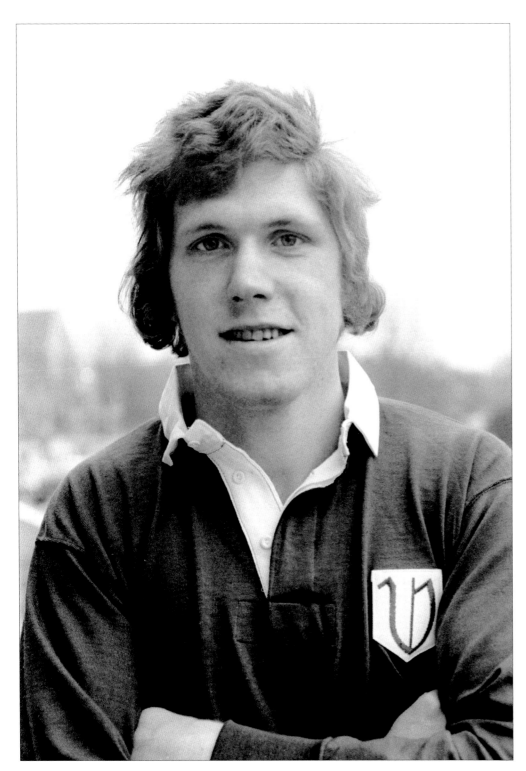

FLANKER FERGUS

Irish flanker Fergus Slattery earned 61 caps for his country, 18 as captain, and scored three tries. He played in all four tests of the Lions' famous undefeated tour to South Africa in 1974, and he was captain of the most successful Irish touring side in 1979, which won seven of the eight games in Australia, including the two Test Matches.

Date: **23rd March, 1974**
Venue: **Blackrock College, County Dublin**

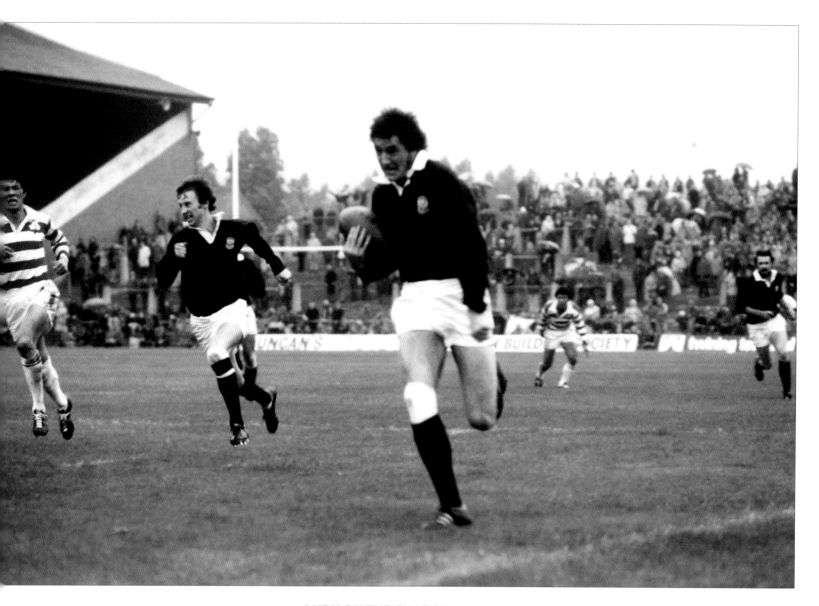

ANDY ON THE CHARGE

Scotland fullback Andy Irvine tears down the wing during a match against Japan. In a 10-year career with Scotland, Irvine earned 51 caps and scored over 250 points. Although he was never the most solid player in defence, his mesmeric attacking abilities, characterised by incisive running at high speed, have ensured that he is considered one of the greatest fullbacks of the modern era, and he is often voted in polls as Scotland's greatest ever player.

Date: **25th September, 1976**
Venue: **Murrayfield, Edinburgh**

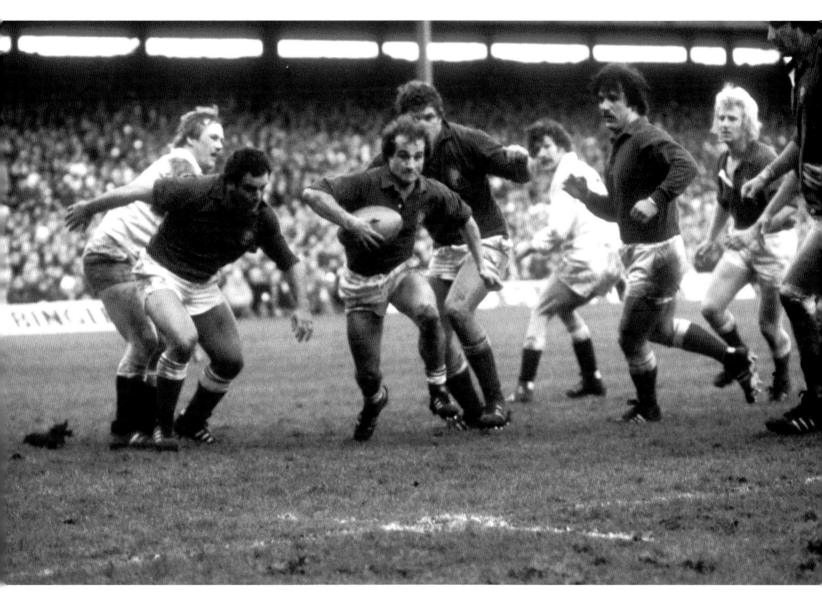

FOLLOW MY LEADER

'The Little Corporal' Jacques Fouroux (C) in action for France against England during a Five Nations Championship game, which the French edged 4–3. Fouroux's sobriquet, borrowed from Napoleon Bonaparte, was an acknowledgement not only of his diminutive stature – he stood just 5ft 4in tall – but also of his immensely self-confident, some would say arrogant, leadership style. As captain, Fouroux led France to a Grand Slam in 1977, the second in the nation's history. Despite his considerable achievements on the pitch, Fouroux is perhaps best known as a coach, having masterminded France's dominance of the Five Nations in the 1980s, when a huge set of forwards muscled *Les Bleus* to six titles.

Date: **19th February, 1977**
Venue: **Twickenham, London**

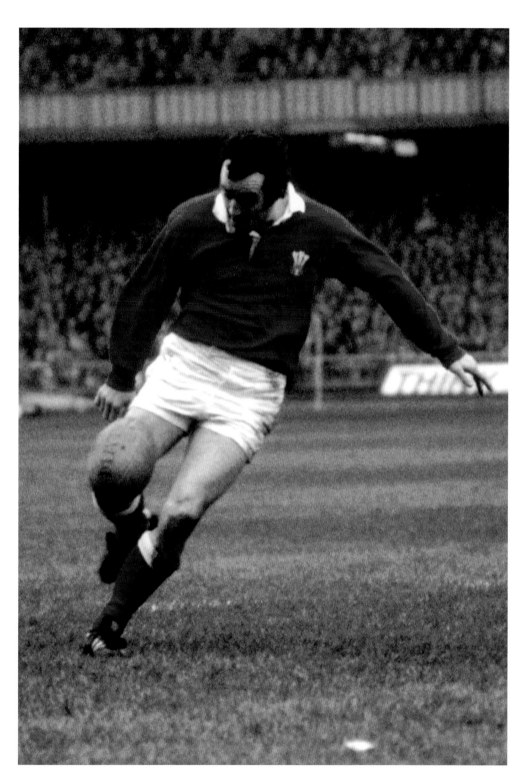

STIRRING MOTIVATION

Phil Bennett, the Llanelli and Wales fly-half, poised to kick the ball during the Five Nations Championship match against England. Before the game, Bennett gave a motivational speech to his fellow players, producing a memorable quote:

"Look what these bastards have done to Wales. They've taken our coal, our water, our steel. They buy our homes and live in them for a fortnight every year. What have they given us? Absolutely nothing. We've been exploited, raped, controlled and punished by the English – and that's who you are playing this afternoon."

A flair player with a large repertoire of tricks, Bennett appeared 29 times for his country, between 1969 and 1978, but perhaps he is best remembered for his superb performances for the British Lions on the 1974 tour to South Africa.

Date: **5th March, 1977**
Venue: **The Arms Park, Cardiff**

FATHER OF A DYNASTY

Derek Quinnell of Wales lines up before a Five Nations Championship match against France. Quinnell plied his trade at both lock forward and number eight, featuring regularly in the great Welsh teams of the 1970s, and in the Lions tours of 1971, 1977 and 1980. Amazingly, he also produced three sons who went to have distinguished rugby careers; Craig and Scott represented Wales on numerous occasions, while Gavin continues to play club rugby at the highest level.

Date: **18th March, 1977**
Venue: **The Arms Park, Cardiff**

ENGLISH POWERHOUSE

Fran Cotton, the England prop forward, captured during a training session ahead of the Five Nations Championship match against Ireland. Cotton had studied physical education at university and was ahead of his time in terms of physical preparation. He was capped 31 times by England, captaining his country on three occasions. Cotton is still involved in Rugby as the founder (with another former England international Steve Smith), of shirt manufacturers 'Cotton Traders'.

Date: **16th March, 1978**

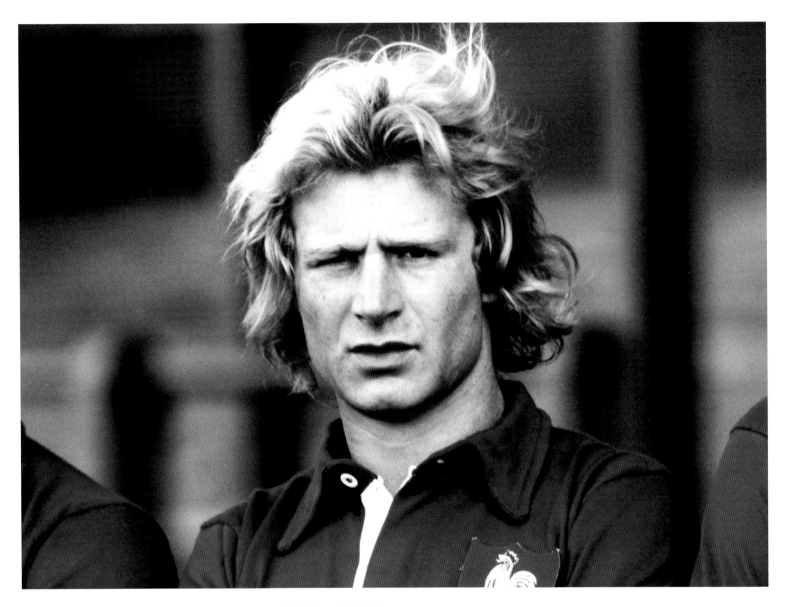

FRENCH ARTIST

French flanker Jean-Pierre Rives before the Five Nations Championship match against Wales. Small in comparison to most flankers, Rives was blessed with courage and flair that more than made up for any physical disadvantages. Indeed, his bravery, as well as his long blonde hair, led to him being dubbed 'Asterix' by his peers. He captained his nation 34 times, and he played in the Grand Slam winning French sides of 1977 and 1981. Rives currently works as an internationally renowned sculptor.

Date: **8th March, 1978**
Venue: **The Arms Park, Cardiff**

FULL SPEED AHEAD

Long hair flailing in the wind and socks around his ankles, the unmistakable J.P.R. Williams is tackled by France's Daniel Bustaffa during a Five Nations Championship match. A fullback renowned for his audacious attacking style, Williams was a key figure in the Grand Slam winning Welsh teams of 1971, 1976 and 1978.

Date: **18th March, 1978**
Venue: **The Arms Park, Cardiff**

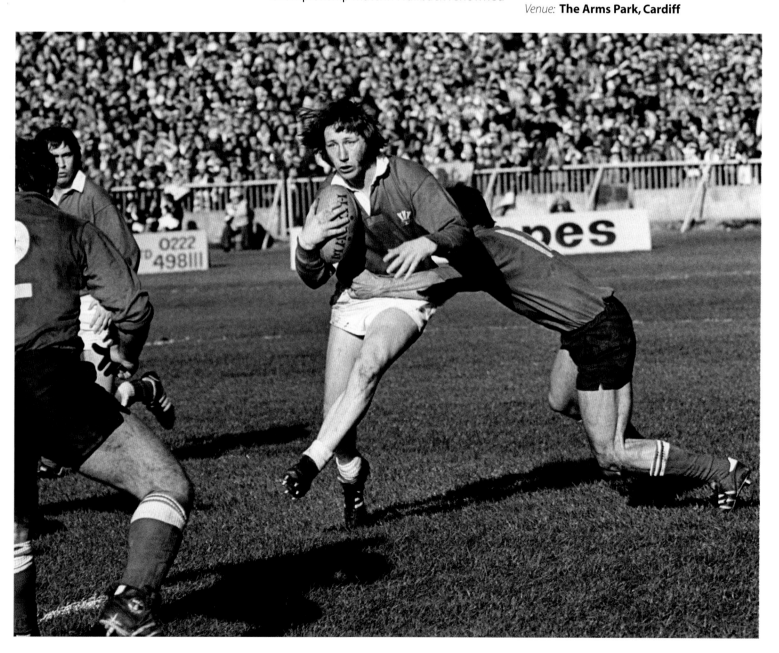

REACH FOR THE LINE

New Zealand captain Graham Mourie dives over the line, evading Welsh scrum-half Terry Holmes, to score the All Blacks' first try in a game against Wales. On the New Zealanders' previous trip to the British Isles, in 1978, Mourie had led his team to a Grand Slam over the Home Nations.

Date: **1st November, 1980**
Venue: **The Arms Park, Cardiff**

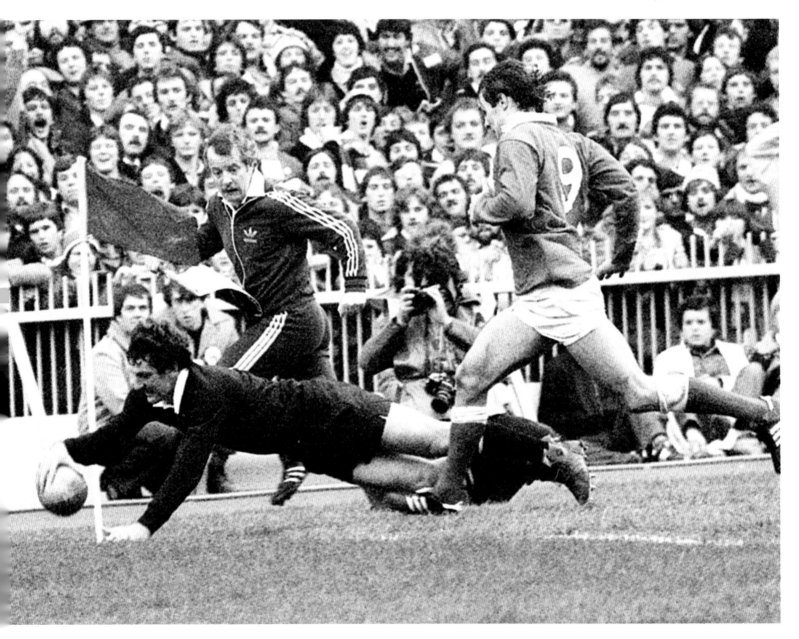

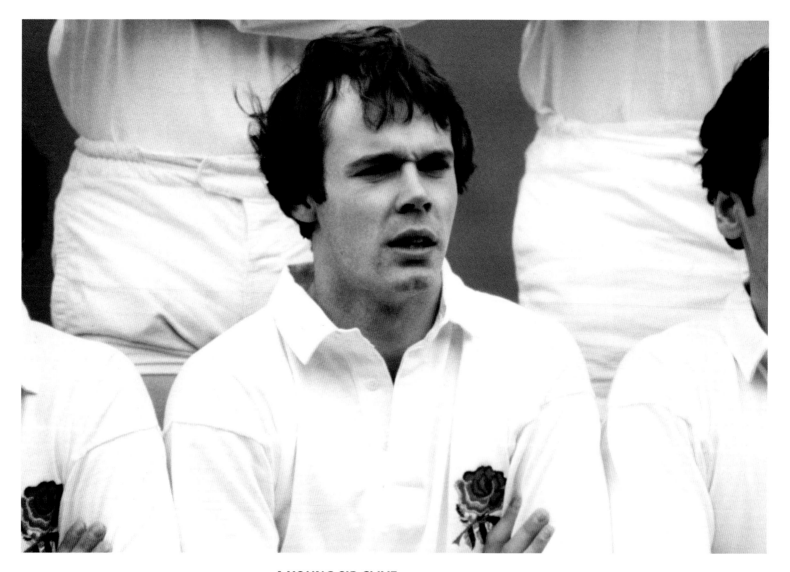

A YOUNG SIR CLIVE

Clive Woodward poses with fellow England players for a team photograph before the start of a Five Nations Championship match against Wales. He made 21 appearances for the country between 1980 and 1984, forging a strong partnership at centre with fellow Leicester player Paul Dodge.

Date: **17th January, 1981**
Venue: **The Arms Park, Cardiff**

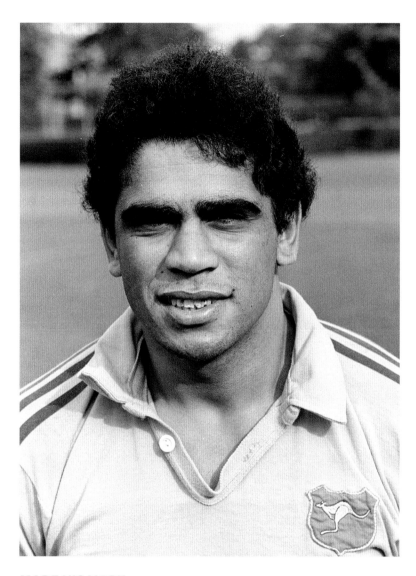

MADE HIS MARK

Mark Ella, one of the few Aborigines to have played rugby for Australia, was an expert at drawing opposing players towards him and creating space for his team-mates. Described by David Campese as "the best rugby player I have ever known or seen", Ella stunned the rugby world by retiring from the game aged just 25.

Date: **8th October, 1981**

PRICE THE PROP

Welsh prop forward Graham Price takes a moment to catch his breath during a Five Nations Championship match against France. As well as winning 41 caps for his country, Price played in 12 successive tests for the British Lions, touring New Zealand in 1977 and 1983, and South Africa in 1980.

Date: **26th February, 1982**
Venue: **The Arms Park, Cardiff**

WORLD PLAYER OF THE YEAR

Ireland's Ollie Campbell shows off the Rugby World Player of the Year Trophy – he was the second Irishman to win the coveted award. Campbell is one of the greatest players ever to wear the emerald green of Ireland, and is one of the best kickers of the ball in the history of the game. In one memorable match, against Scotland in 1982, he kicked all of Ireland's 21 points, securing his team their first Triple Crown since 1949. He won a total of 22 caps for Ireland, scoring 217 test points.

Date: **24th June, 1982**

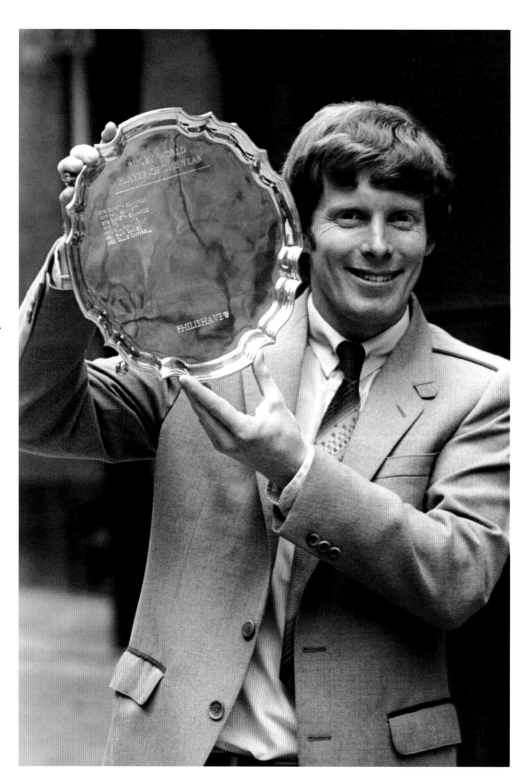

TOP SELLA

The versatile Philippe Sella wearing the famous French jersey. Sella, who played on the wing or at centre for his national side, is one of the greats of French rugby. His pace and vision helped earn him 111 caps for *Les Bleus*, which stood as a world record for number of appearances until it was surpassed by England's Jason Leonard.

Date: **21st March, 1987**

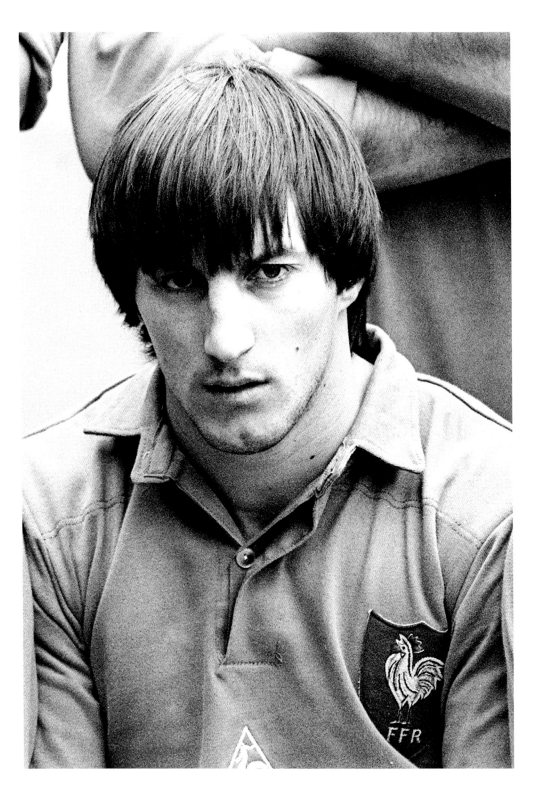

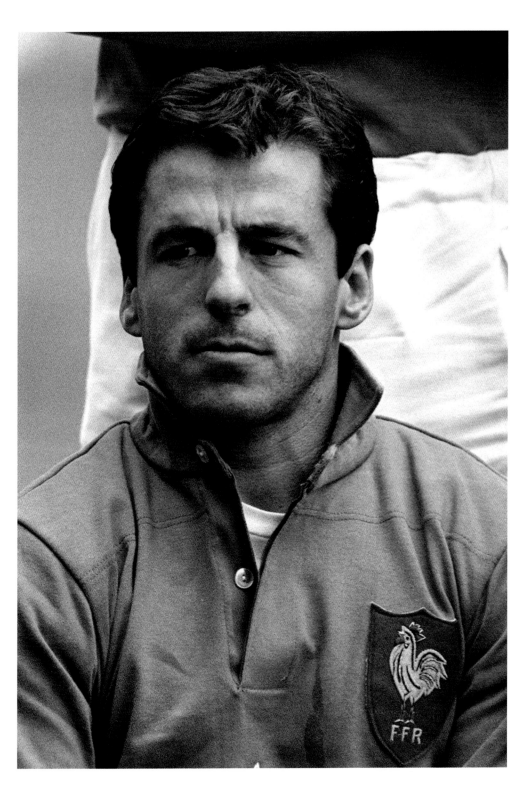

PROUD CAPTAIN

France's captain, Pierre Berbizier, just weeks after he had led his team to Grand Slam glory. Playing mainly at scrum-half, Berbizier made his French debut in 1981, but it wasn't until the mid-1980s that he became a fixture in the side. As well as leading his nation to Grand Slam success, he captained the team during the inaugural World Cup in Australia and New Zealand. The French secured a memorable 30–24 victory against Australia in the semi-final, but went down 29–9 to the All Blacks in the final.

Date: **1st April, 1987**

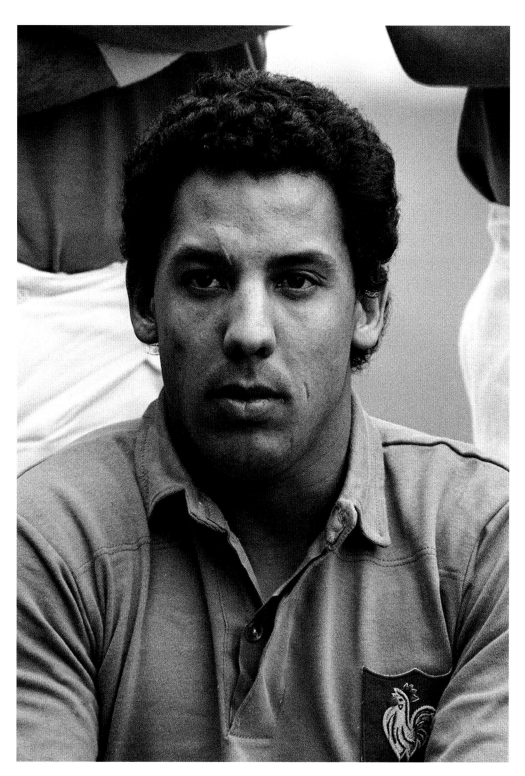

BRILLIANT BLANCO

French fullback Serge Blanco during the build-up to the first Rugby World Cup. Winning 93 caps for his country, Blanco was known for his flair and creativity, and he is considered by many commentators on the game to be one of the finest fullbacks in rugby history. Inventive and always willing to take risks, he enjoyed his finest hour in the 1987 World Cup Semi-Final, when he scored a dramatic late try to dump the Australians out of the competition and secure a historic final against the All Blacks.

Date: **21st April, 1987**

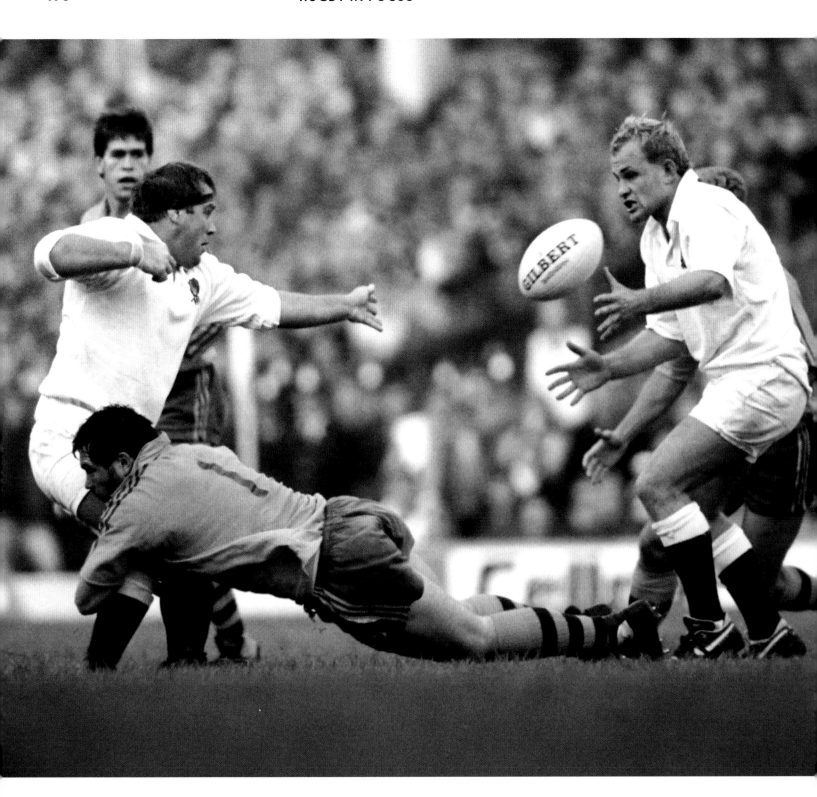

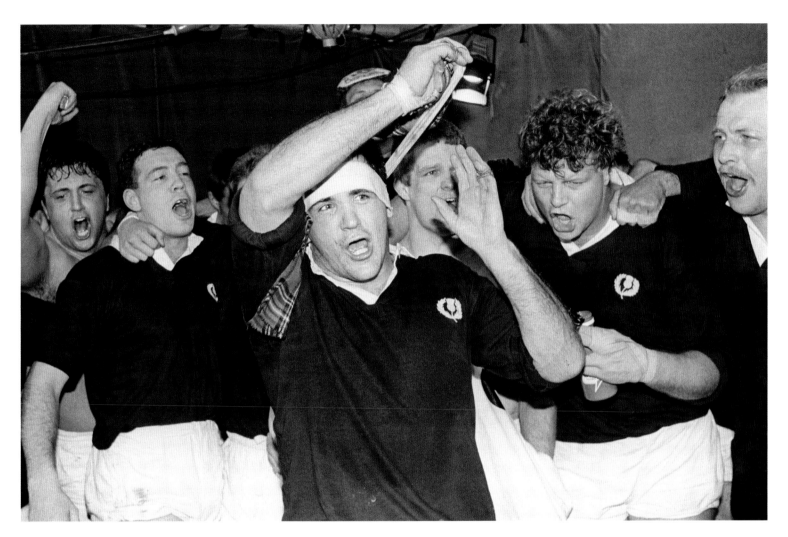

PROBYN OFFLOADS

England's Jeff Probyn (L) offloads the ball to team-mate Andy Robinson as he is tackled by Australia's Mark Hartill. A late bloomer, Probyn didn't make his debut for England until he was 31. Phenomenal in the scrum, despite his relatively slight build, Probyn made 37 appearances for England at prop, bowing out in a 17–3 defeat to Ireland in 1993.

Date: **5th November, 1988**
Venue: **Twickenham, London**

SOLE AND MATES

Scotland captain David Sole (C) leading his team in celebration after their Grand Slam Five Nations rugby championship victory over 'old enemy' England by 13–7 at Murrayfield.

Date: **17 March, 1990**
Venue: **Murrayfield, Edinbrugh**

FOX HUNTED DOWN

Grant Fox looks to release the ball before he's grounded during a Pool A match at the 1991 Rugby World Cup. Although he was a limited player when running with the ball – his record of just a single try in 46 matches attests to this – he was endowed with brilliant distribution skills. But it is for his kicking that Fox is remembered. A true pioneer of the art of goal kicking, he amassed an incredible 645 points during his All Blacks career.

Date: **13th October, 1991**
Venue: **Welford Road, Leicester**

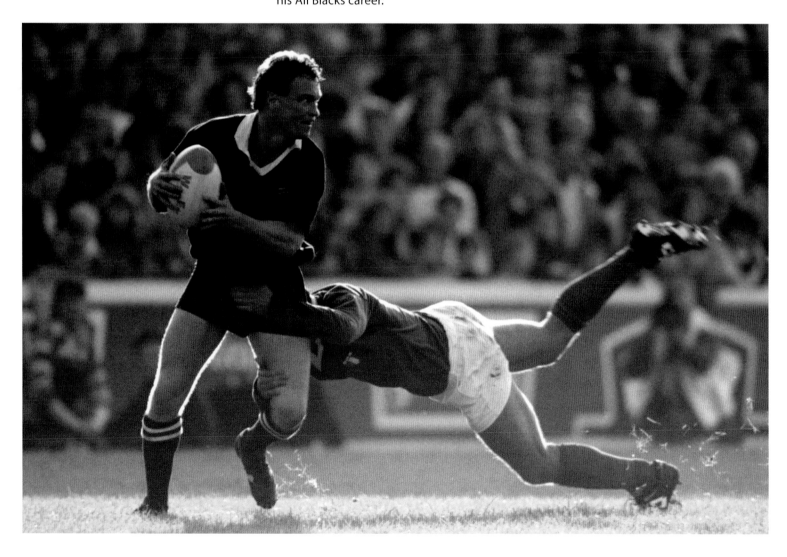

CHAIR LIFT

England's Jason Leonard (L), Dewi Morris (C, partly submerged) and Martin Bayfield (R) are carried off the field by the ecstatic Twickenham crowd after England's Grand Slam winning victory over Wales by 24 unanswered points.

Date: **7th March, 1992**
Venue: **Twickenham, London**

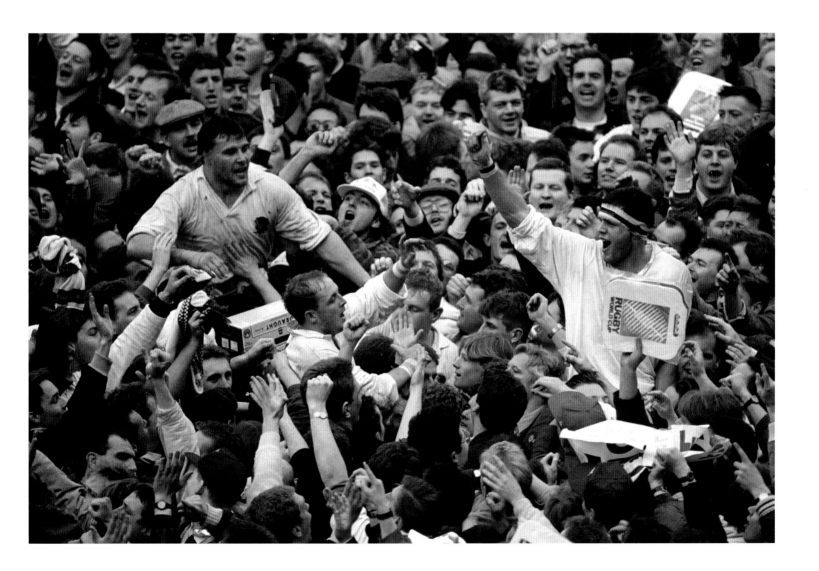

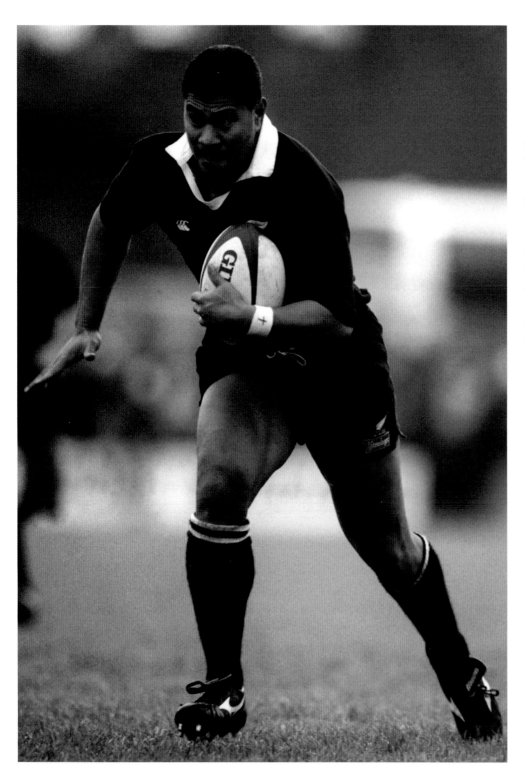

SAMOAN ALL BLACK

The imposing figure of Va'aiga Tuigamala bears down on goal during an All Blacks game. Tuigamala represented both Samoa, his place of birth, and New Zealand, playing most commonly at wing. Equipped with the pace and acceleration of a winger, but with a large and powerful physique, he was an intimidating and effective player. In his 19 tests with the All Blacks, he scored five tries, before switching codes and signing for Wigan rugby league team.

Date: **13th November, 1993**
Venue: **Old Anniesland, Glasgow**

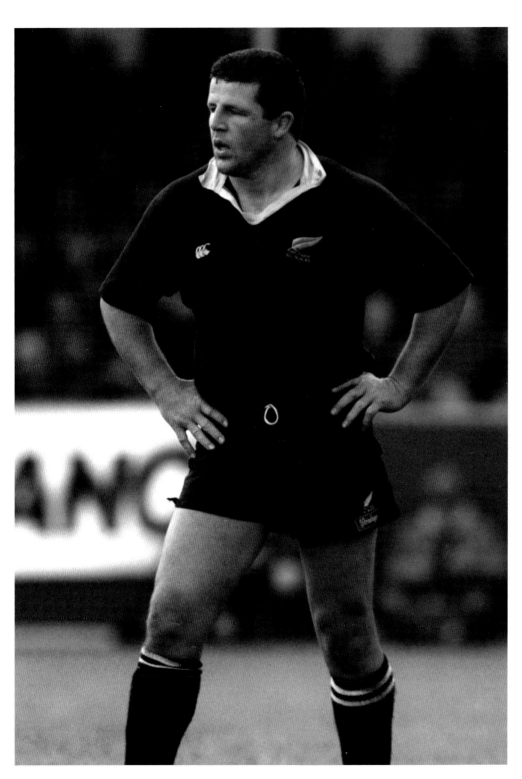

ALL BLACK LEGEND

In an international career that began against France in 1986 and lasted until 1997, Sean Brian Thomas Fitzpatrick played in a total of 92 test matches, captaining the All Blacks on 51 occasions. An inspiring leader who was as competitive and energetic in the loose as he was durable in the middle of the front row, this mobile hooker had amassed a total of 55 test points before a chronic knee injury ended his career.

Date: **13th November, 1993**
Venue: **Old Anniesland, Glasgow**

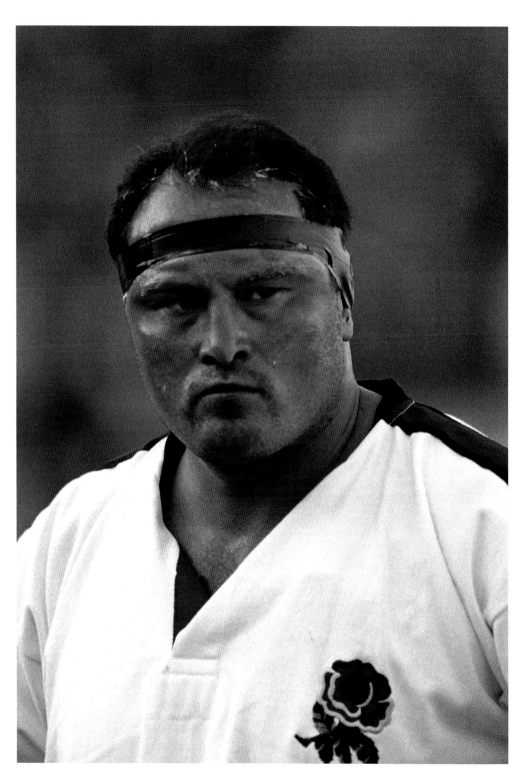

BRITISH BULLDOG

Brian Moore aims an intimidating glance at the opposition as the England team lines up before their second test match of the 1994 South African tour. England were to lose the game by 27 points to 9 as South Africa tied the two-match series. A tough and combative player, Moore was one of the most effective hookers of his era; alongside Jeff Probyn and Jason Leonard, he formed a fearsome English front row in the early 1990s.

Date: **11th June, 1994**
Venue: **Newlands, Cape Town, South Africa**

RICHARDS THE PLAYER

Dean Richards, Leicester captain, stands with the league trophy after his side had finished top of the table in the 1994–95 season. A central figure in the England pack of the early 1990s, Richards won 48 international caps and was one of the best number eights of his generation. Unfortunately, his considerable reputation was tarnished in 2009, when he resigned from his post as coach of Harlequins for orchestrating a fake blood injury to one of his charges. He was handed a three-year suspension from coaching.

Date: **29th April, 1995**
Venue: **Welford Road, Leicester**

THE NEW SOUTH AFRICA

André Joubert salutes the new South African national anthem (*Nkosi Sikelel, iAfrika*) before a match against Wales. Joubert played 34 times at fullback for the Springboks, scoring a total of 115 test points.

Date: **15th December, 1996**
Venue: **The Arms Park, Cardiff**

CRASH BALL

Wales's Scott Gibbs breaks through a tackle from Dawie Theron of South Africa. A renowned tough tackler himself, Gibbs was equally dangerous on the attack, attributes that persuaded St Helens rugby league team to sign him in 1994. In 1997, a year after his return to union, he put in a Player of the Series performance on the British Lions tour to South Africa, which the Lions won 2–1. However, he is perhaps best known for scoring a late try at Wembley in 1999, denying England the Grand Slam.

Date: **15th December, 1996**
Venue: **The Arms Park, Cardiff**

WINGER IN FULL FLIGHT
Ieuan Evans embarks on a typical surging run during a match against South Africa. Despite playing in a disappointing era for Welsh rugby, Evans is considered one of his country's greatest ever wingers, scoring 33 tries in 72 appearances in the famous red shirt.

Date: **15th December, 1996**
Venue: **The Arms Park, Cardiff**

FIJIAN FLYER *(Facing page)*
Waisale Serevi comes forward with the ball during a Heineken Cup match for Leicester against Toulouse. Widely regarded as the greatest ever player of Rugby Sevens, Serevi also distinguished himself in the 15-man game, making 39 appearances for Fiji and scoring 376 points.

Date: **4th October, 1997**
Venue: **Welford Road, Leicester**

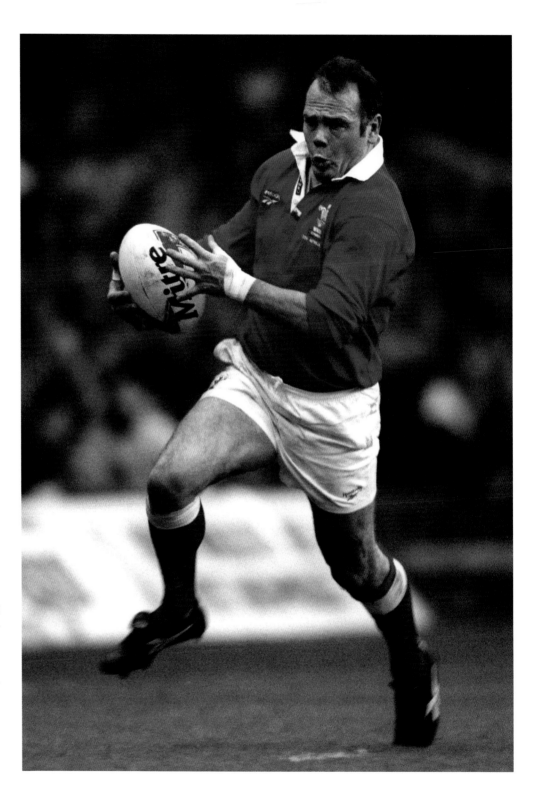

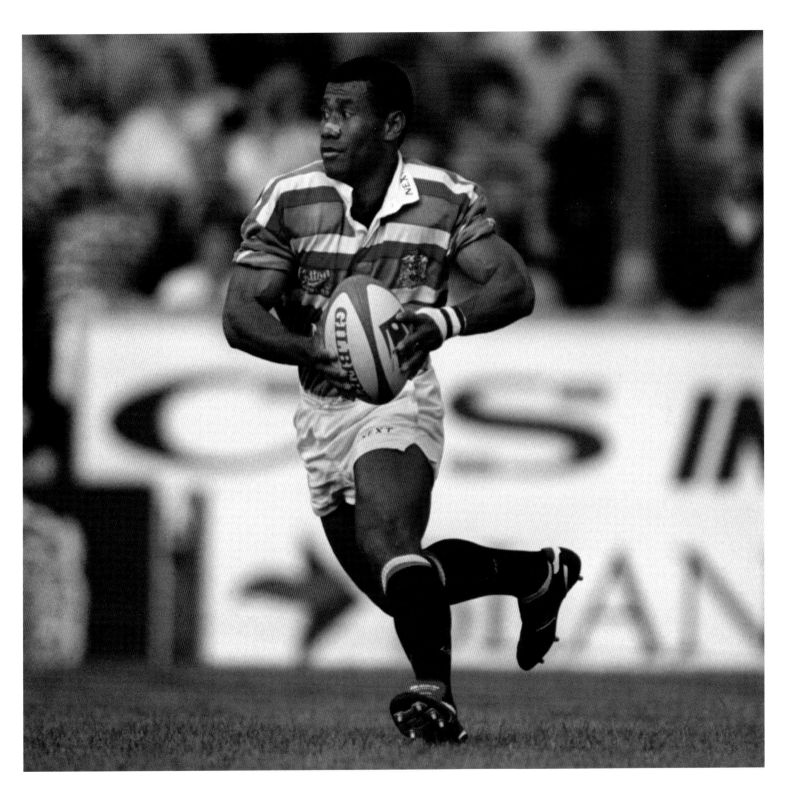

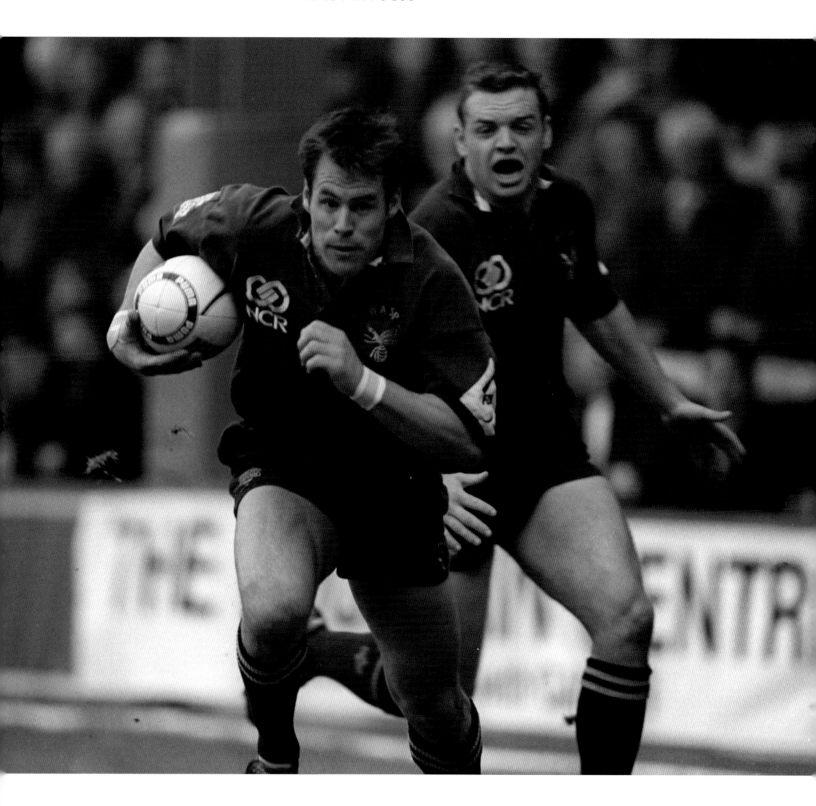

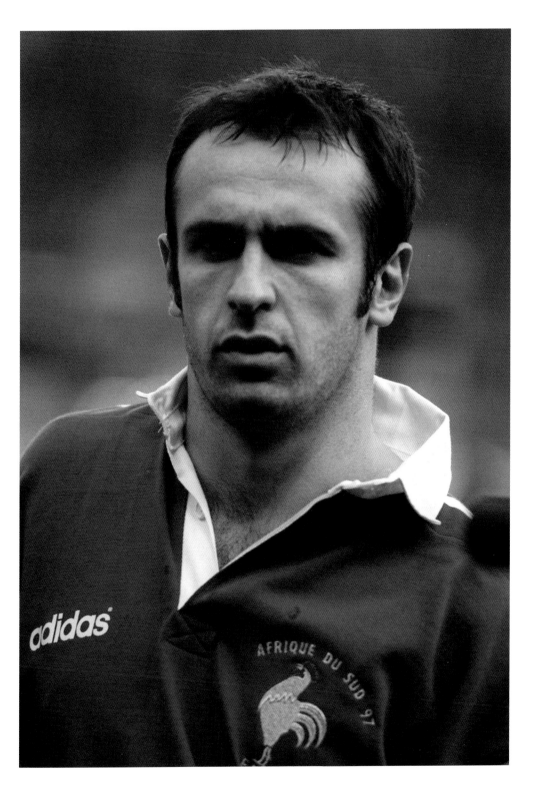

MAKING A BREAK FOR IT

Kenny Logan makes a break for Wasps, where he spent seven years. Logan made 70 appearances for Scotland over a 13-year international career, his final match coming at the 2003 Rugby World Cup.

Date: **20th December, 1997**
Venue: **Loftus Road Stadium, London**

SAINT PHILIPPE

Philippe Saint-André of France lines up before the start of a match against South Africa. Saint-André was one of the finest players of his generation, and one of France's greatest ever captains, leading the team in half of the 68 games in which he appeared. His greatest moment was undoubtedly on the 1994 tour to New Zealand, where he captained *Les Bleus* to a historic 2–0 series victory. In the Second Test, with time running out and the All Blacks leading, Saint-André started a counterattack deep within French territory, which culminated in a remarkable winning try. Speaking after the game, he memorably described the play as *"The counterattack from the end of the world."*

Date: **22nd November, 1997**
Venue: **Parc des Princes, Paris, France**

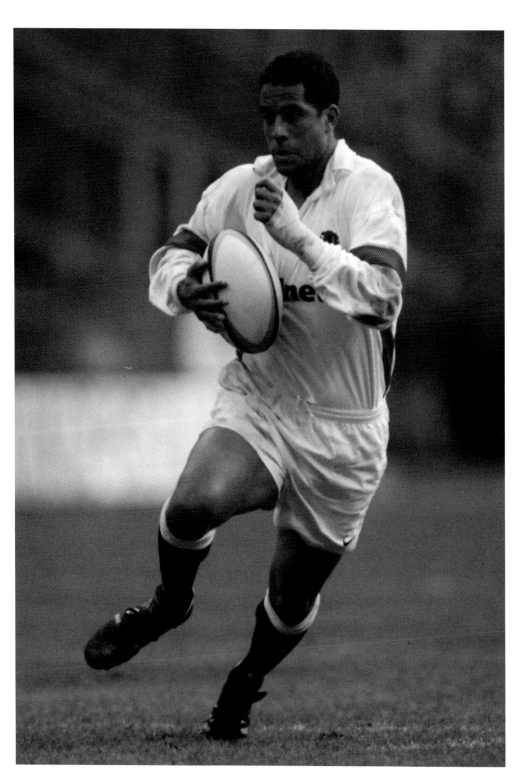

SMOOTH OPERATOR

The smooth running Jeremy Guscott launches an attack against France during a Five Nations Championship match. Considered by many to be the most naturally gifted back England has ever produced, Guscott even drew plaudits from David Campese, high praise indeed from an Australian not known for paying compliments to the English. He scored a hat-trick of tries on his debut against France and wrote himself into British Lions history with a match winning drop goal in the decisive Second Test of the 1997 tour to South Africa.

Date: **7th February, 1998**
Venue: **Parc des Princes, Paris. France**

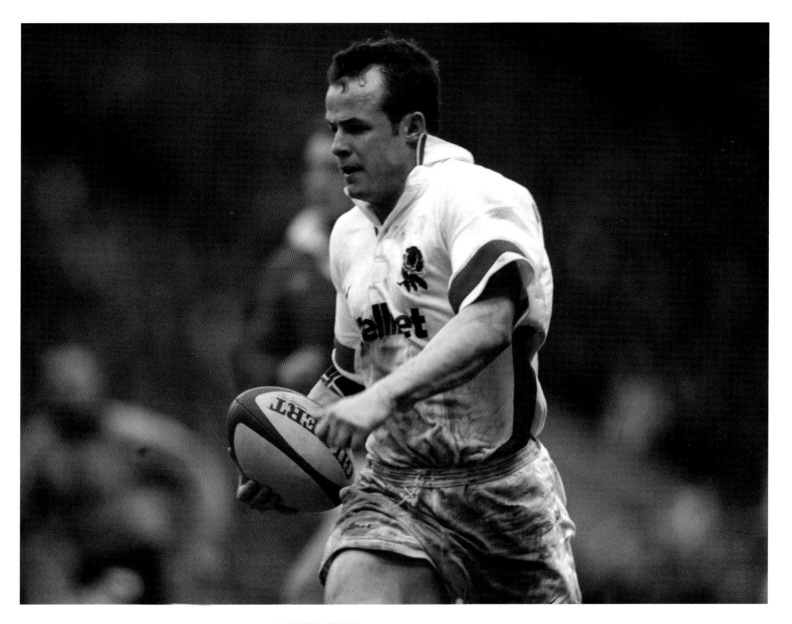

IN TOP GEAR

The versatile Austin Healey motors with the ball in hand during a Five Nations Championship match against Wales. His ability to play in a variety of positions (scrum-half, fly-half, fullback and wing) meant that he was often employed as a substitute in international matches. He made 51 appearances for England and earned two Lions caps.

Date: **21st February, 1998**
Venue: **Twickenham, London**

ROB ON THE BREAK
Wales's Rob Howley in action during a
Five Nations Championship game against
Scotland. A remarkably gifted scrum-half,
Howley won 59 caps and captained his
country on 22 occasions.

Date: **7th March, 1998**
Venue: **The Arms Park, Cardiff**

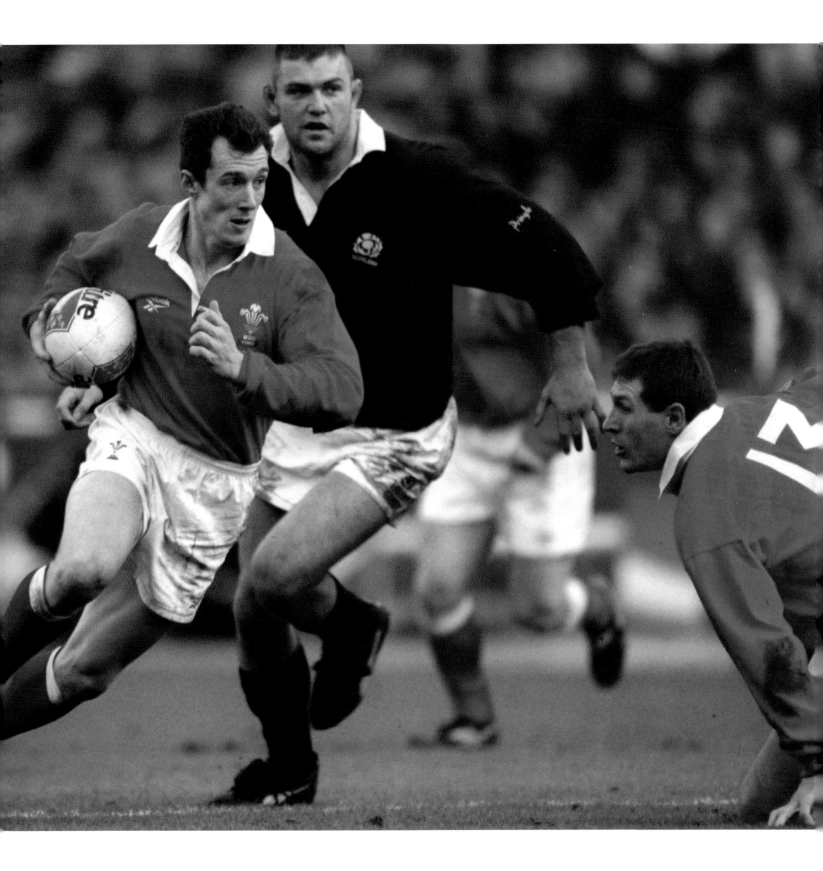

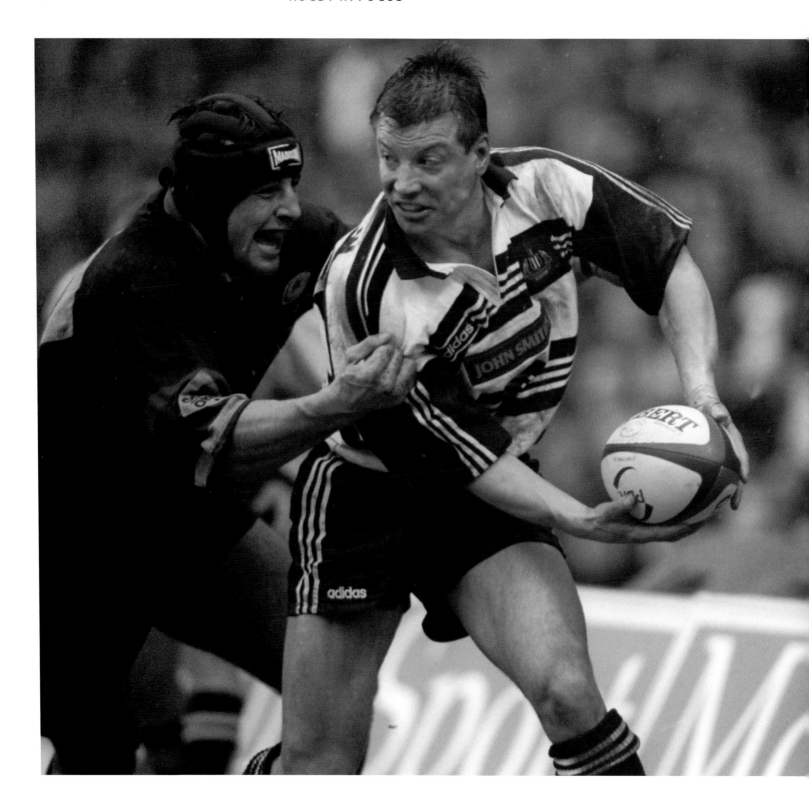

MASTER KICKER

Newcastle and England's Rob Andrew (R) looks to release the ball just as he is tackled by Saracens' Danny Grewcock. Andrew played at fly-half for England for 12 years from 1985, scoring 396 points and winning three Grand Slams in the process. He was criticised for kicking the ball too often while playing for England, so it is somewhat ironic that his finest moment in an England shirt was a winning drop goal in the quarter-final match against Australia in the 1995 World Cup.

Date: **19th April, 1998**
Venue: **Vicarage Road, Watford**

TACKLE ME IF YOU CAN

Australia's David Wilson is steamrollered by the marauding Jonah Lomu during a Blediscoe Cup match. Lomu's ability to combine blistering pace with brutal strength made him one of the most feared players in rugby, and his performances in 1995 earned him superstar status.

Date: **1st August, 1998**
Venue: **Jade Stadium, Christchurch, New Zealand**

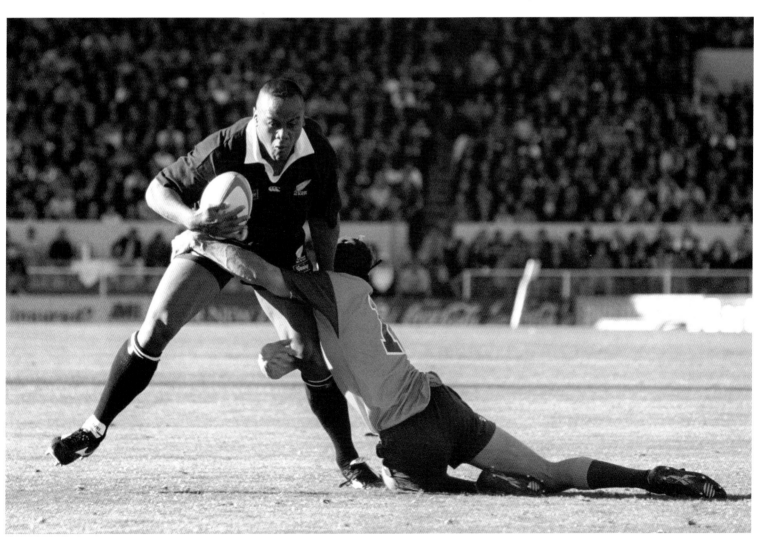

PASS MASTER

Joost Van Der Westhuizen, big by scrum-half standards, was able to mix it with forwards, and was known for his direct and aggressive running. By the time he retired, he had won 89 caps for the Springboks, a record at the time, and had scored 38 tries, the most scored by any scrum-half in the history of the game.

Date: **21st November, 1998**
Venue: **Murrayfield, Edinburgh**

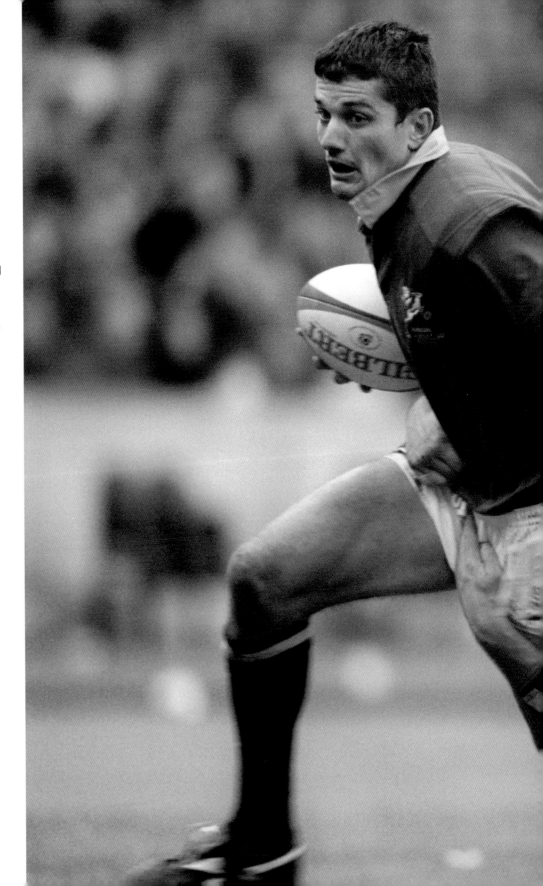

LEADER IN THE PACK

Ireland captain Keith Wood (C) leads his pack into a scrum during a Five Nations Championship match against Wales. Wood was one of the greatest hookers of his generation; his ability in open play and his inspirational leadership skills made him a towering figure in world rugby. He played 29 times for his country, scoring 15 tries, a record for a hooker.

Date: **20th February, 1999**
Venue: **The Arms Park, Cardiff**

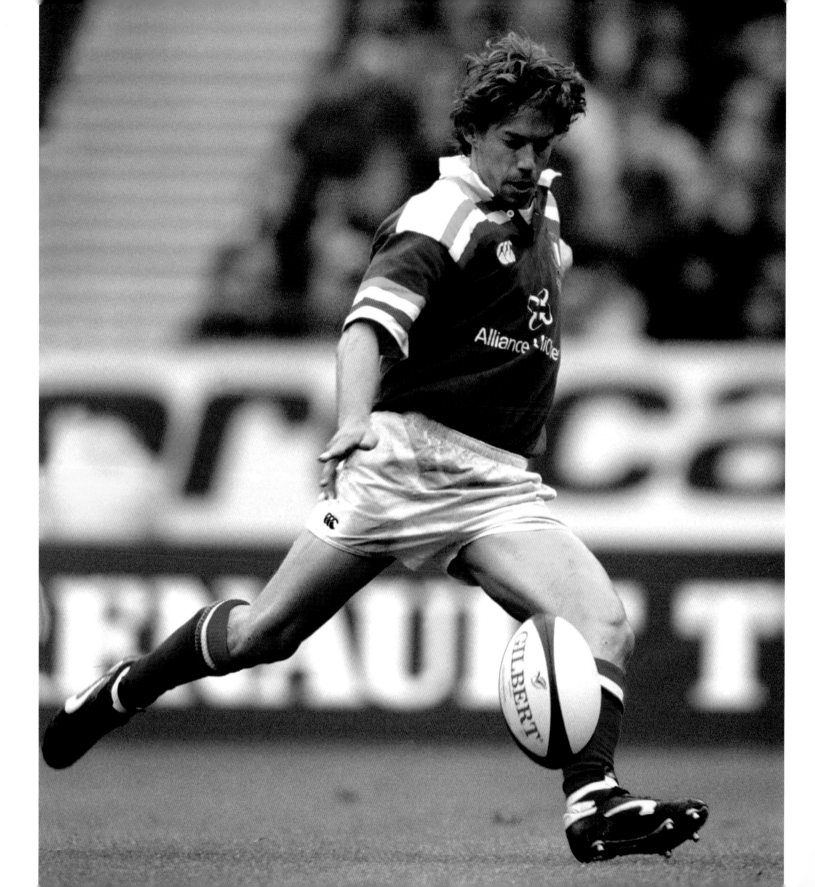

PLAYMASTER

Italy's Diego Dominguez poised to kick during a Six Nations Championship match against France. Born in Argentina, Dominguez began his international career with his home country, but moved to Italy in 1986, making 76 appearances for his adopted nation. Playing at fly-half, he represented the *Azzurri* in three World Cups.

Date: **1st April, 2000**
Venue: **Stade de France, Paris, France**

LEADING SPRINGBOK

England's Jonny Wilkinson (R) makes a desperate dive in an effort to tackle South Africa's Percy Montgomery. One of the most devastating backs of the modern game, Montgomery holds two significant records for the Springboks: he is the most capped player in South African history, with 102 appearances, and he is the country's leading scorer, with 893 points.

Date: **2nd December, 2000**
Venue: **Twickenham, London**

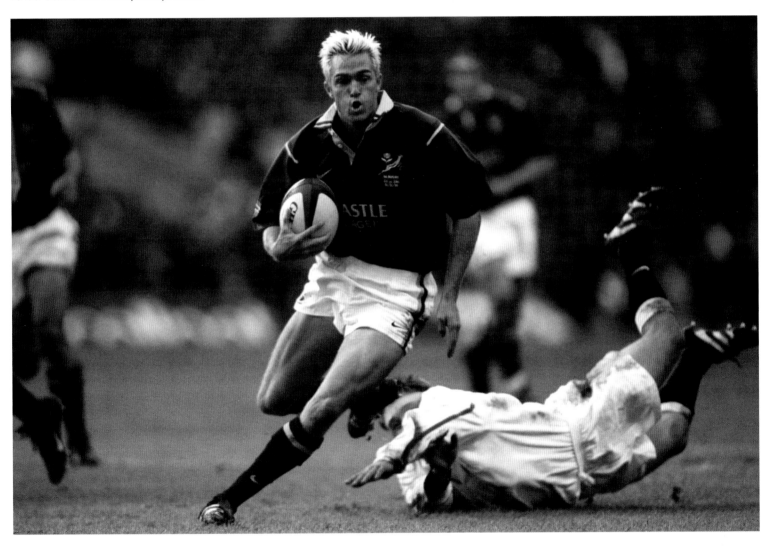

BEN BOMBS IN

England's wing Ben Cohen scores the 12th try during the International match between England and Romania. England ran out winners in a one sided contest by a record 134 points to 0.

Date: **17th November, 2001**
Venue: **Twickenham, London**

JOB DONE

Lawrence Bruno Nero Dallaglio was capped by England in all three positions in the back row. He made his debut in 1995, bowing out in 2008. Along the way he earned over 80 caps, including the victory over Ireland by 42 points to 6 in the final match the 2003 season. Dallagio scored the opening try in England's first Six Nations Grand Slam triumph since 1995.

Date: **30th March, 2003**
Venue: **Landsdowne Road, Dublin**

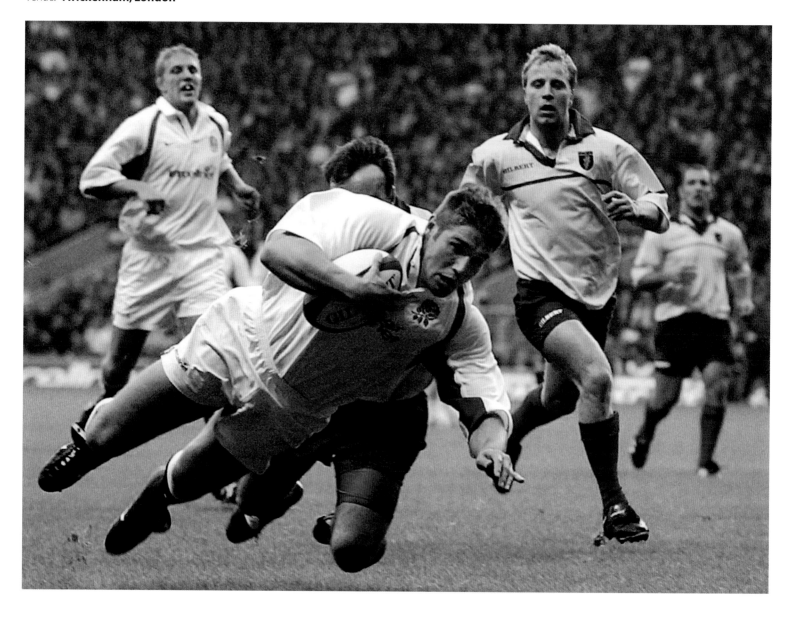

IRISH IMP

Ireland scrum-half Peter Stringer lines up at the start of a match against France in the Six Nations Championship. Standing at just 5ft 7in tall, the diminutive Stringer has enjoyed a long and illustrious career at both club and international levels, playing a key role in Munster's 2006 Heineken Cup victory and Ireland's 2009 Grand Slam triumph.

Date: **8th March, 2003**
Venue: **Lansdowne Road, Dublin**

GO JONNY GO

Jonny Wilkinson shows he can run as well as kick as he prepares to hand off a Samoan defender in the World Cup Group D Match which England ran out victors by 35 points to 22.

Date: **26th October, 2003**
Venue: **Telstra Dome, Melbourne, Australia**

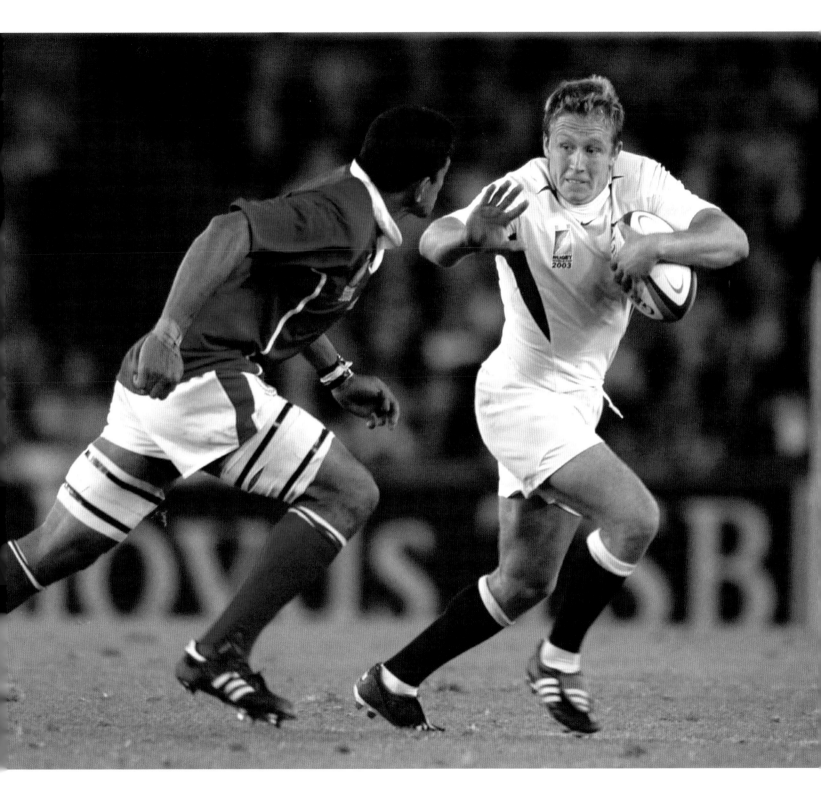

GREAT IRISHMAN

Ireland's Brian O'Driscoll with the RBS Six Nations Trophy. Always totally committed and leading by example, captain O'Driscoll defines the resurgence of Irish Rugby. He won his first cap in 1999 aged just 20 and became Ireland's most capped player on 26th June, 2010 against Australia, when he won his 103rd cap.

Date: **4th February, 2004**
Venue: **Congress Centre, London**

MR RELIABLE

Jason Leonard of England lines up before the start of a Six Nations Championship match against Italy, his last match for his country in an illustrious career spanning 14 years. He made 114 appearances for England, a world record for a forward. Leonard is almost as wide as he is tall, his sheer bulk and low centre of gravity making him one of the most devastating pack players of his era.

Date: **15th February, 2004**
Venue: **Stadio Flaminio, Rome, Italy**

GREAT SCOT

Scotland's Scott Murray wins the line-out ball during a game against France in the Six Nations Championship. Murray is the second most capped player, after Chris Paterson, in Scottish history, having won the last of his 87 caps against the All Blacks in the 2007 Rugby World Cup.

Date: **21st March, 2004**
Venue: **Murrayfield, Edinburgh**

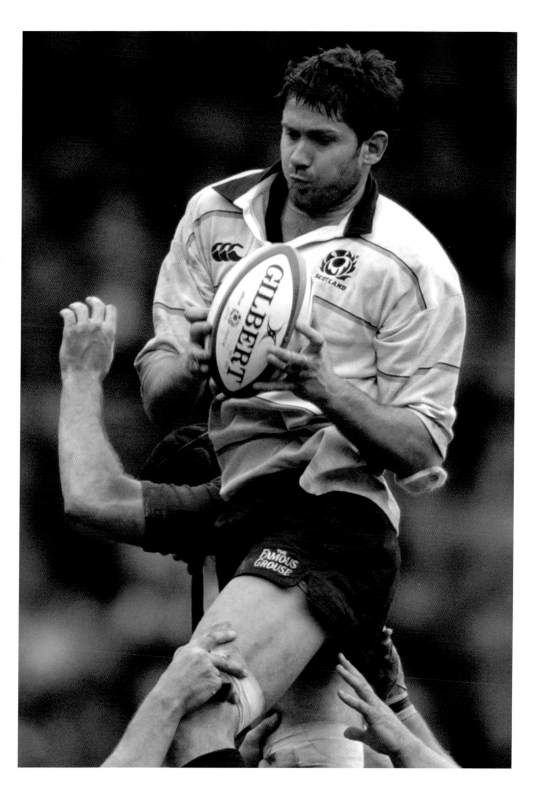

RECORD BREAKER

Australian captain George Gregan holds the Cook Trophy after defeating England in a Test Match in Brisbane. A true legend of the game, Gregan is universally admired, not only for his considerable achievements and immense talent, but also for his ability to inspire others and his sportsmanship. He made 139 appearances for the Wallabies, making him the most capped player in the history of the sport.

Date: **21st March, 2004**
Venue: **ANZ Stadium, Brisbane, Australia**

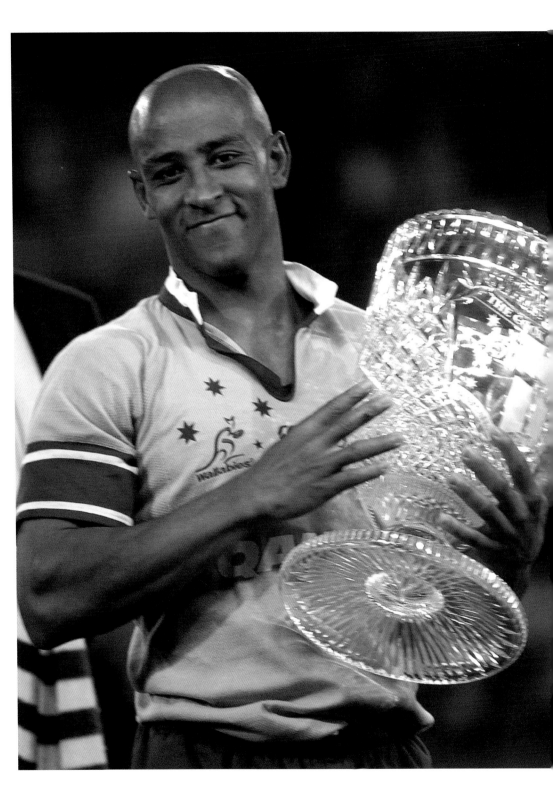

GREAT ENGLISHMAN

Leicester captain Martin Johnson licks blood from his nose during his team's 28–13 victory over Gloucester in a Zurich Premiership match. Johnson is best known for his inspirational captaincy of the England team from 1999, leading his men to both a Grand Slam and a first World Cup victory in 2003. Perhaps one of the greatest lock forwards ever to play the game, Johnson retired from internationals following the 2003 World Cup and was made England coach in 2008.

Date: **6th November, 2004**
Venue: **Welford Road, Leicester**

GREAT WELSHMAN

Martyn Williams of Wales with the champagne he won for his Man-of-the-Match performance in the victory over Italy in the Six Nations Championship. Playing at open-side flanker for his country, Williams is the most capped forward in Welsh history. He decided to retire from international rugby in 2007, but was persuaded to play in the 2008 Six Nations Championship by Wales coach Warren Gatland. The Welsh went on to win the Grand Slam that year, and Williams was widely regarded as one of the players of the tournament.

Date: **12th February, 2005**
Venue: **Stadio Flaminio, Rome, Italy**

DAN THE MAN

New Zealand's Dan Carter scores his second try of the Second Test against the British & Irish Lions, in a 48–18 demolition of the touring team. Carter is one of the most devastating points scorers ever to have played the game, equally as comfortable with the ball in hand as he is kicking. With many years left to play, he is already the third leading scorer in the history of rugby union Test Matches, with over 1,000 points at an incredible average of 15 points a game.

Date: **2nd July, 2005**
Venue: **Westpac Stadium, Wellington, New Zealand**

QUICK ON THE DRAW

Richie McCaw lines up for New Zealand before the start of a Test Match against England. As captain of the All Blacks, he was named the IRB International Player of the Year in 2006 and 2009, the first player to achieve this accolade twice.

Date: **5th November, 2006**
Venue: **Twickenham, London**

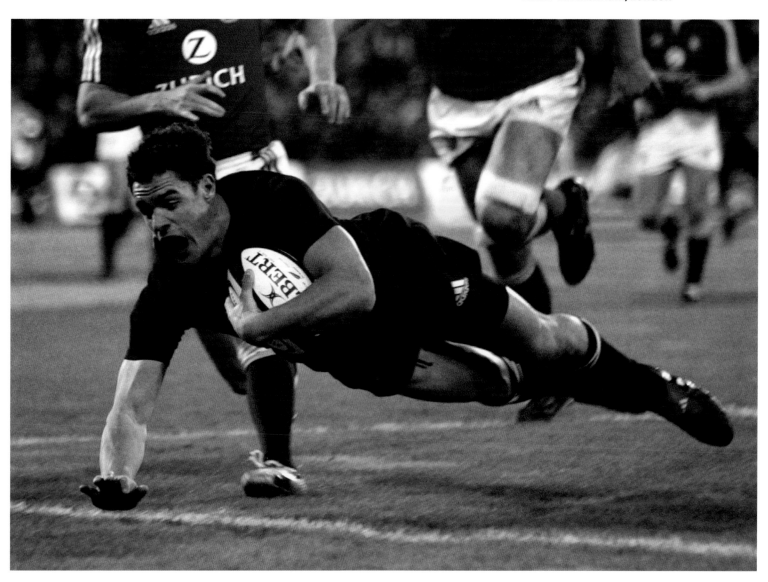

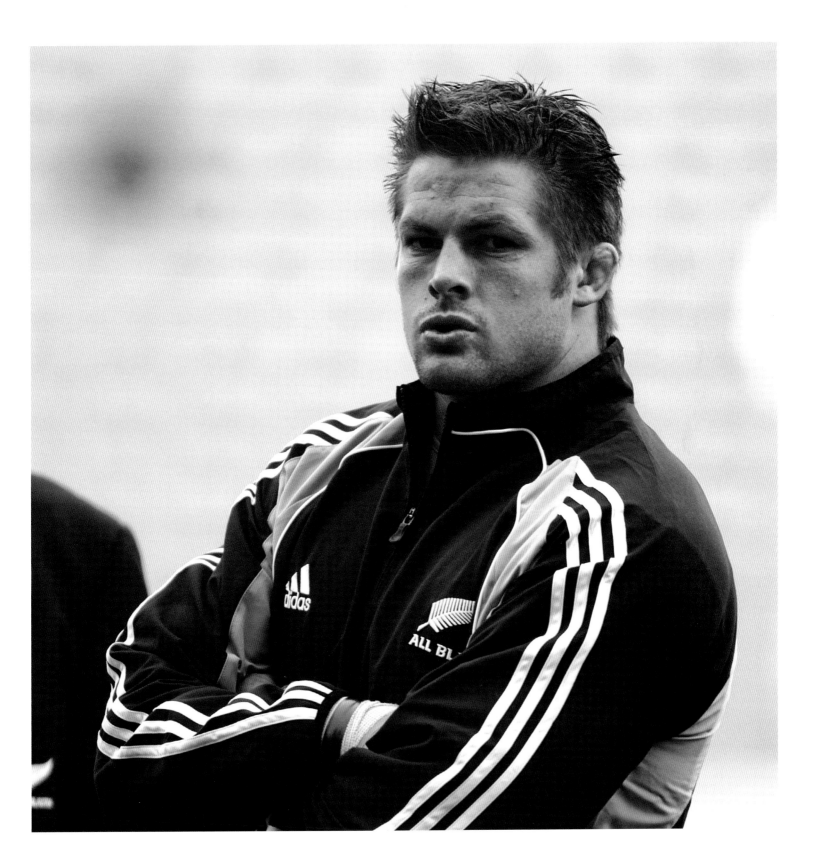

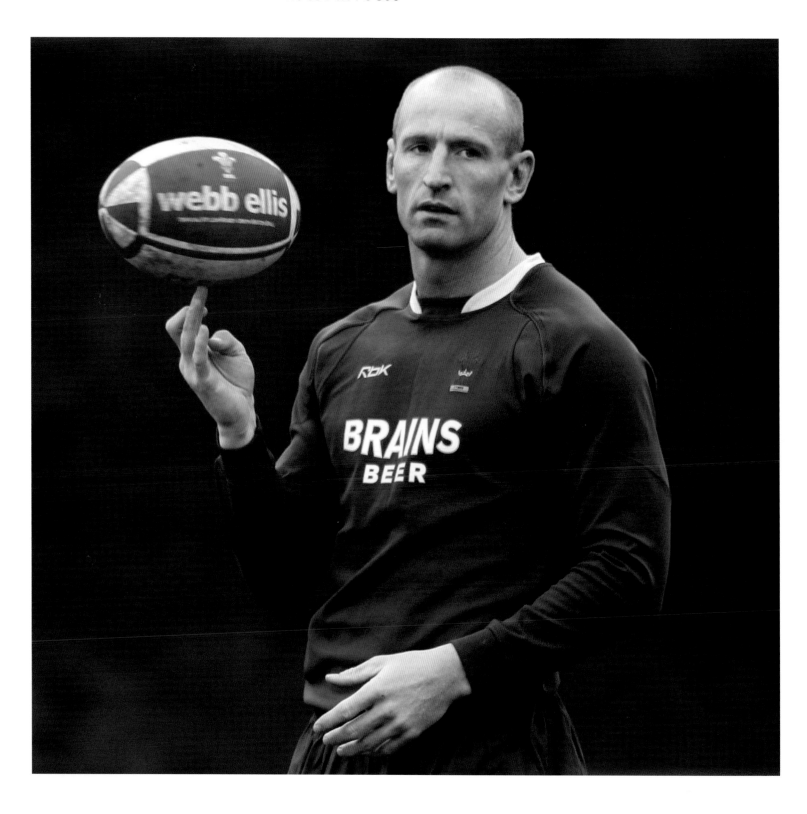

LEADING FROM THE BACKS

Wales's Gareth Thomas balances a ball on his finger during a training session. Thomas has played for Wales more times than anybody in history, winning 100 caps at centre, wing and fullback. One of the most prolific try scorers in the history of the game, Thomas is number nine in the list of all-time leading Test try scorers.

Date: **31st January, 2007**
Venue: **Sophia Gardens, Cardiff**

LEADING FROM THE FRONT ROW

England captain Phil Vickery celebrates with the Calcutta Cup following victory over Scotland. A combative tighthead prop, Vickery made his debut in 1998 and played in all seven matches of England's triumphant World Cup campaign of 2003.

Date: **3rd February, 2007**
Venue: **Twickenham, London**

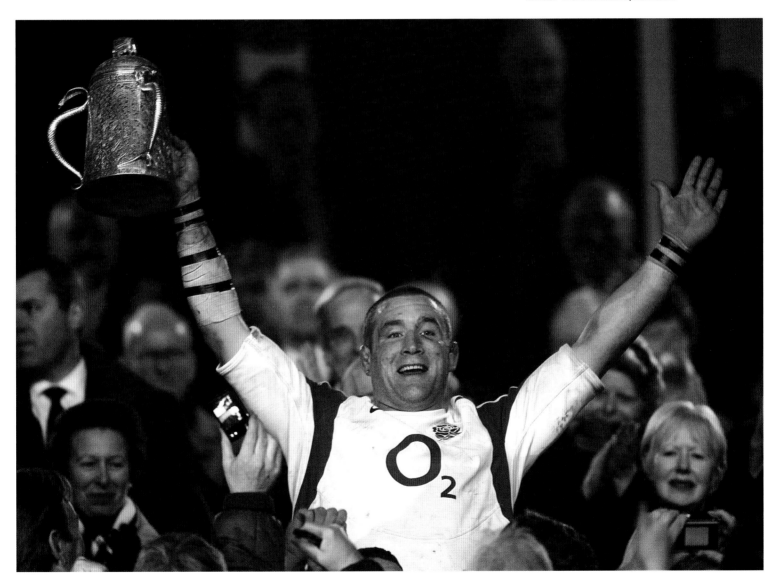

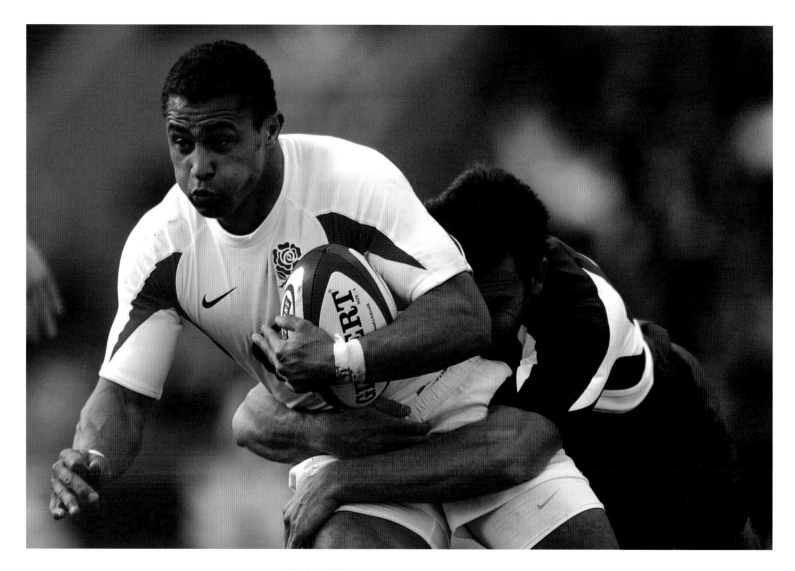

BILLY WHIZZ

England's Jason Robinson (L) is tackled by France's David Marty during a Six Nations Championship match. Robinson started his career in rugby league, playing for Hunslet Hawks and Wigan. With the professionalisation of union in 1996, Robinson signed for Bath, playing for them during the rugby league close season. In 2000, he opted to concentrate solely on union, signing for Sale Sharks. Robinson made his debut for the England rugby union side in 2001 and was a crucial member of the 2003 World Cup winning team, scoring a try during a memorable final.

Date: **11th March, 2007**
Venue: **Twickenham, London**

SERGE THE TERROR

France's Serge Betsen celebrates winning the Six Nations Championship after victory over Scotland. One of the toughest tacklers of the modern era and with a phenomenal work-rate, Betsen plays as a flanker and is notable for being equally comfortable on both sides of the scrum.

Date: **17th March, 2007**
Venue: **Stade de France, Paris**

ON TOP OF THE WORLD

South Africa's captain, John Smit, lifts the Rugby World Cup, following the Springboks' 15–6 victory over England. Smit made his debut in 2000 and is South Africa's most capped forward. Between October 2003 and June 2007, he played in a record 46 consecutive Test Matches for South Africa.

Date: **20th October, 2007**
Venue: **Stade de France, Paris, France**

WELSH SPEEDSTER

The prolific Shane Williams with the Triple Crown Trophy after Wales defeated Ireland in their Six Nations Championship match. Williams is one of the most exciting players of recent times, his pace and trickery lighting up many an international match.

He is Wales's leading try scorer and is third on the all-time test try scoring list.

Date: **8th March, 2008**
Venue: **Croke Park, Dublin**

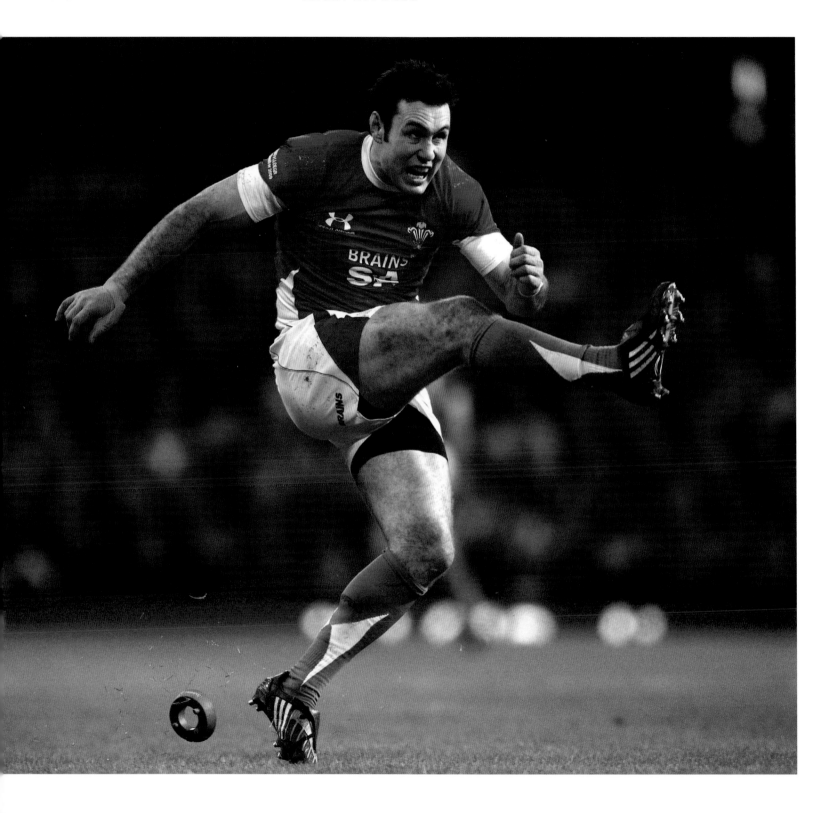

MAXIMUM EFFORT

Wales's Stephen Jones kicks a goal attempt during the Six Nations Championship match against England. Playing at fly-half, Jones has been a key figure in the recent successes of Wales, making significant contributions to the Grand Slam victories of 2005 and 2008.

Date: **14h February, 2009**
Venue: **Millennium Stadium, Cardiff**

MR ACCURACY

Scotland's Chris Paterson comes forward with the ball during the Calcutta Cup match against England in the Six Nations Championship. Capable of playing a number of positions, Paterson has started games for Scotland at fullback, wing and fly-half. He is one of the most accurate dead-ball kickers the game has ever seen, once kicking an incredible 36 consecutive goals in international matches. In 2008, during a match against Argentina, he overtook Gavin Hastings as Scotland's leading points scorer.

Date: **21st March, 2009**
Venue: **Twickenham, London**

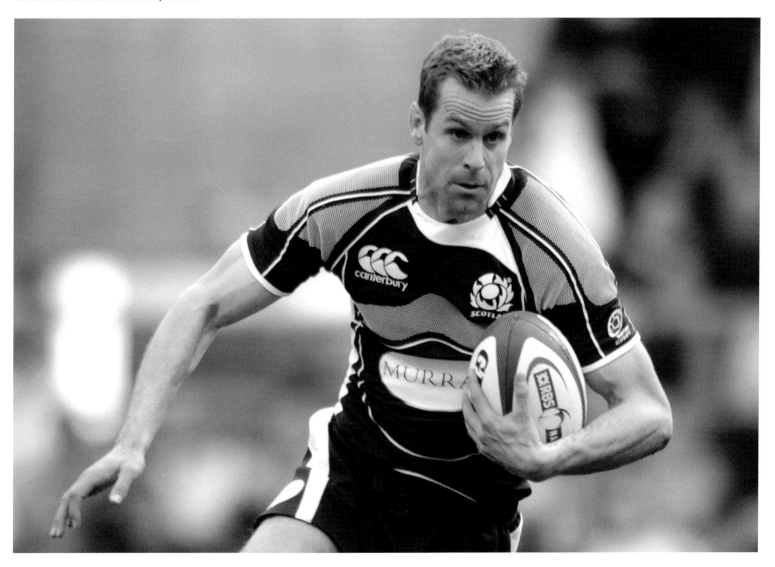

TAKE A BOWE

Irish wigner Tommy Bowe won the Welsh Rugby player of the year award in May 2010 for his performances with The Ospreys. Already voted the Player of the Six Nations, Bowe thus cemented his reputation as one of the most exciting finishers of his generation. He made his Ireland debut against Argentina in 2004 and added three Lions caps to his International collection in 2009.

Date: **14th March, 2009**
Venue: **Croke Park, Dublin**

ARGENTINIAN BEEF

Argentina's Juan Fernandez Lobbe has played both openside flanker and No 8 for his country. He made his debut against Uruguay in Santiago on 1st April, 2004. Lobbe started in all of the 'Pumas' 2007 World Cup games, including the dramatic 17 points to 12 defeat of hosts France in the tournament's opening game at the Stade de France. He subsequently captained Argentina to victories over both Ireland, and on this occasion, England, by 24 points to 22.

Date: **13th June, 2009**
Venue: **Estadio Padre Ernesto Martearena, Salta, Argentina**

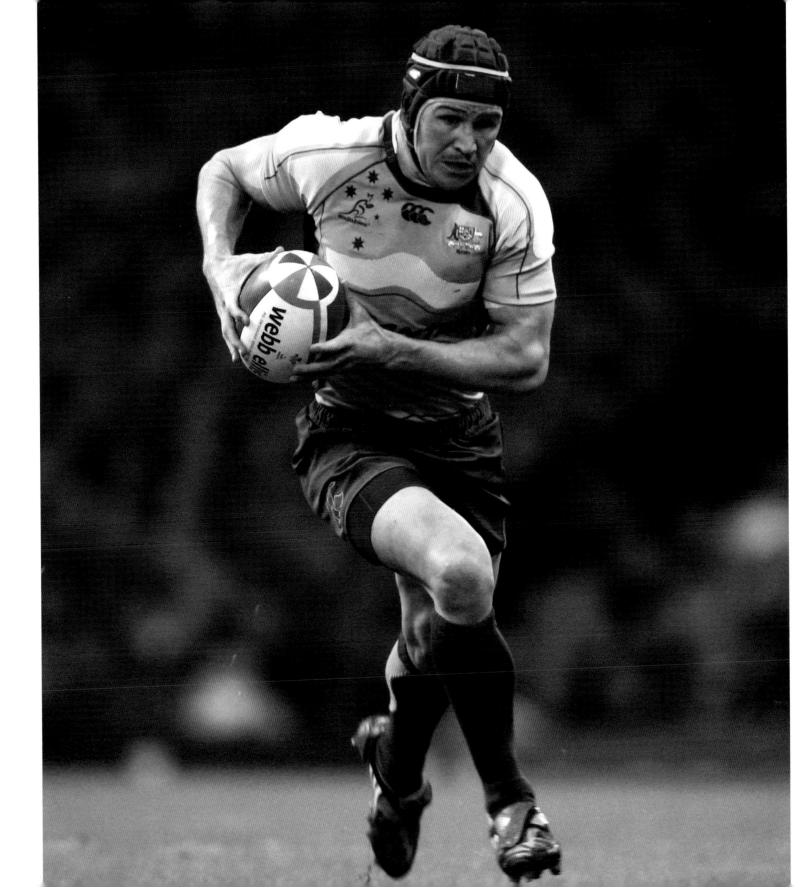

WALLABY ON THE CHARGE

Australia's Matt Giteau made his international debut against England at Twickenham in 2002. Regarded as one of the most talented players of his generation, he can play both inside centre or fly-half, and he even played several matches at scrum half for Australia in the 2006 season, before returning to centre for the 2007 World Cup. The quarter-final defeat to England at least allowed him to win his 50th International cap. He is not the only Giteau with international pedigree, since his sister Kirsty represented Australia in the 2010 Women's World Cup Finals.

Date: **26th November, 2009**
Venue: **Millennium Stadium, Cardiff**

MAXIMUM HEART

The elder of the two Bergamasco brothers, Mauro has been at the heart of the development of Italian rugby for more than a decade. He made his first international appearance against the Netherlands in 1998, prior to Italy's debut in the new 2000 Six Nations Championship. A powerful and combative back row forward, he has been ever present as Italy tried to establish itself in the top tier of world rugby.

Date: **27th February, 2010**
Venue: **Stadio Flamingo, Rome, Italy**

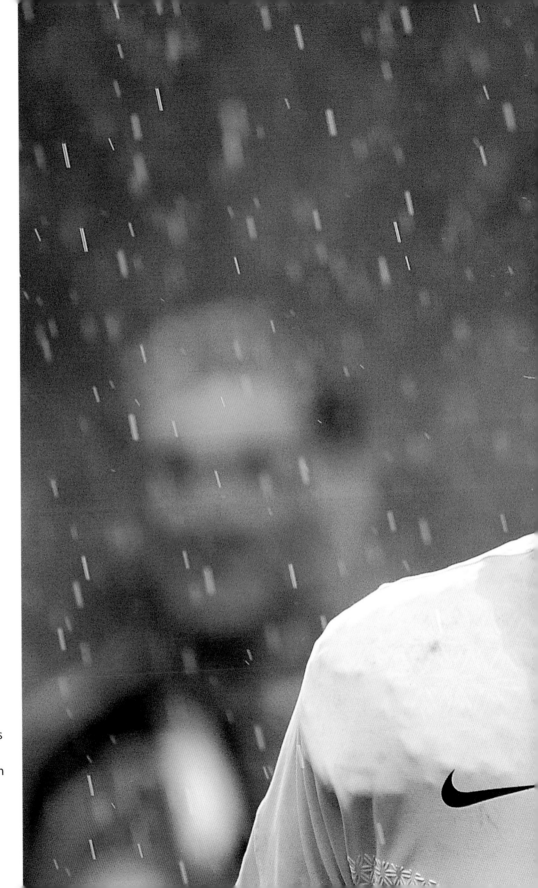

ENGLISH PRIDE

With the rain lashing down in Paris, Lewis Moody lines up before the start of a Six Nations Championship match against France. Moody is one of the most enthusiastic players to have represented England, regularly putting the interests of the team above any concerns for self-preservation. He made his international debut in 2001, went on to play a role in all seven games of England's victorious World Cup campaign of 2003, and deservedly was awarded the captain's armband in this the final 2010 Six Nations Championship match against France.

Date: **20th March, 2010**
Venue: **Stade de France, Paris, France**

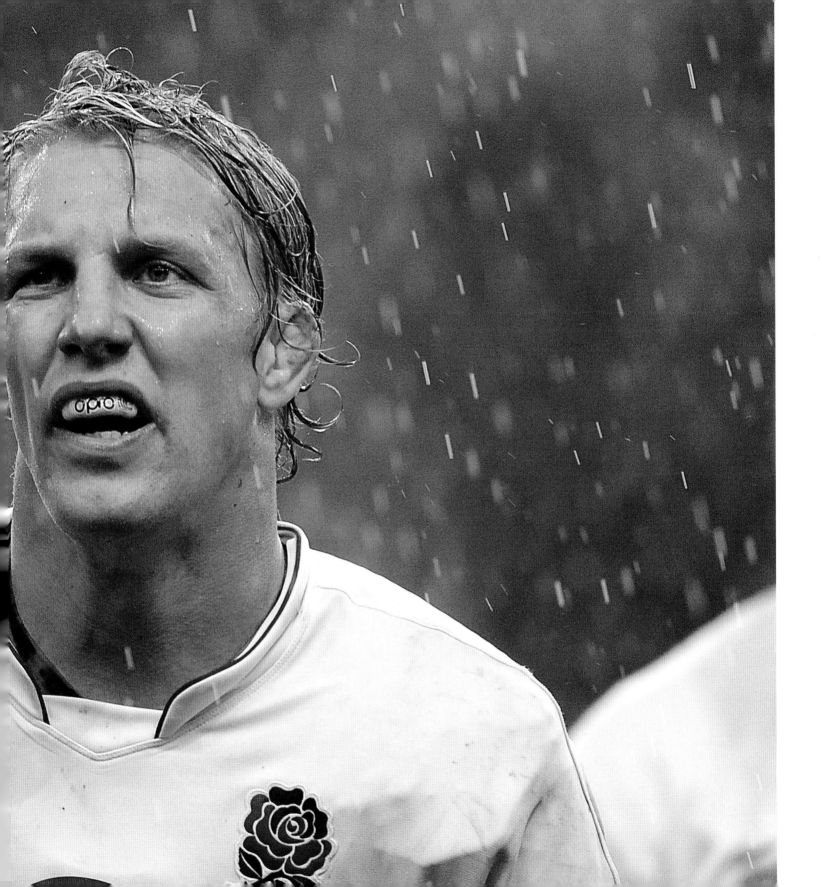

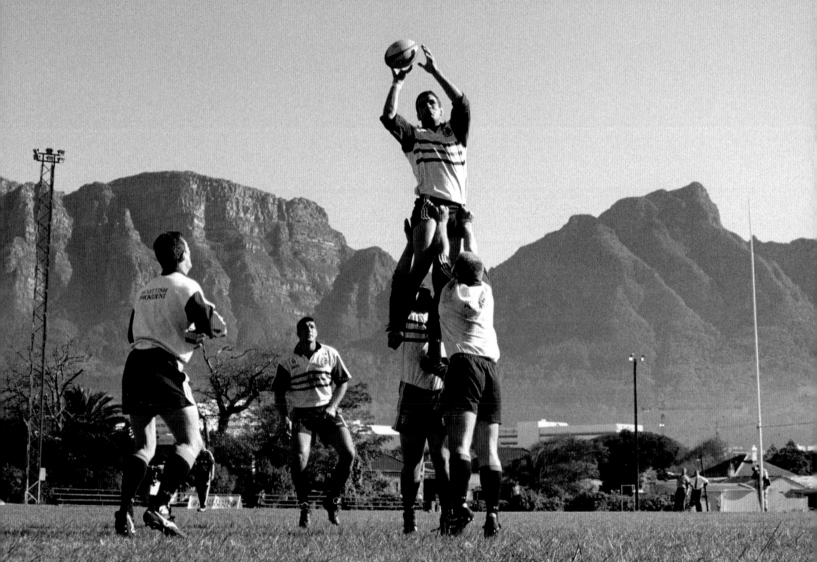

3 THE LIONS

The game was born in the British Isles, but quickly spread to many corners of the Empire. In 1888, an unofficial British Isles squad toured Australia and New Zealand, and over the next 20 years six more unsanctioned tours to the Antipodes and South Africa took place.

The interest generated convinced the rugby authorities of their worth, and in 1910 the four Home Nations selected a squad for the first official British Isles tour, to South Africa. Although the 1910 team sported a single lion on their jerseys, it wasn't until the 1924 tour to South Africa that they became known as the 'Lions', when local journalists used the name after spotting the same emblem displayed on the tourists' ties. By 1950, the Home Nations had adopted this name themselves.

Successive Lions squads, as well as their opponents, have etched their names into rugby history.

PRACTISING IN THE CAPE
The British Lions in training the day before their third match of the 1997 tour against Western Province. They won the game 38–21 against the Cape Town side.

Date: **30th May, 1997**
Venue: **Cape Town, South Africa**

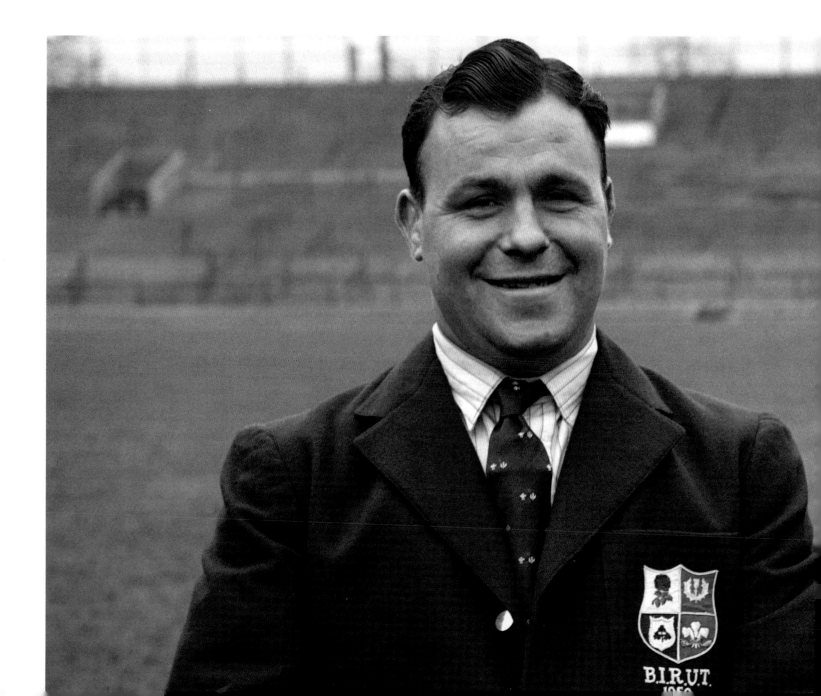

PRIDE OF THE LIONS

(L–R) Cliff Davies and G.M. Budge at Twickenham for a British Lions photo call before the tour of Australia and New Zealand. Davies, a Welsh international prop, played only one test for the Lions – the Fourth Test against New Zealand – but was a popular member of the touring squad. The Lions had mixed fortunes in the southern hemisphere, drawing the First Test against the All Blacks, but losing the remaining three. They won both the tests against Australia, with 19–6 and 24–3 wins in Brisbane and Sydney respectively.

Date: **21st January, 1950**
Venue: **Twickenham, London**

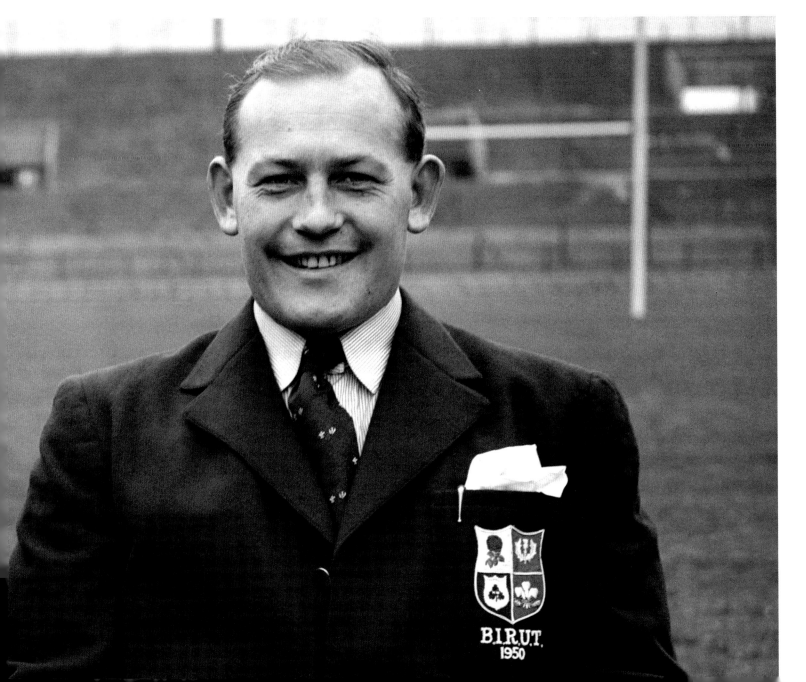

B.I.R.U.T.
1950

THE WARM UP

British Lions captain Robin Thompson warms up during a training session, shortly before the squad's departure for South Africa. The Lions drew the Test Series with the Springboks, both sides winning two matches apiece. The Lions won the Third Test in Johannesburg by just a single point, taking the game 23–22, and secured the Third Test in Pretoria 9–6. The home nation won the Second and Fourth Test matches in Cape Town and Port Elizabeth respectively. Despite the failure to win the series, overall the tour was a success for the Lions, who won 19 of the 25 matches they played.

Date: **6th June, 1955**
Venue: **Chelmsford Hall School, Eastbourne**

THE ACTION

A view of the action in the match between Western Province and the British Lions. The touring side came out on top 11–3 in front of a capacity Cape Town crowd.

Date: **9th July, 1955**
Venue: **Newlands, Cape Town, South Africa**

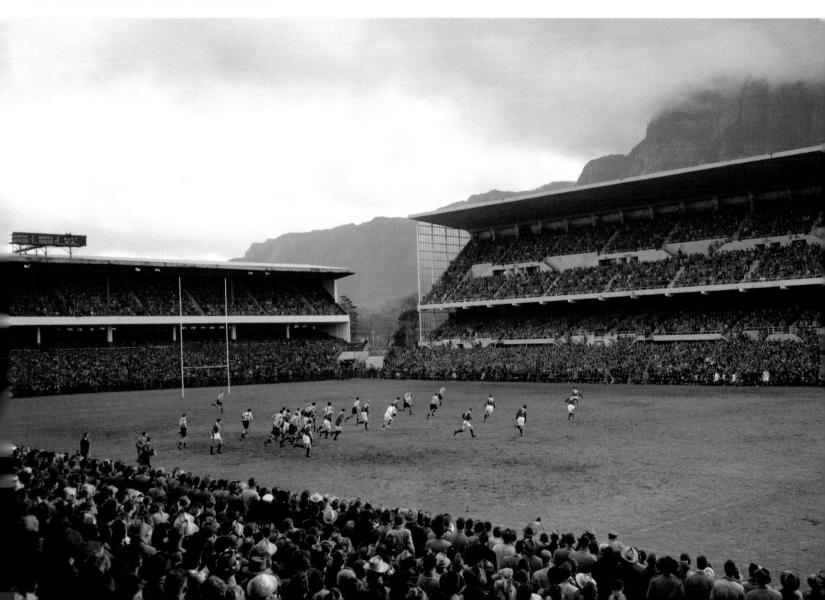

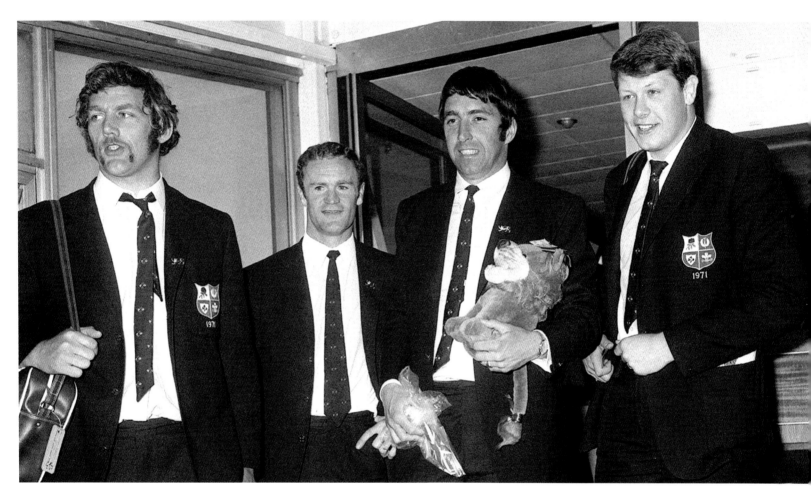

MEMORY STICK

Leicester winger Tony O'Reilly pictured with a souvenir of New Zealand – a carved Maori stick – upon his return from the British Lions tour of Australia and New Zealand. O'Reilly, who went on to a distinguished business career that would see him become one of Ireland's richest people, scored a remarkable 22 tries during the tour, a Lions record. The team had mixed fortunes, winning the two test matches against Australia, but losing the four-match series against the All Blacks 3–1.

Date: **1st October, 1959**

RETURNING HEROES

Four of the British Lions players from England, Wales, Ireland and Scotland: (L–R) Mike Roberts, Mike Gibson, Bob Hiller and Gordon Brown. The 1971 tour to New Zealand and Australia was arguably the most successful in Lions history, the team winning the four-match Test Series against the All Blacks 2–1 after wins in Dunedin and Wellington and a draw in the Final Test in Auckland. Wales, fresh from a glorious Grand Slam, supplied more players to the squad than any other home nation; the captain (John Dawes) and coach (Carwyn James) were also Welsh. It was fitting, therefore, that a Welshman scored the crucial points to secure a draw in the Final Test, J.P.R. Williams successfully converting the only drop goal of his career.

Date: **7th May, 1971**

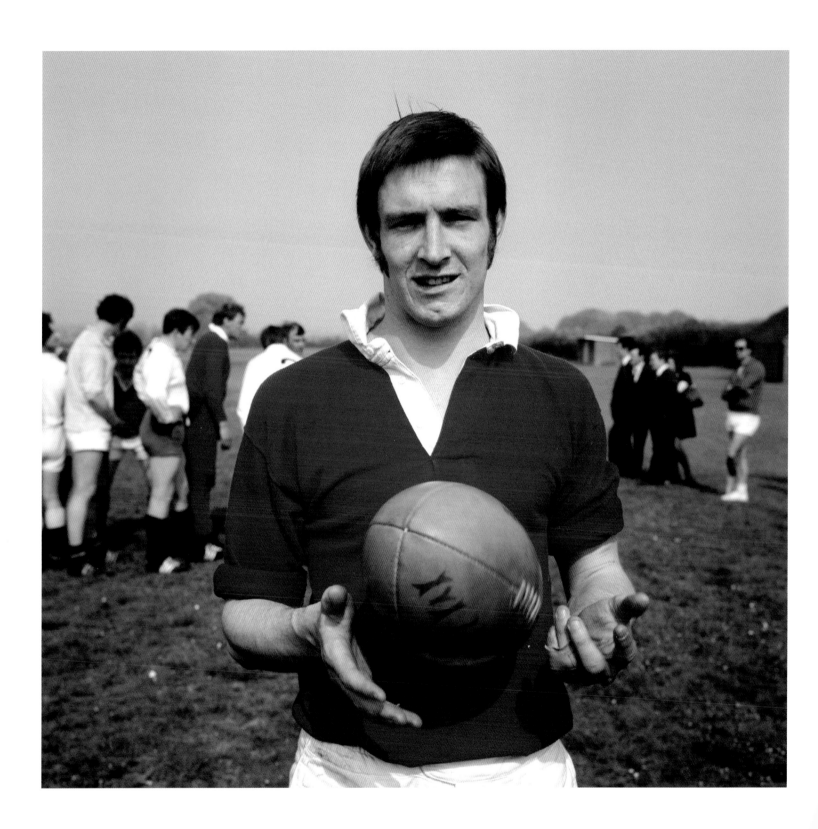

LIVE WIRE

Welsh winger John Bevan during a British Lions training session. Endowed with electric pace, Bevan scored 18 tries on the 1971 tour to New Zealand and Australia. Only 20 at the time, he made just one appearance in the Test Series, in the 9–3 win in the First Test in Dunedin.

Date: **30th May, 1971**

THREE TIME LION

London Welsh's Gerald Davies, a member of the brilliant Wales team of the 1970s, began his career at centre, but switched to wing at a relatively young age and played in that position for the remainder of his career. He appeared 46 times for his country, and was selected for both the 1968 and 1971 Lions tours. He was tour manager for the 2009 Lions foray to South Africa, which the home side won 2–1.

Date: **7th July, 1971**

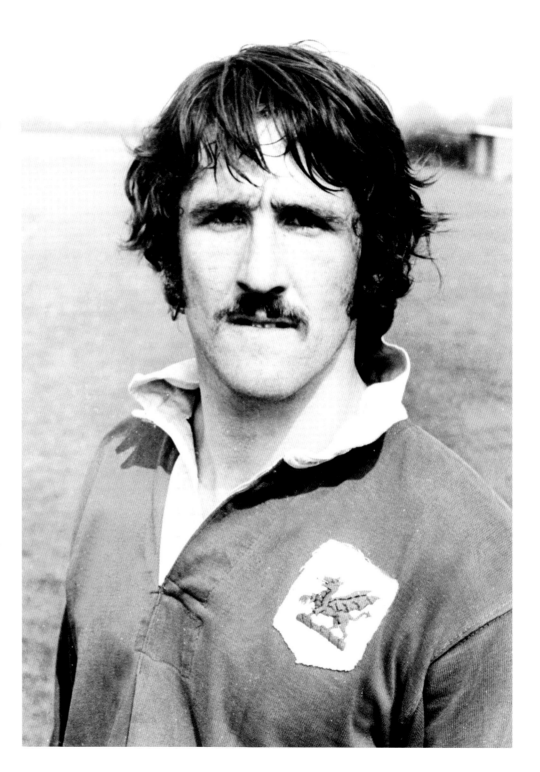

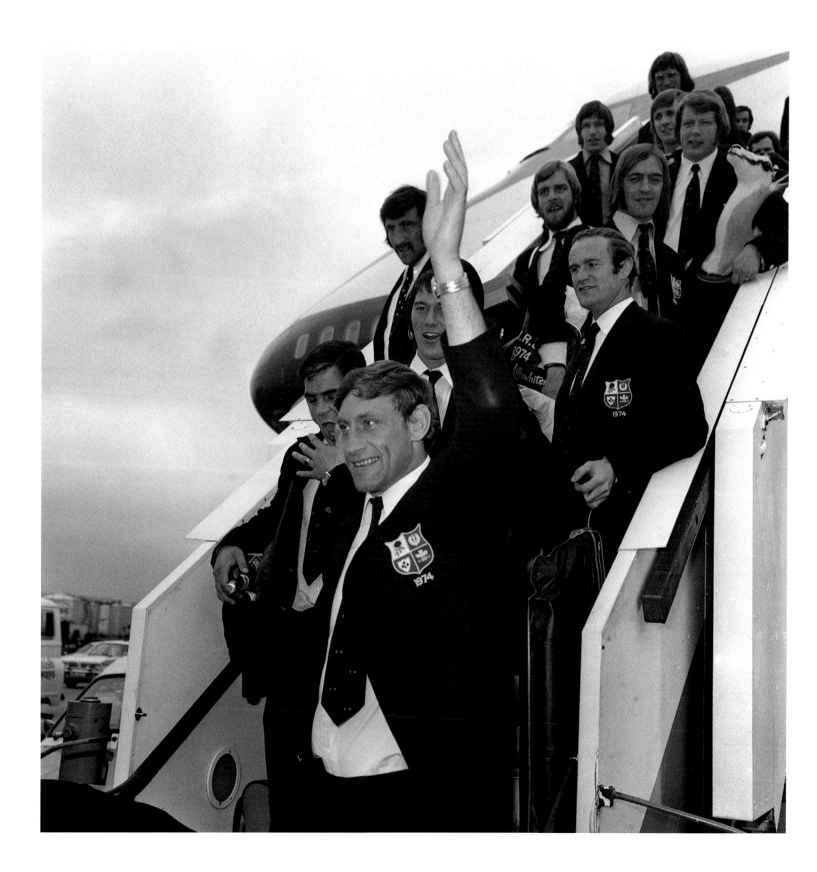

TRIUMPHAL RETURN

Captain Willie John McBride waves to the crowds of fans as he and his team-mates of the 'invincible' British Lions arrive back home to a heroes' welcome. The team played 22 matches on their tour to South Africa, winning 21 and drawing one, a feat to rival the series win against the All Blacks in 1971. The four-match Test Series against the Springboks was a bruising affair, the Lions having decided to 'get their retaliation in first' against a South African side they believed relied on physical aggression.

Date: **30th July, 1974**

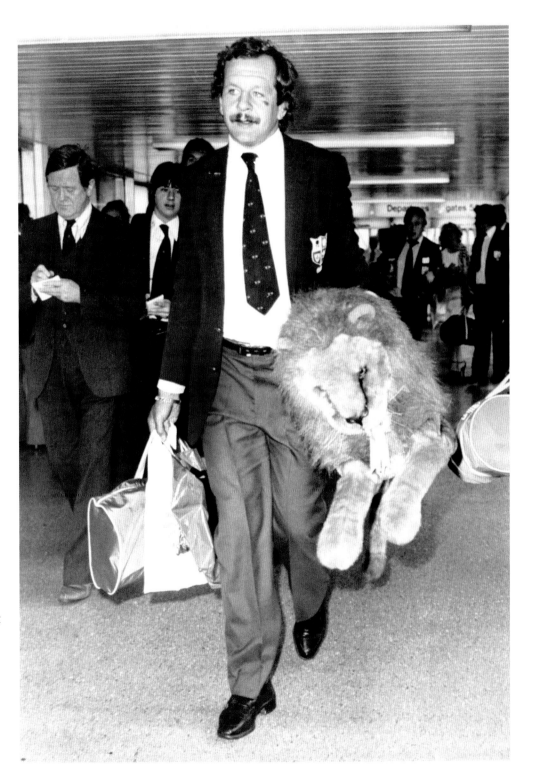

TAMED LION

British Lions captain Bill Beaumont on his return from the tour to South Africa. Although the Lions won all 14 of the non-international matches on tour, the team lost the Test Series 3–1. After losing the first three tests, the Lions salvaged some pride by winning the Fourth Test in Pretoria 17–13. The tour went ahead despite opposition from the British government and groups opposed to sporting contact with the Apartheid regime of South Africa.

Date: **25th June, 1980**

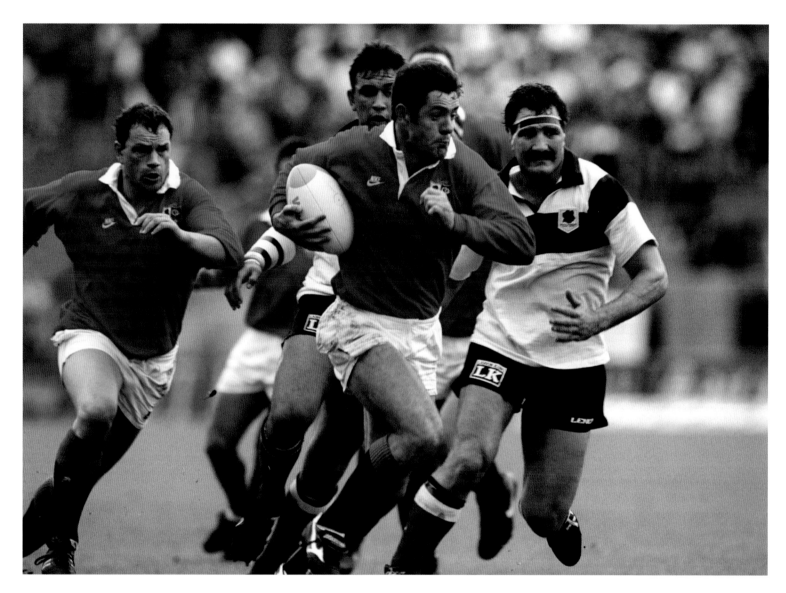

LEADING FROM THE FRONT
Captain Gavin Hastings (C) runs past Kevin
Boroevich during the North Harbour v
British Lions match that formed part of the
Lions' tour of New Zealand. The Lions ran
out 29–13 winners in their second match.

Date: **26th May, 1993**
Venue: **North Harbour Stadium,**
North Shore City, New Zealand

BALL WATCHING
Towering Blackpool policeman and British
Lion Wade Dooley wins a line-out ball during
the match against New Zealand Maoris. The
Lions recorded their third consecutive victory
of the tour, shading a close game 24–20.

Date: **29th May, 1993**
Venue: **Athletic Park, Wellington,**
New Zealand

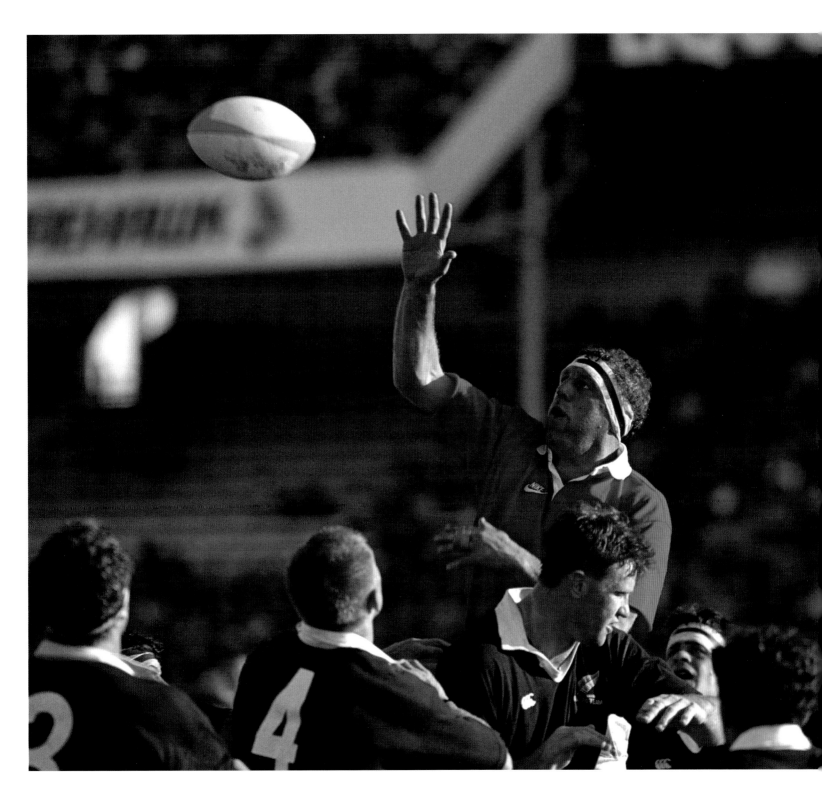

JOHNO'S BALL

Martin Johnson in the famous red strip of the British Lions during the match against Taranaki. The game was played just four days after the First Test, which the Lions lost narrowly 20–18. Johnson, aged 23, had been called up to replace Wade Dooley, who had returned home for the funeral of his father.

Date: **16th June, 1993**
Venue: **Rugby Park, New Plymouth, Taranaki, New Zealand**

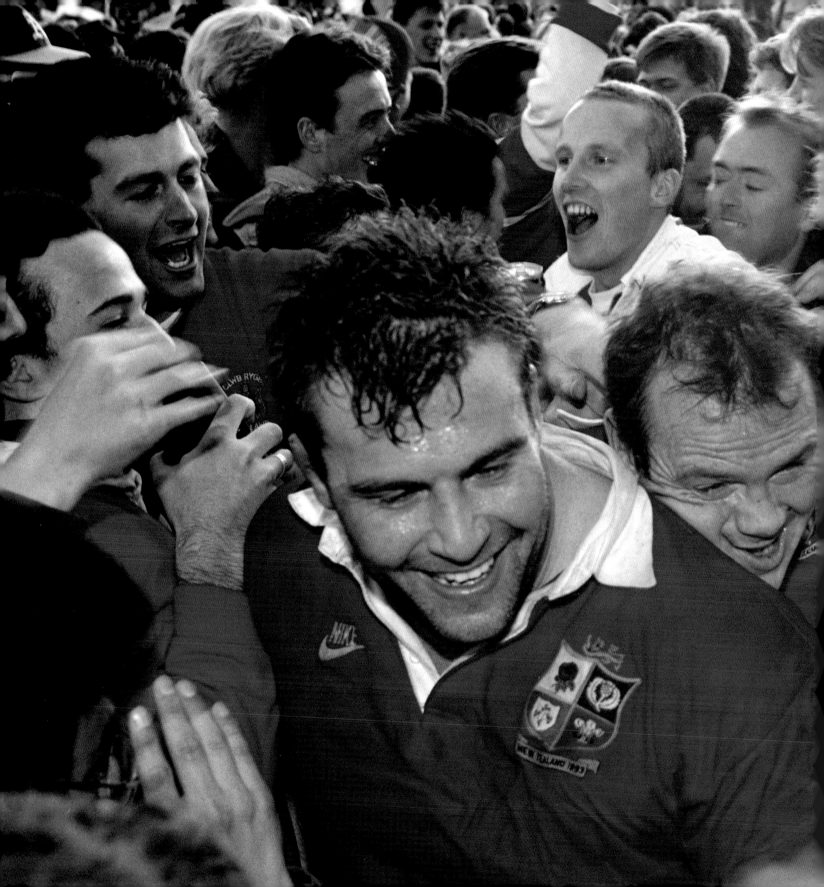

FINAL WHISTLE SCRUM

Jason Leonard (L) and Ieuan Evans (R) celebrate victory for the British Lions over the All Blacks in the Second Test of the three-match series in New Zealand. Following the disappointment of the two-point defeat in the First Test, the Lions bounced back to dominate the game in Wellington, winning 20–7 and setting up a series decider in Auckland.

Date: **26th June, 1993**

Venue: **Athletic Park, Wellington, New Zealand**

ON THE CHARGE

Welsh winger Ieuan Evans on a characteristic surging run during the crucial Third Test against New Zealand. The prolific Evans was powerless to prevent a dominant second-half performance by the All Blacks, however, who ran out 30–13 winners to seal a 2–1 series win. The 1993 Lions tour is notable for being the last of the amateur era of rugby.

Date: **3rd July, 1993**
Venue: **Eden Park, Auckland, New Zealand**

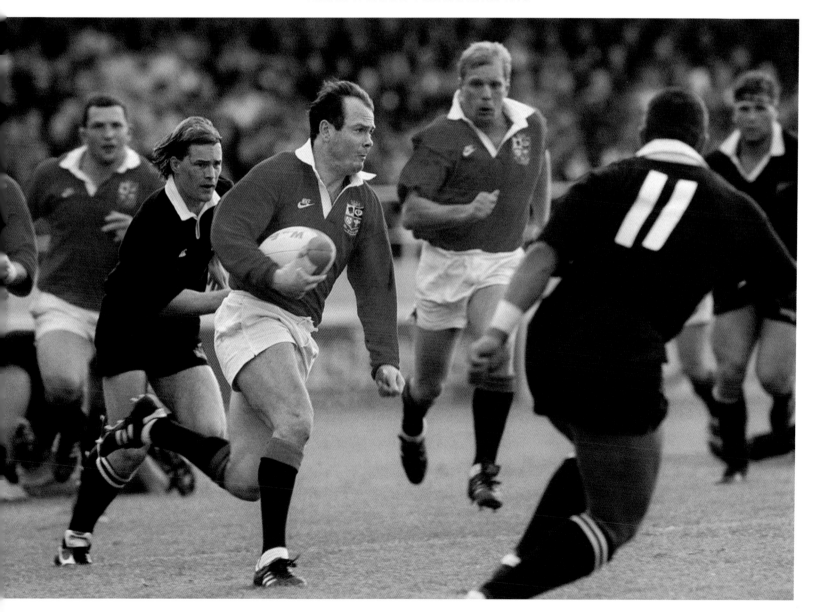

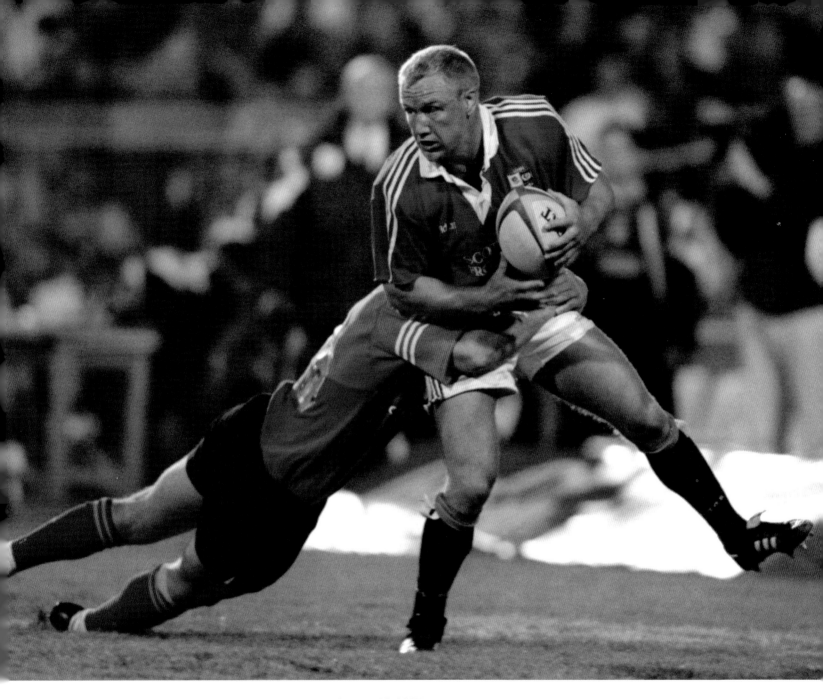

BACK TO THE FRONT

England flanker Neil Back on the charge for the British Lions in the match against Free State, a game that the Lions won convincingly 52–30. Just three days earlier, the Lions had secured a win in the First Test against the Springboks, running out 26–15 victors thanks to tries from Matt Dawson and Alan Tait, and five penalties from the metronomic Neil Jenkins.

Date: **24th June, 1997**
Venue: **Free State Stadium, Bloemfontein, South Africa**

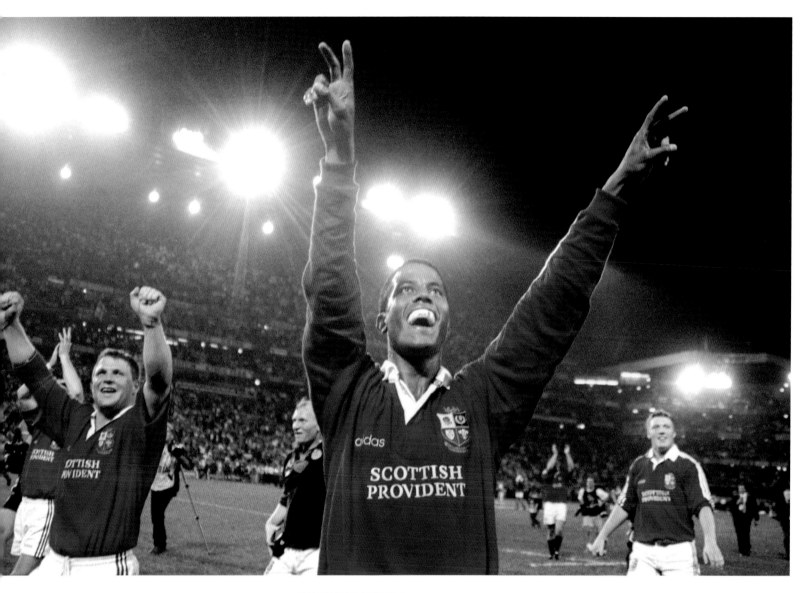

'V' FOR VICTORY

Jeremy Guscott celebrates at the end of the Lions' dramatic Second Test victory over South Africa. A committed defensive effort from the Lions and the ever-reliable boot of Neil Jenkins ensured that the touring team went into the closing stages of the match tied at 15–15. With just three minutes remaining, the Lions manoeuvred themselves into Springbok territory, allowing Guscott to seal a famous series win with a drop goal.

Date: **28th June, 1997**
Venue: **Kings Park Stadium, Durban, South Africa**

UNDERWOOD RELEASED

Tony Underwood leaves the Northern Free State defence trailing as he goes on to score a try in the Lions tour match. The Lions dominated the high-scoring encounter, coming out on top 67–39.

Date: **1st July, 1997**
Venue: **Free State Stadium, Welkom, South Africa**

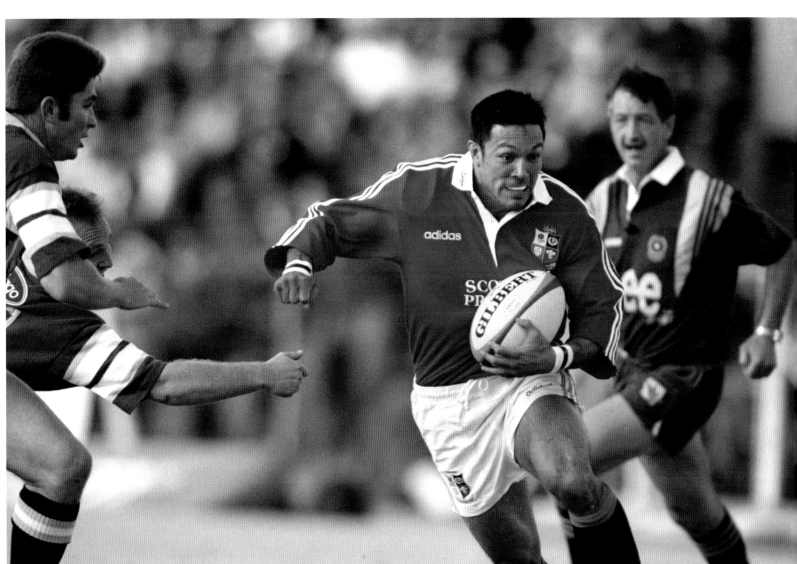

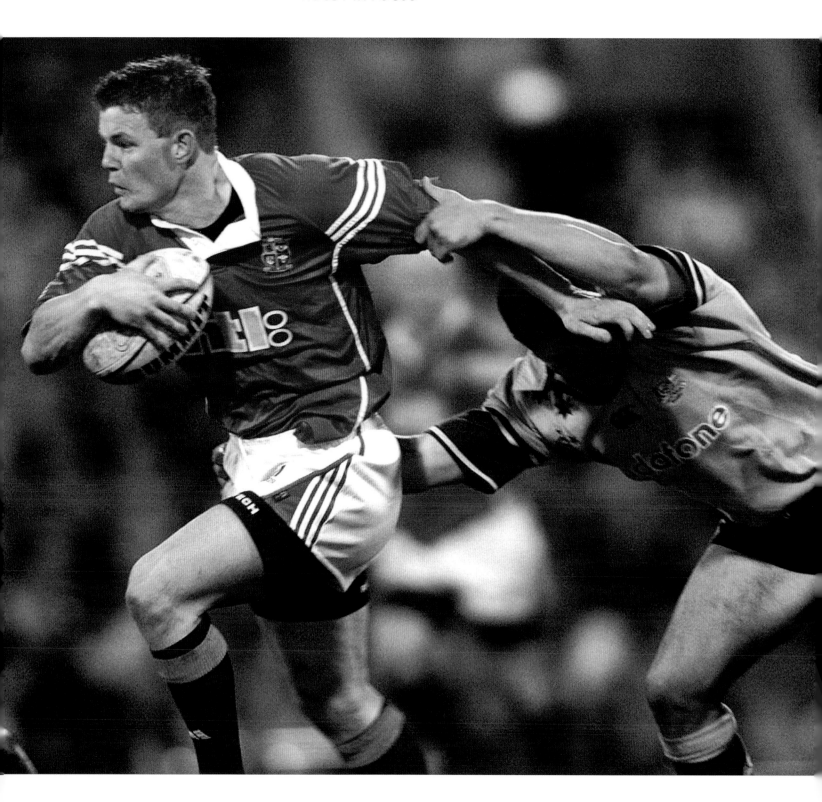

O'DRISCOLL'S AWAY

British Lions player Brian O'Driscoll breaks away to score a third try against Australia during the First Test match. The Lions dominated the first of the three-match series, scoring four tries to Australia's two and coming out on top 29–13.

Date: **30th June, 2001**
Venue: **The Gabba, Brisbane, Australia**

WALKER STOPPED

Australian winger Andrew Walker runs into the Lions defensive line in the shape of Dafydd James during the third and final test match of the tour. Despite two excellent tries from Jason Robinson and Jonny Wilkinson, the Lions couldn't force the victory that would have given them the series.

Date: **14th July, 2001**
Venue: **Telstra Stadium, Sydney, Australia**

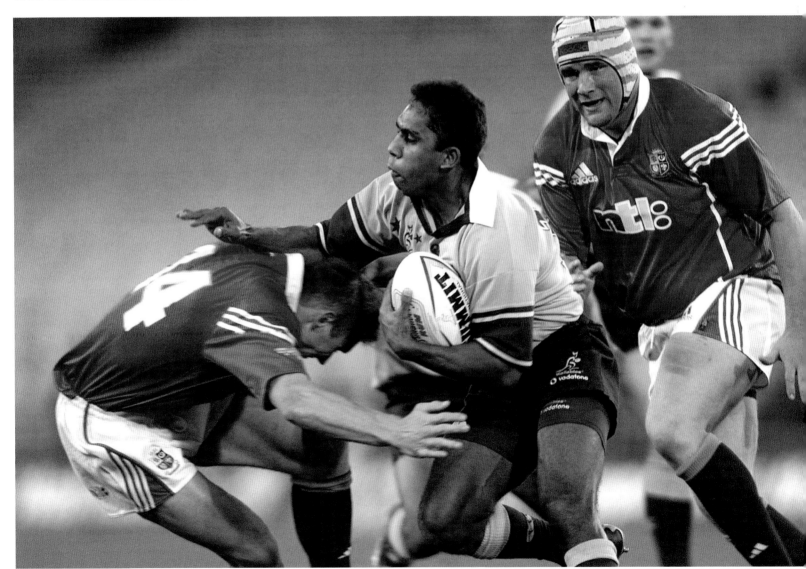

COLOURFUL FANS
British & Irish Lions fans before the Lions'
match against Otago, which the touring
side won 30–19. A strong second-half
performance, particularly from Welsh
forward Ryan Jones, secured a somewhat
surprising result for the Lions, who had
lost to Otago on the previous four tours to
New Zealand.

Date: **18th June, 2005**
Venue: **Carisbrook, Dunedin, New Zealand**

LIONS TAMED

The Lions' Jonny Wilkinson is tackled by Richie McCaw during the First Test in 2005. Having lost this test 21–3, and after a dire Second Test performance, the touring team went into the Final Test with only pride at stake. They lost the game in Wellington 38–19, the first time they had been whitewashed in a series against the All Blacks.

Date: **25th June, 2005**
Venue: **Jade Stadium, Christchurch, New Zealand**

CAPTAIN O'CONNELL

British & Irish Lions captain Paul O'Connell makes his way off the field after the bitterly disappointing ending to the Second Test against South Africa. The Lions had led 19–8 after an hour, but tries from Bryan Habana and Jaque Forie levelled the match at 25–25 before Morne Steyn nailed a penalty from inside his own half to seal the series win. Aside from the remarkable conclusion, the game is perhaps best known for two ugly incidents perpetrated by Springbok players. Schalk Burger was booked and subsequently banned for gouging Luke Fitzgerald's eye and Bakkies Botha was banned for two weeks for a dangerous charge on Adam Jones. The Lions salvaged some pride with a heroic 28–9 win in the Third Test.

Date: **27th June, 2009**
Venue: **Loftus Versfeld, Pretoria, South Africa**

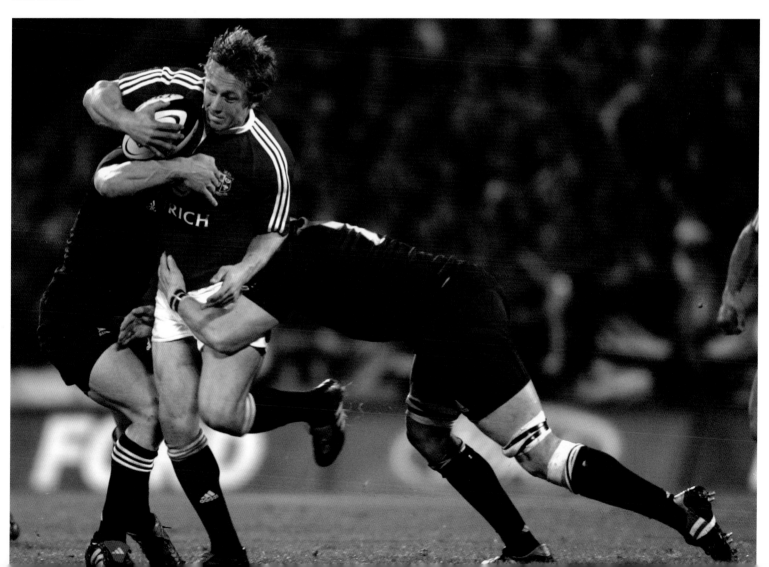

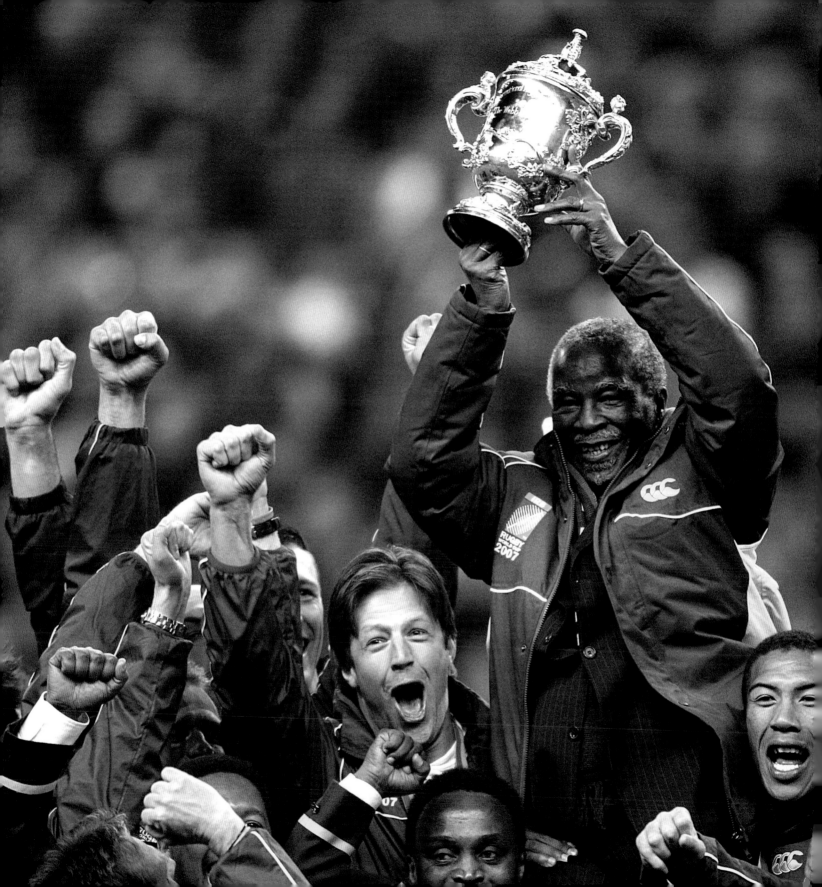

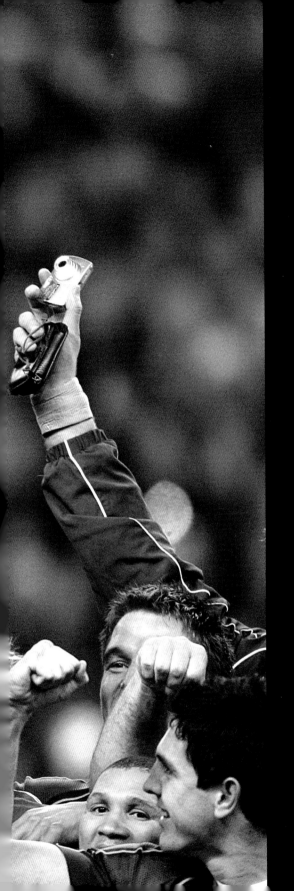

4 THE WORLD CUP

The first international rugby match to be televised was broadcast from Twickenham in 1938, when England met Scotland. The coverage may have been crude by modern standards, but it was clear that there was a tremendous appetite for televised games. By 1992 the 'Home' internationals attracted an audience of over five million locally and could be viewed in 50 countries.

The game needed a global showcase and despite the fear of attracting unwanted commercial pressures to the amateur game the International Rugby Board (IRB) finally sanctioned the first World Cup in 1987. Since then, the tournament has consistently produced some wonderful matches: France beating Australia in the 1987 Semi Final; South Africa winning for the fledgling 'rainbow nation' in 1995; Argentina beating France to third place in 2007 – and who could forget Jonny Wilkinson's decisive drop goal, in the last minute of extra time, to win England the trophy in Sydney in 2003?

CHAMPION FEELING
South African President Thabo Mbeki lifts the 2007 Rugby World Cup in echoes of Nelson Mandela's celebration of the Springboks' 1995 World Cup triumph in Johannesburg.

Date: **20th October, 2007**
Venue: **Stade de France, Paris, France**

PLAYING CATCH-UP RUGBY

New Zealand's John Kirwan is chased down by England's Chris Oti during the opening fixture of the Rugby World Cup. A try from All Black Michael Jones proved the decisive score in a tight 18–12 encounter.

Date: **3rd October, 1991**
Venue: **Twickenham, London**

WALLABY WIN

The mercurial David Campese runs at Argentina's defence during Australia's first game of the 1991 Rugby World Cup. Two tries apiece from Campese and Tim Horan, as well as a Phil Kearns touchdown, contributed to a convincing 32–19 win for the Wallabies.

Date: **4th October, 1991**
Venue: **Stradey Park, Llanelli**

THE ACTION

Australia's Nick Farr-Jones feeds from the base of the scrum during the all-Antipodean semi-final in Dublin. An impressive all-round performance by Australia limited the All Blacks to two Grant Fox penalties. Tries from David Campese and Tim Horan helped Australia to a 16–6 victory and set up an intriguing final against England, who edged out Scotland 9–6 in the other semi-final.

Date: **27th October, 1991**
Venue: **Lansdowne Road, Dublin**

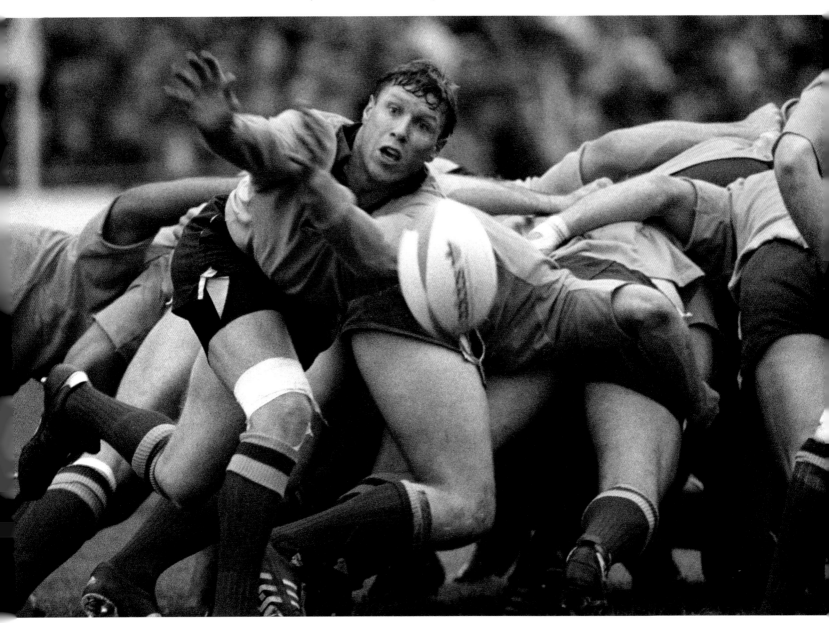

GAME PLANNING

Scotland's Gavin Hastings issues instructions during the Third-place Play-off match against New Zealand. Two Hastings penalties were never going to be enough against the All Blacks, who ran out 13–6 winners through a Walter Little try and three Jon Preston penalties.

Date: **30th October, 1991**
Venue: **The Arms Park, Cardiff**

CAPTAIN IN CONTROL

Australian captain Nick Farr-Jones kicks the ball downfield under the watchful eyes of England's Mick Skinner (R) and Brian Teague (L) during the 1991 Rugby World Cup Final, which the Wallabies won 12–6.

Date: **2nd November, 1991**
Venue: **Twickenham, London**

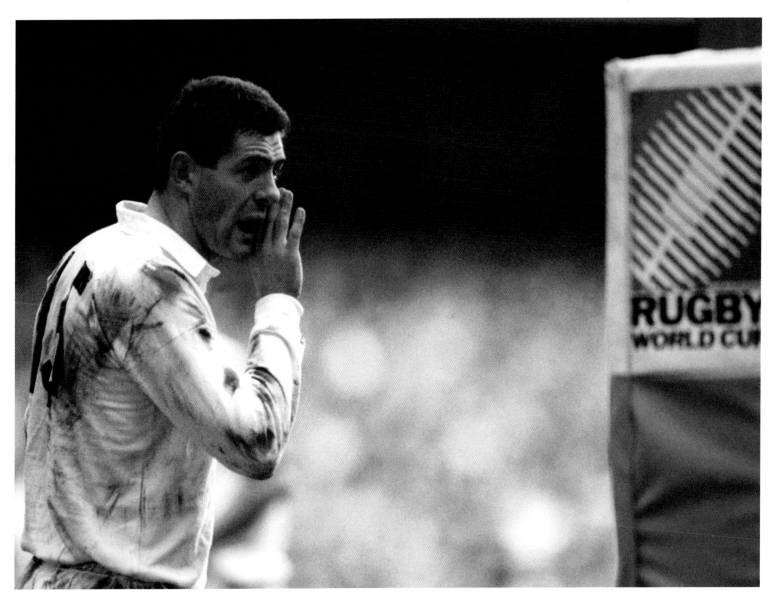

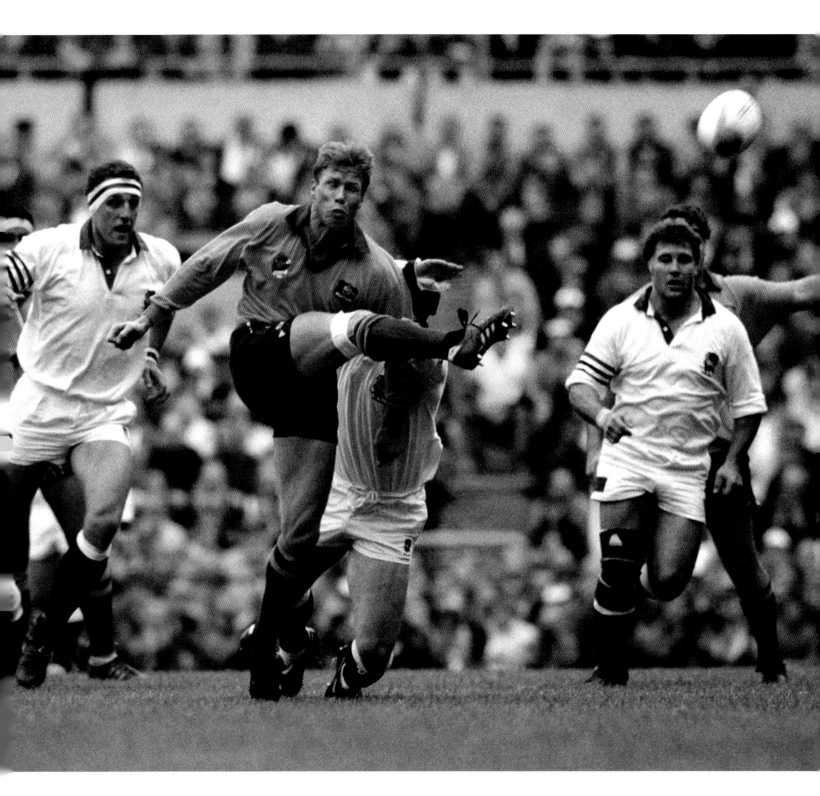

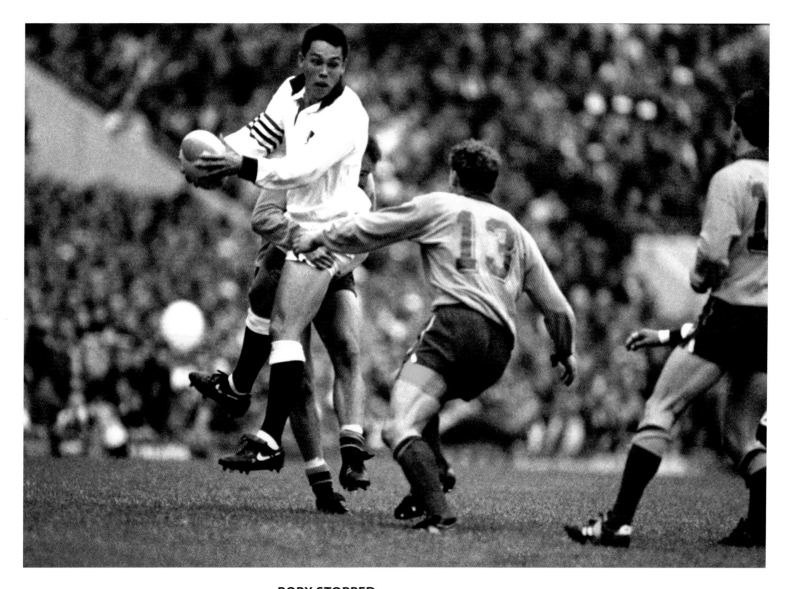

RORY STOPPED

England's Rory Underwood (C) is stopped by Australia's Rob Edgerton and Jason Little (R) during the 1991 Rugby World Cup Final. One of the most deadly wing men of his era, Underwood won 85 England caps and six Lions caps between 1984 and 1996, scoring a record 49 tries for England and a solitary try for the Lions. During his final years with England, he played alongside his brother, Tony, the first siblings to appear in the same England team since 1937.

Date: **2nd November, 1991**
Venue: **Twickenham, London**

AUSSIE TRIUMPH

David Campese holds aloft the Webb Ellis Trophy following Australia's 12–6 triumph over England in the Rugby World Cup Final. Campese, a player whose brashness and unshakable self-confidence didn't exactly endear him to opposing fans, was voted player of the tournament following six tries and some moments of undeniable genius. 'Campo' won 101 caps for the Wallabies and is regarded by some as the greatest player ever to wear the famous green and gold of Australia.

Date: **2nd November, 1991**
Venue: **Twickenham, London**

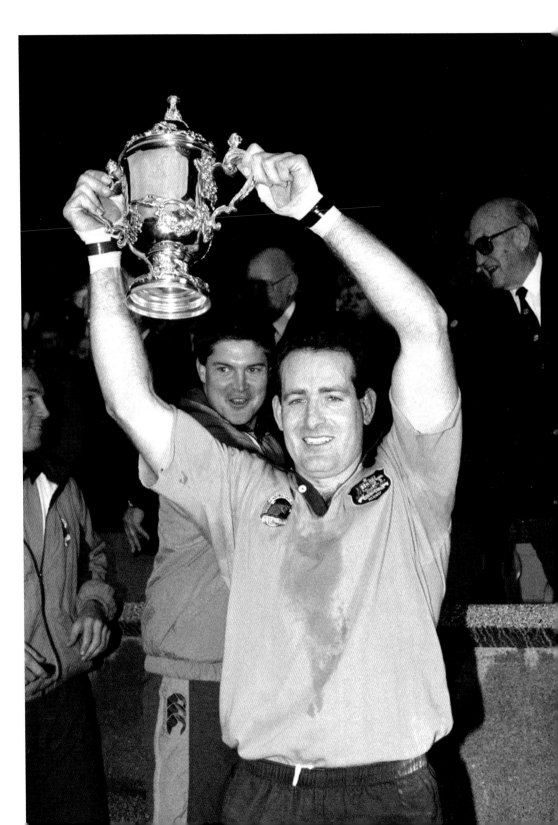

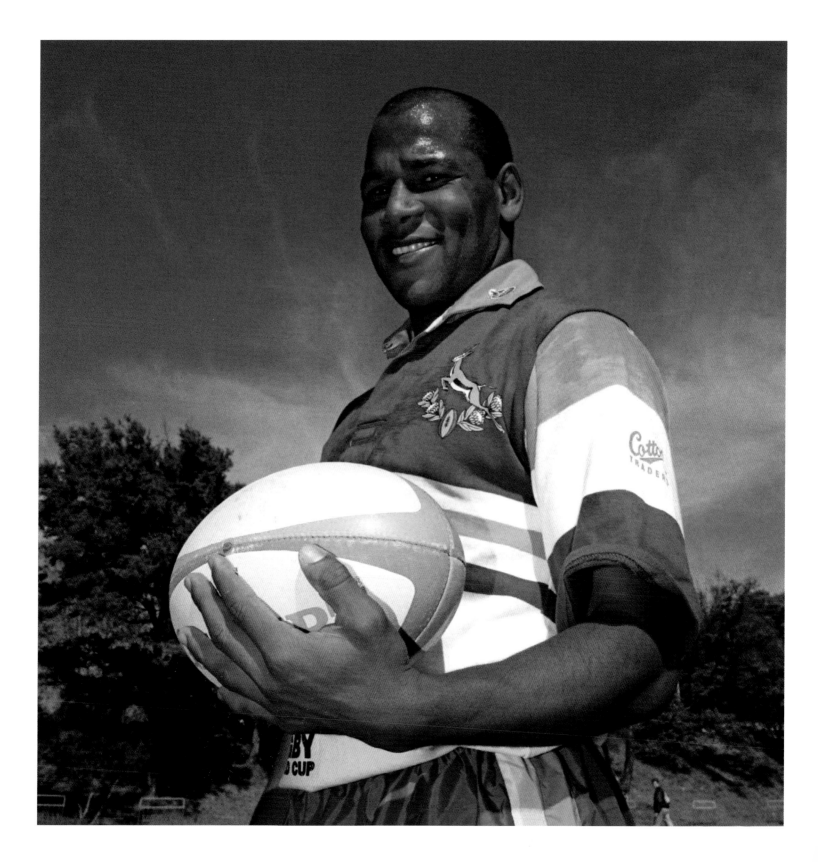

THE FACE OF NEW SOUTH AFRICA

South African winger Chester Williams poses for the camera before a World Cup training session. A quick, skilful player, Williams was in many ways the face of the World Cup in South Africa. The only black player in the Springboks squad and the first to be selected by South Africa since Errol Tobias in the early 1980s,

Williams came to symbolise reconciliation between the communities following the end of Apartheid.

Date: **6th June, 1995**

INSPIRES HIS TEAM-MATES

South Africa's Gavin Johnson is tackled by Western Samoa's Mike Umaga during the Rugby World Cup Quarter-Final. The Springboks dominated the game, coming out on top 42–14, thanks in no small measure to four tries from Chester Williams.

Date: **10th June, 1995**
Venue: **Ellis Park, Johannesburg, South Africa**

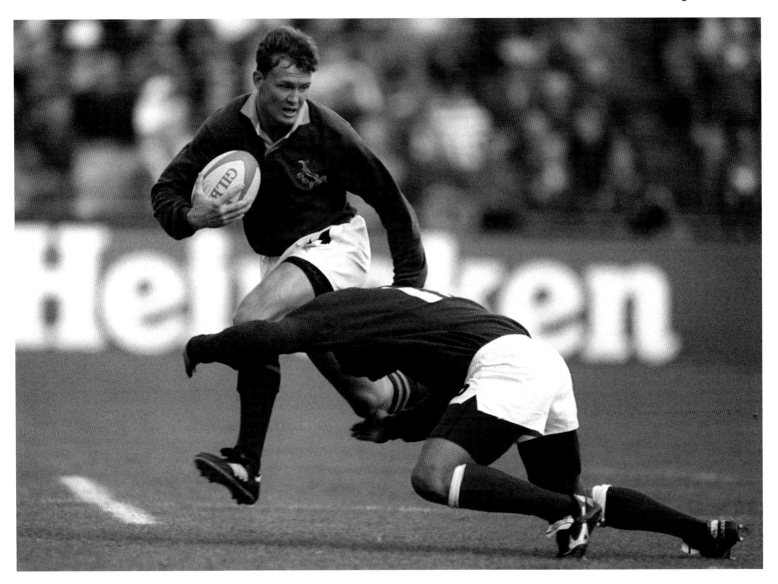

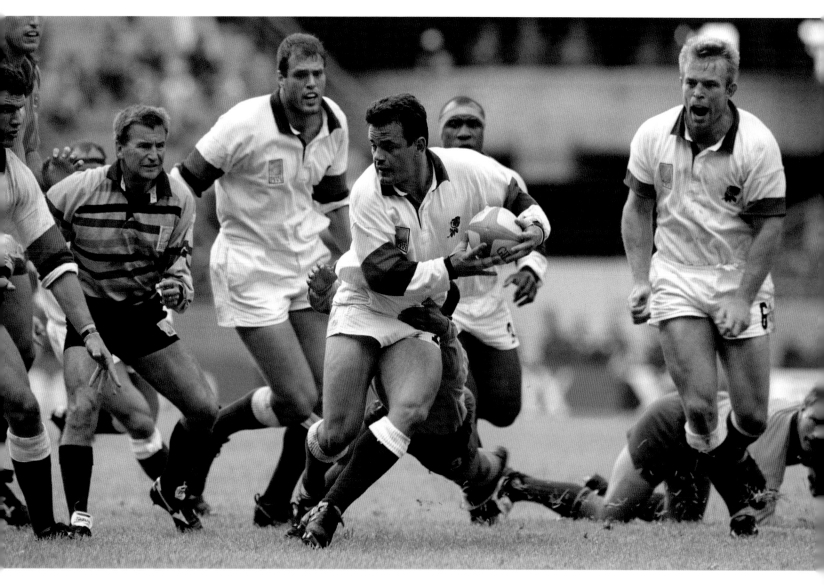

ENGLAND ATTACK

England's Will Carling (C) supported by Martin Bayfield (background, L) and Tim Rodber (R) during their victorious Rugby World Cup Quarter-Final against Australia. It was the first time England had beaten the Wallabies away from home.

Date: **11th June, 1995**
Venue: **Newlands, Cape Town, South Africa**

MEMORABLE MOMENT

In extra time, with the game tied at 22–22, England won a crucial line-out marginally within Australian territory. The pack pressed towards the Australian goal line, and as the ball came loose, Dewi Morris swept a superb pass to Rob Andrew, who in turn unleashed a fearsome drop-kick from 45 metres. The ball sailed between the posts, securing England's place in the last four. Afterwards, England coach Jack Rowell summed up the moment, saying: *"People jumped ten feet when that went over. When they came down to earth, they were crying."*

Date: **11th June, 1995**
Venue: **Newlands, Cape Town, South Africa**

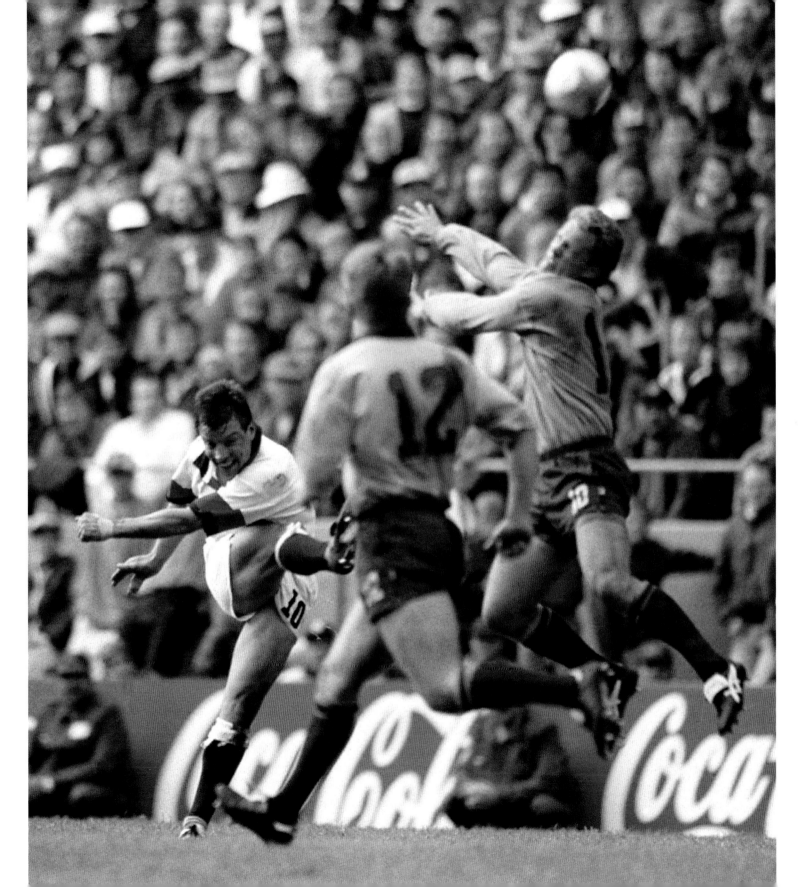

HANDED OFF

England's Tony Underwood fails to tackle New Zealand's phenomenal Jonah Lomu during the Rugby World Cup Semi-Final. The virtually unstoppable Lomu, a giant of a man with the speed of a sprinter, almost single-handedly blew England off the pitch, scoring four tries in a 45–29 win.

Date: **18th June, 1995**
Venue: **Newlands, Cape Town, South Africa**

GAME ON

Ruben Kruger of South Africa is tackled by New Zealand's Walter Little during the 1995 Rugby World Cup Final. Both teams took a cautious approach, the Springboks opting to mark Jonah Lomu out of the game. The home nation went into the second half just 9–6 up, but the All Blacks levelled courtesy of an Andrew Mehrtens penalty. Mehrtens nearly broke South African hearts in the dying moments of regulation time, but his drop goal attempt veered wide. The match went into extra time, with each side notching up an early penalty. But the game finally headed South Africa's way in the second half of extra time when Joel Stransky received the ball and slotted over the winning drop goal with his right boot.

Date: **24th June, 1995**
Venue: **Ellis Park, Johannesburg, South Africa**

NATION BUILDING

South Africa's captain, Francois Pienaar, receives the Webb Ellis Trophy from Nelson Mandela in one of the most iconic moments in recent sporting history. The Springbok jersey, so long associated with South Africa's minority white community, had suddenly become a symbol for unity. Pienaar, reflecting on an extraordinary match and a fairytale ending, said: *"No one could have written a better script."* It was a statement heeded by the Hollywood writers of the Oscar winning film *Invictus*, which told the story of the 1995 Rugby World Cup.

Date: **24th June, 1995**
Venue: **Ellis Park, Johannesburg, South Africa**

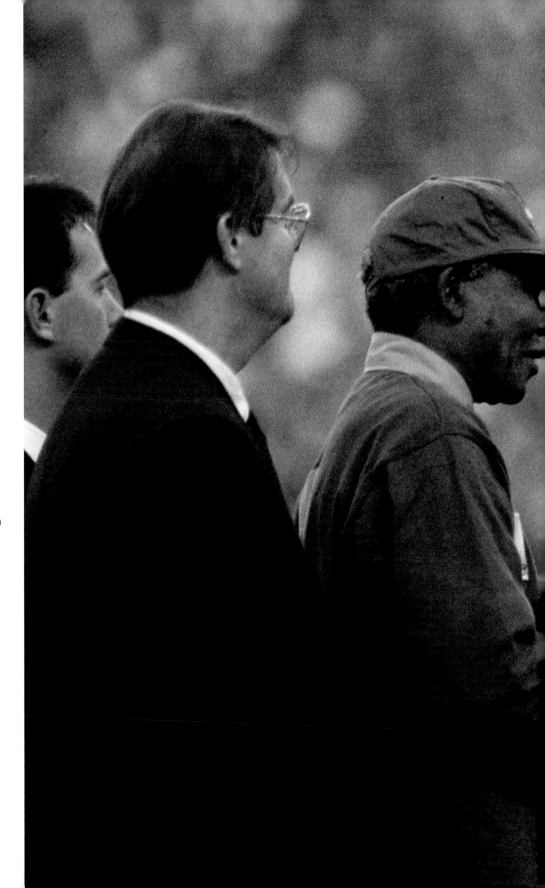

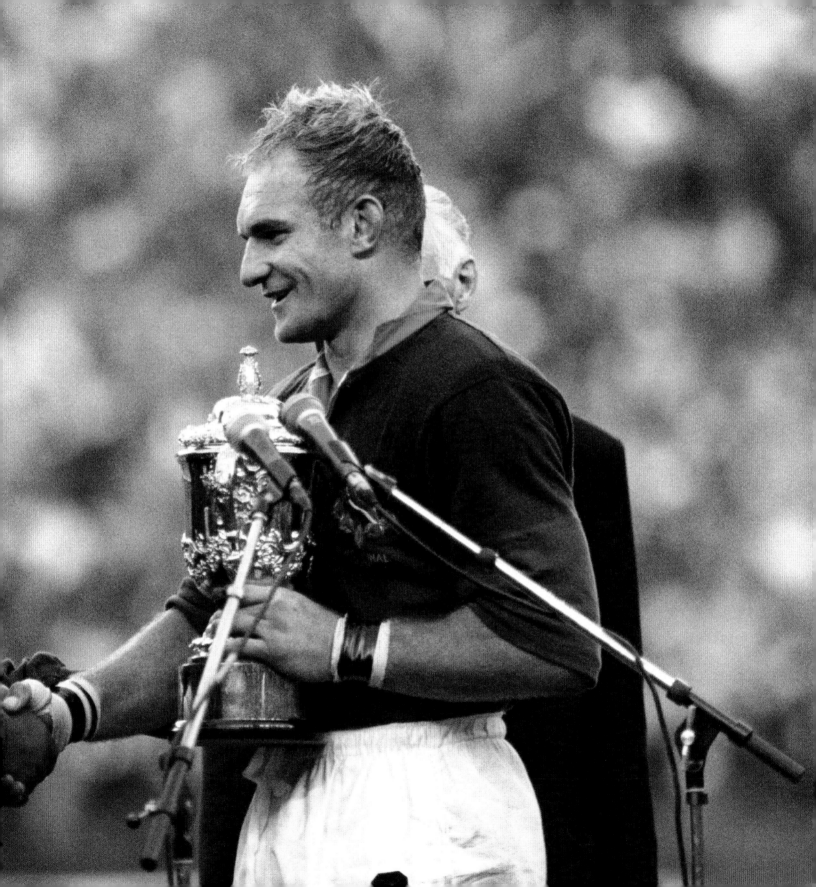

JENKINS THE BOOT

Neil Jenkins (R) in action during Wales's opening fixture of the 1999 Rugby World Cup, against Argentina. Jenkins converted Colin Charvis and Mark Taylor tries, and kicked three penalties for a 23–18 win. Wales lost against Samoa, but beat Japan to top Pool 4 and qualify for a quarter-final against Australia.

Date: **1st October, 1999**
Venue: **Millennium Stadium, Cardiff**

LARKHAM ON THE RAMPAGE

Australia's Stephen Larkham tries to get away from Wales's Mark Taylor during a Rugby World Cup quarter-final match. When he began his international career, Larkham was switched to fly-half, where he played the majority of his 102 games for the Wallabies. In this position, he forged a formidable reputation, his running skills and ability to galvanise the back line contributing to Australia's World Cup victory in 1999. He is perhaps best remembered for scoring a 48-metre drop goal against South Africa in the 1999 Rugby World Cup Semi-Final.

Date: **23rd October, 1999**
Venue: **Millennium Stadium, Cardiff**

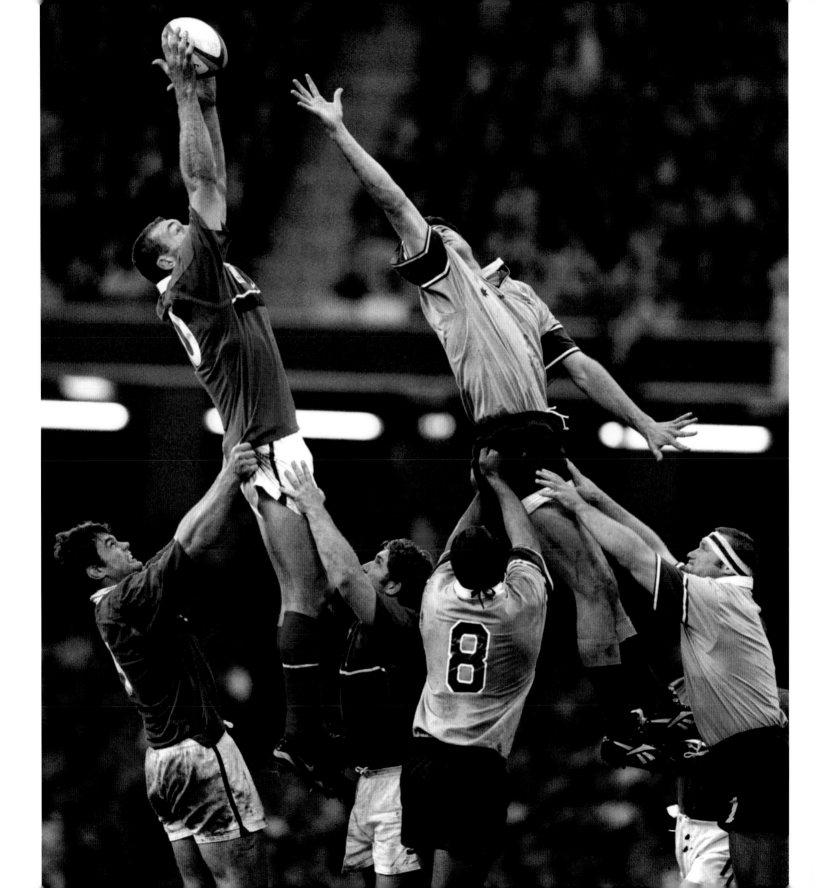

EALES LIFTED IN VAIN

France's Olivier Brouzet (L) takes the ball at a line-out, as Australia's John Eales (R) just fails to reach it, during the Rugby World Cup Final. France had shocked the rugby world with a thrilling display in the semi-final against New Zealand, which they won 43–31. With the All Blacks cruising at 24–10, the French embarked on one of the most extraordinary comebacks ever witnessed, scoring 33 points to their opponents' seven, comprehensively outplaying a clearly shell-shocked All Blacks side.

Date: **6th November, 1999**
Venue: **Millennium Stadium, Cardiff**

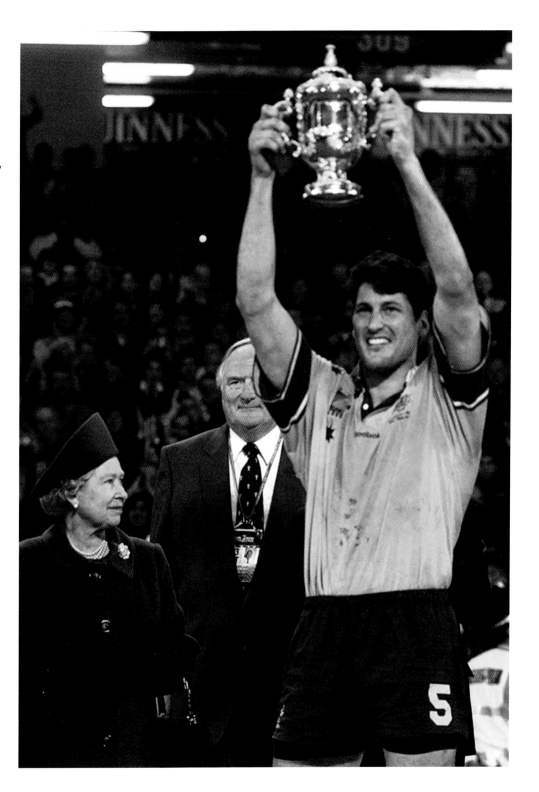

EALES LIFTS THE TROPHY

John Eales, captain of Australia, receives the Webb Ellis Trophy from the Queen, after the Wallabies' victory against France in the Rugby World Cup Final. French indiscipline allowed Matt Burke to kick seven penalties, four of which he scored in the first half to give Australia a 12–6 lead at the interval. Further Burke penalties and tries from Ben Tune and Owen Finegan, after the break, put the game beyond *Les Bleus*, who lost 35–12.

Date: **6th November, 1999**
Venue: **Millennium Stadium, Cardiff**

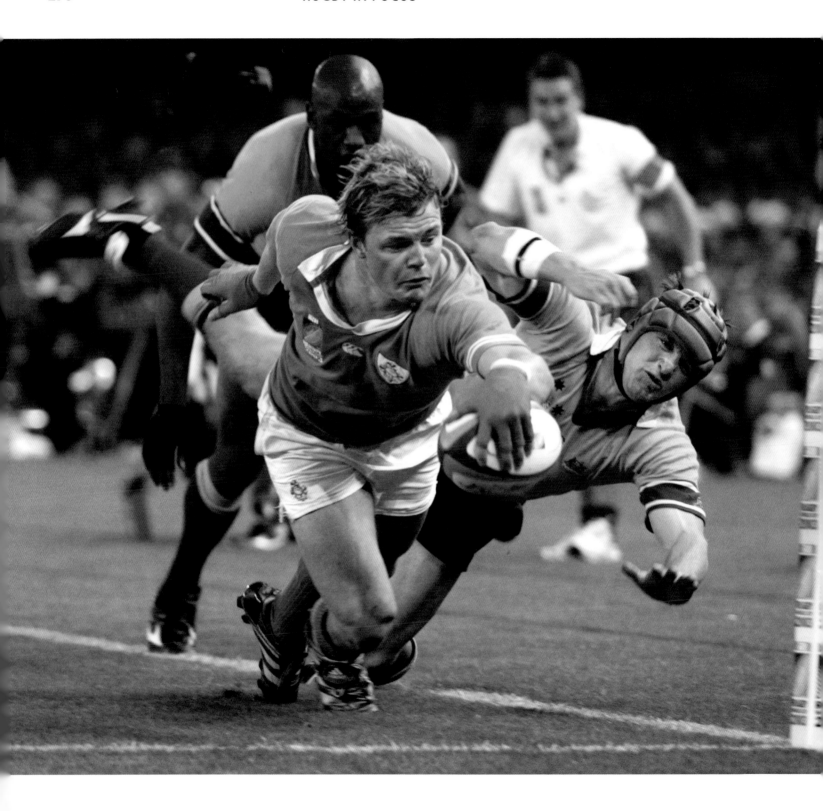

O'DRISCOLL'S TRY

Brian O'Driscoll reaches over to score Ireland's first try against Australia during the Pool A match of the 2003 Rugby World Cup. Later, O'Driscoll would score a drop goal, but it would not be enough, and Ireland would lose 17–16 to the reigning World Champions.

Date: **1st November, 2003**
Venue: **Telstra Dome, Melbourne, Australia**

MAUGER BREAK

New Zealand centre Aaron Mauger breaks through the diving tackle of South Africa's De Wet Barry (C) and Derick Hougaard during their 29–9 victory in the Rugby World Cup Quarter-Final. Tries from Leon MacDonald, Keven Mealamu and Joe Rokocoko sealed the win for the All Blacks to set up an all-Antipodean semi-final against Australia.

Date: **8th November, 2003**
Venue: **Telstra Dome, Melbourne, Australia**

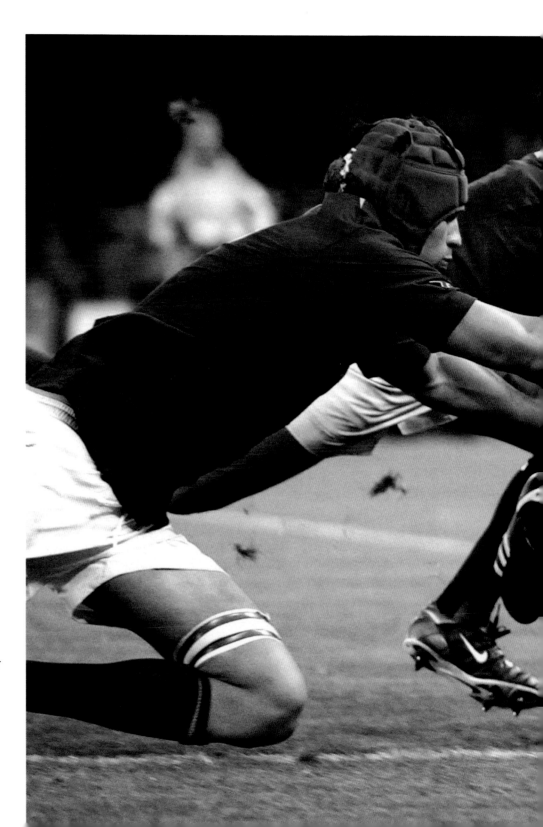

FINISHED IN STYLE
Winger Joe Rokocoko, the latest in a long
line of clinical All Black finishers, goes over
to score New Zealand's third try during
their Rugby World Cup Quarter-Final
against South Africa.

Date: **8th November, 2003**
Venue: **Telstra Dome, Melbourne, Australia**

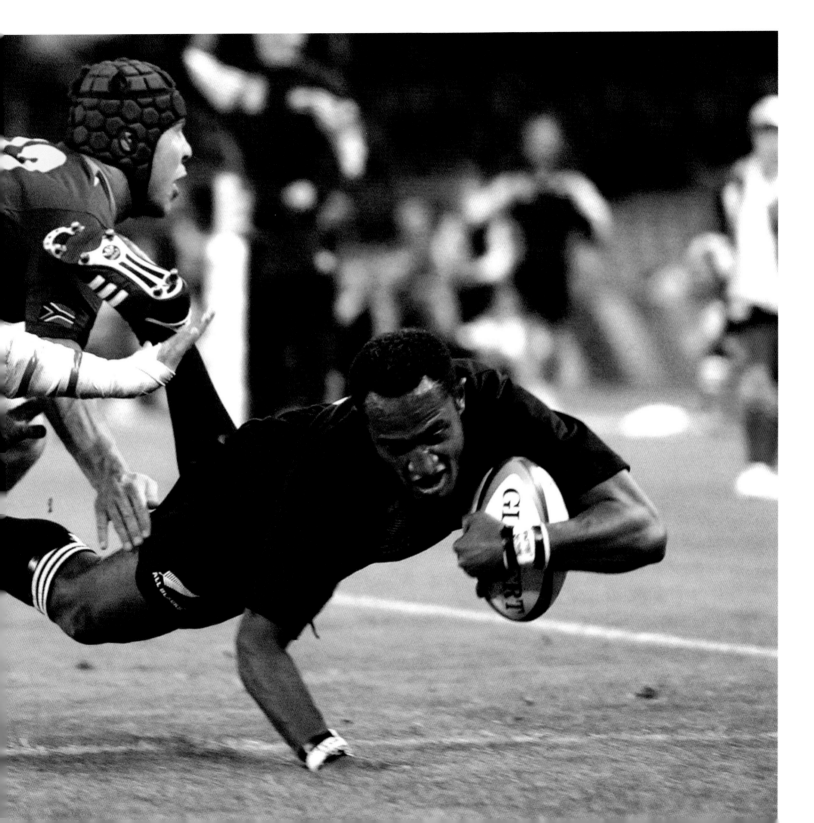

BALL OUT

France's scrum-half, Fabien Galthie, sends out a classic dive pass during their 43–21 victory over Ireland in the Rugby World Cup Quarter-Final.

Date: **9th November, 2003**
Venue: **Stade de France, Paris, France**

ON THE CHARGE *(right)*

Olivier Magne of France during the quarter-final match against Ireland. Magne scored the first of France's four tries in only the third minute of the match. It was a lead that they never looked like relinquishing despite a gallant second-half performance by the Irish. A quick and skilful back-row forward, Magne made 89 appearances for his country, scoring 14 tries.

Date: **9th November, 2003**
Venue: **Stade de France, Paris, France**

JASON'S TRY *(following page)*

Jason Robinson celebrates scoring his try for England against Australia during the Rugby World Cup Final. Robinson went over on 38 minutes to ensure that England went into the half-time interval with a 14–5 lead.

Date: **22nd November, 2003**
Venue: **Telstra Stadium, Sydney, Australia**

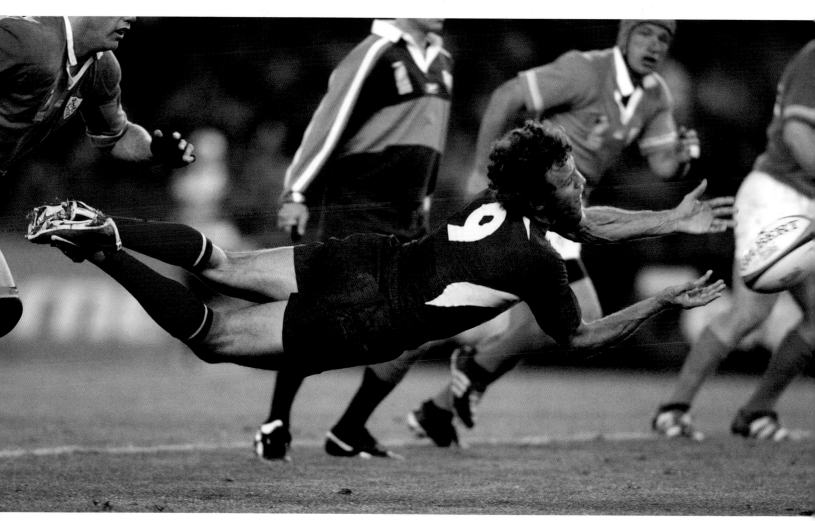

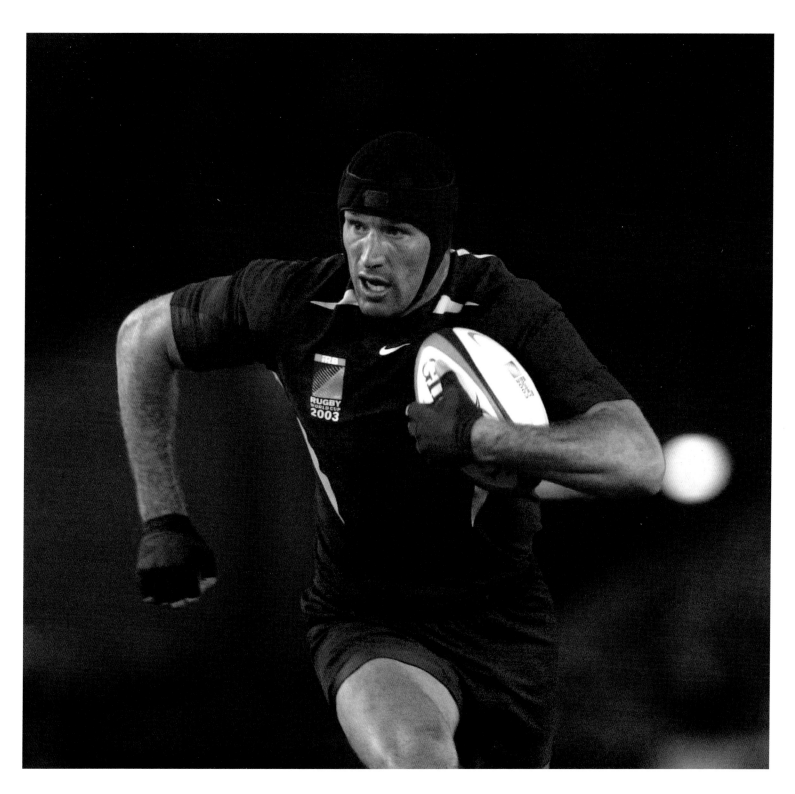

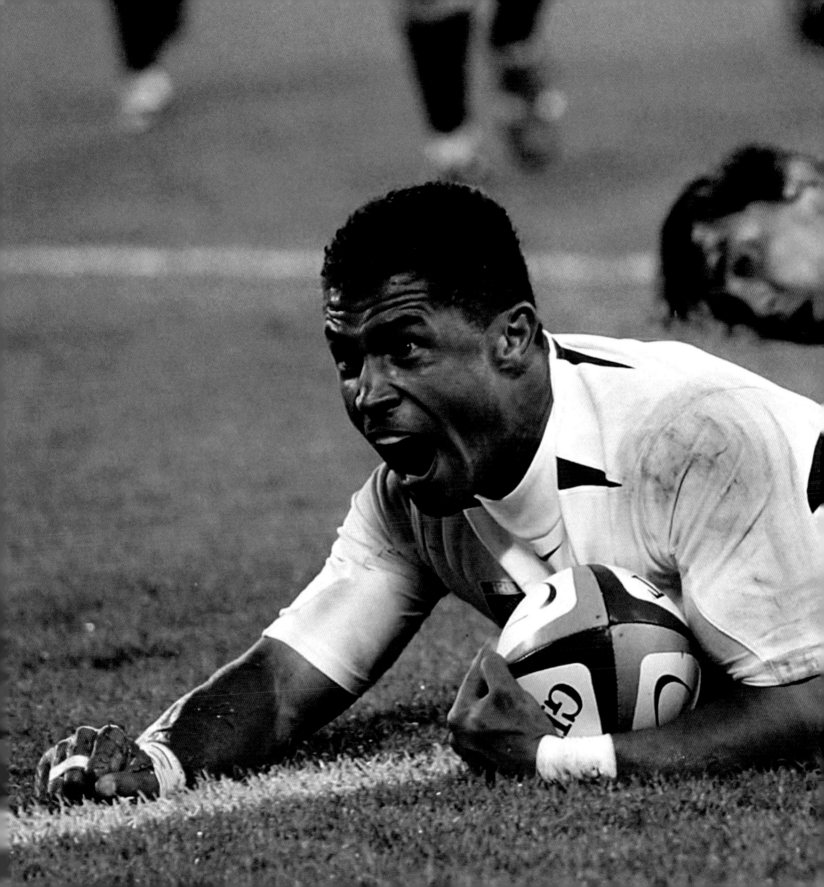

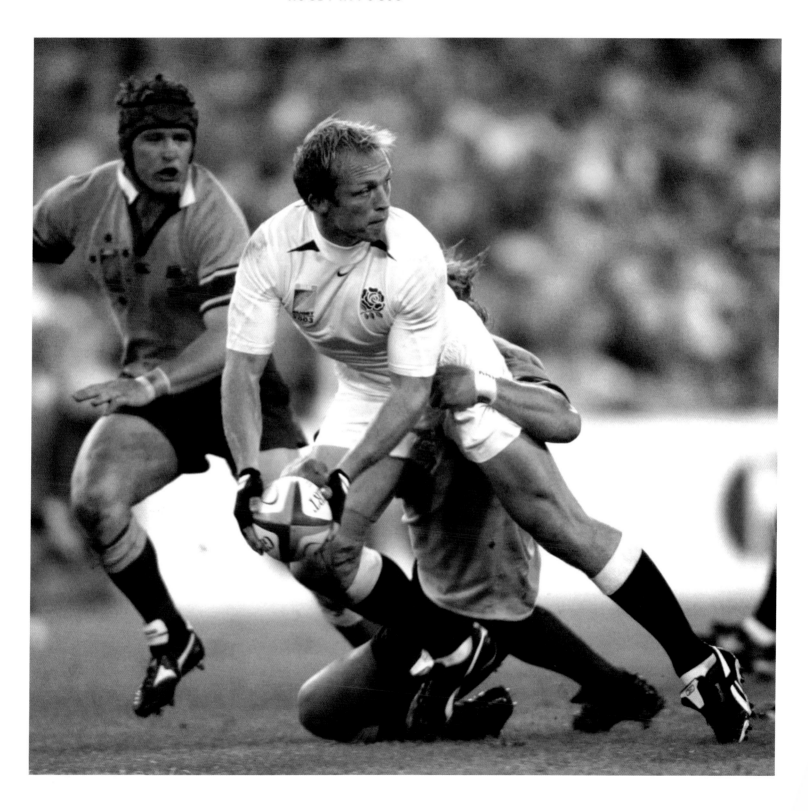

PASS MASTER

England's Matt Dawson is tackled by Australia's Phil Waugh during the Rugby World Cup Final. Scrum-half Dawson was one of the key men for England in the game, making a 20-metre break deep into extra time to set up Jonny Wilkinson's dramatic drop goal.

Date: **22nd November, 2003**
Venue: **Telstra Stadium, Sydney, Australia**

SCRUM MASTERS

(L–R) Phil Vickery, Steve Thompson, Trevor Woodman, Richard Hill and Lawrence Dallaglio prepare themselves for a scrum in the 2003 Rugby World Cup Final against Australia.

Date: **22nd November, 2003**
Venue: **Telstra Stadium, Sydney, Australia**

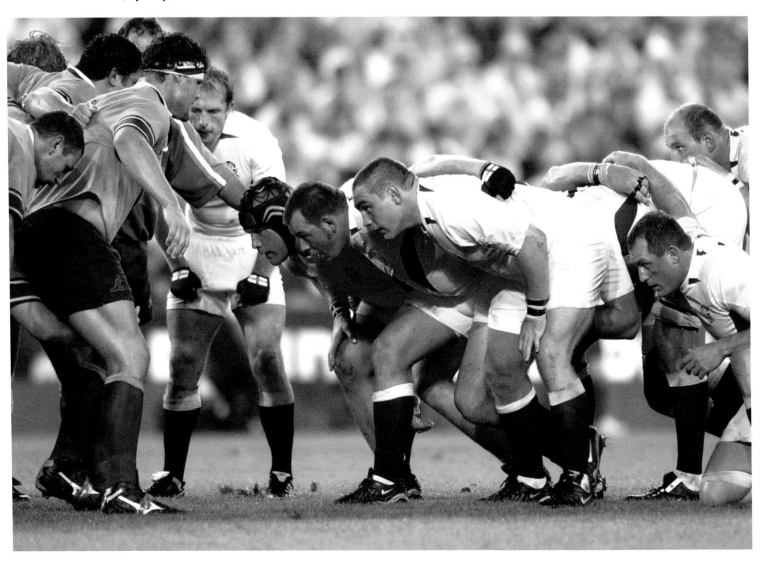

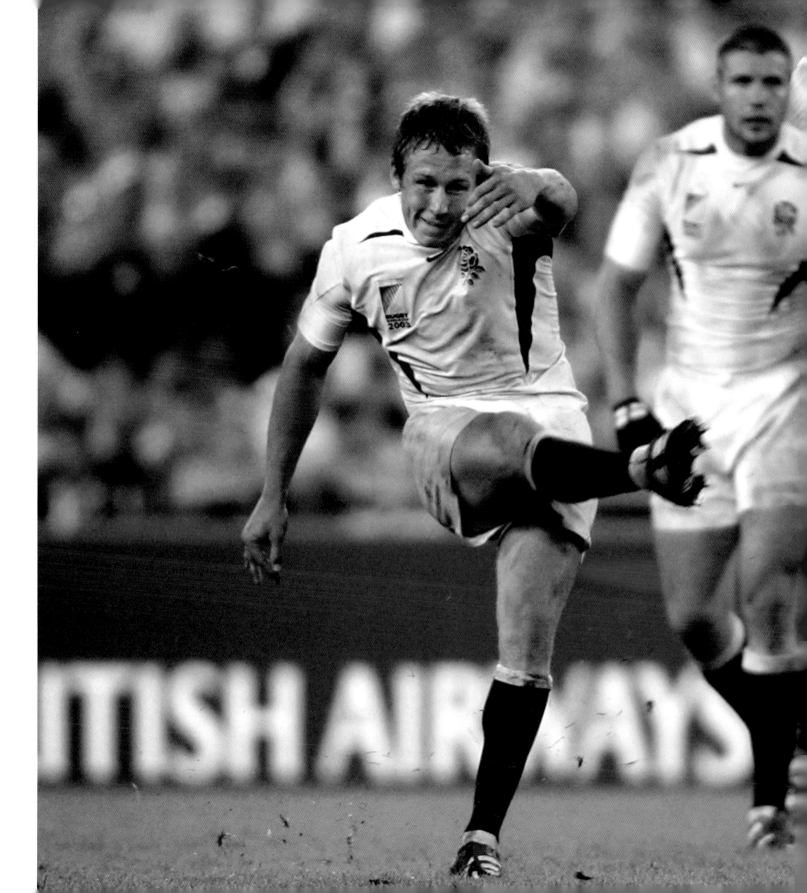

WILKINSON KICKS FOR GLORY
England's Jonny Wilkinson kicks the winning drop goal to clinch the Rugby World Cup for England in the final seconds of a thrilling final between Australia and England in Sydney. With the game heading towards 'Sudden Death', a brilliant surge by Matt Dawson into kicking range set up Wilkinson's chance to write himself into English sporting history.

Date: **22nd November, 2003**
Venue: **Telstra Stadium, Sydney, Australia**

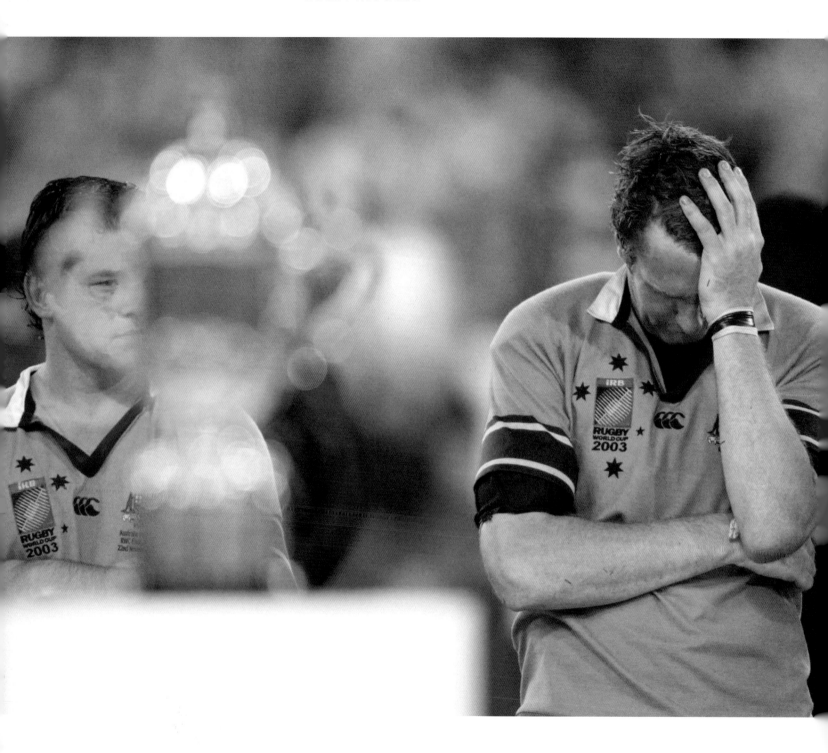

SO NEAR YET SO FAR

Australia's Justin Harrison holds his head in dejection following defeat by England in the Rugby World Cup Final. The Wallabies lost out on the opportunity to beat their old foe in front of home support after Jonny Wilkinson's last-minute drop goal secured a historic England win.

Date: **22nd November, 2003**
Venue: **Telstra Stadium, Sydney, Australia**

MARTIN'S MOMENT

England captain Martin Johnson celebrates with the Webb Ellis Trophy following the 2003 World Cup Final victory over Australia. Standing next to Johnson is Jonny Wilkinson (L), whose dramatic last-minute extra-time drop goal secured a 20–17 triumph for England.

Date: **22nd November, 2003**
Venue: **Telstra Stadium, Sydney, Australia**

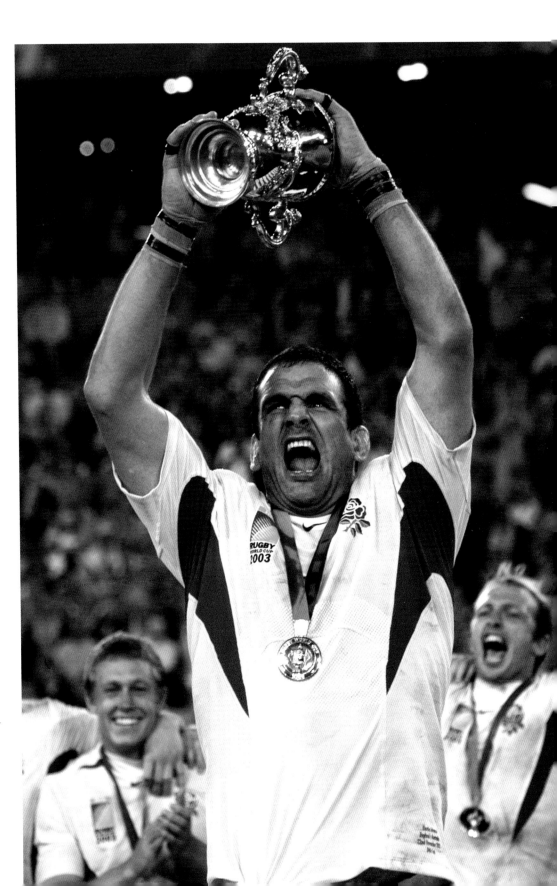

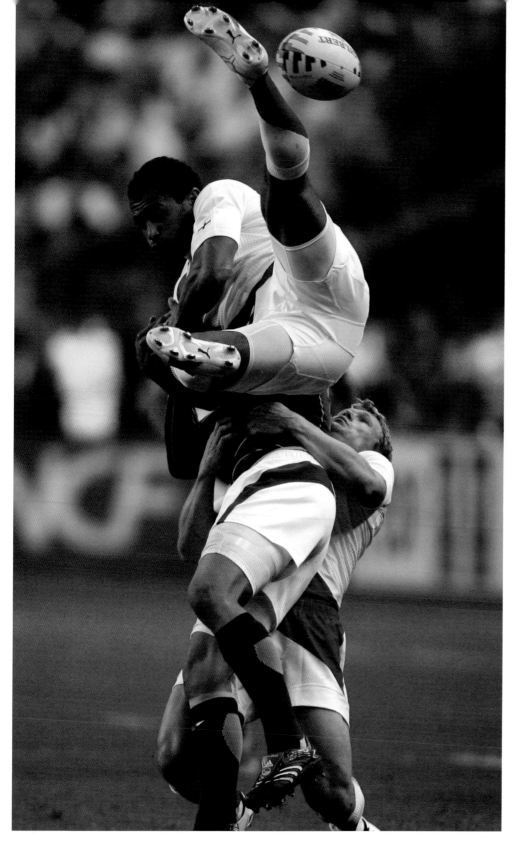

WHAT GOES UP

Jason Robinson, the smallest man in the England squad, goes up for a high ball during the Pool A match against South Africa during the 2007 Rugby World Cup. Coming into the tournament with no form and after a less-than-convincing opening victory against the United States of America, England were thrashed by the Springboks 36–0, doing nothing to suggest that the team were capable of retaining their world championship status.

Date: **14th September, 2007**
Venue: **Stade de France, Paris, France**

MUST COME DOWN

France's Julien Bonnaire during the 2007 Rugby World Cup Pool D match against Namibia. The French thrashed the African minnows 87–10, their biggest ever win in a rugby international. Namibia's already difficult task was made significantly harder following the 19th-minute sending off of Jacques Nieuwenhuis for a dangerous high tackle on France's Sébastien Chabal.

Date: **15th September, 2007**
Venue: **Stadium Municipal, Toulouse, France**

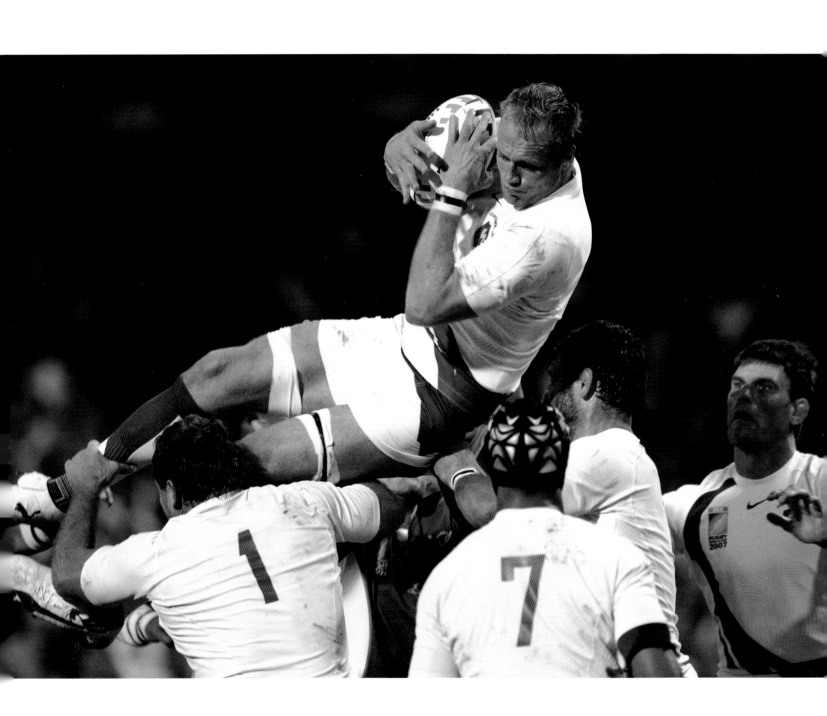

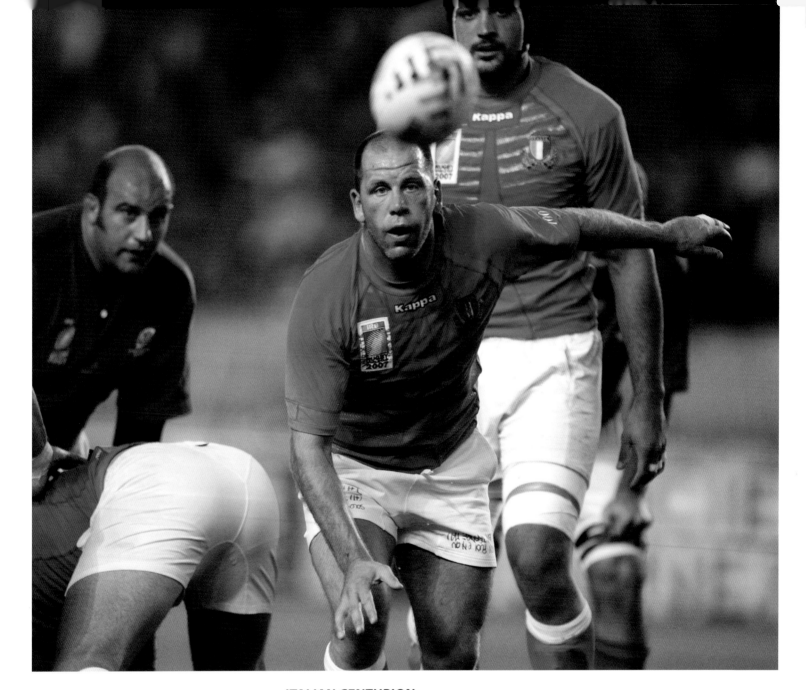

ITALIAN CENTURION

Italy's Alessandro Troncon passes the ball during the Rugby World Cup Pool C match against Portugal. The Italians ran out 31–5 winners in a match that saw Troncon become the seventh player to reach 100 Tests.

Date: **19th September, 2007**
Venue: **Parc des Princes, Paris, France**

FORWARD POWER

England's Lawrence Dallaglio celebrates at the end of the 12–10 quarter-final triumph against Australia. A monumental effort by the forwards gave England almost total dominance of the scrum and rucks, putting Australia on the back foot for the majority of the game. Despite scoring the only try of the match, the Wallabies had no answer to the power of the English, who came out on top thanks to four Jonny Wilkinson penalties.

Date: **6th October, 2007**
Venue: **Stade Vélodrome, Marseille, France**

CLOSE UP OF THE FULL BACK

South Africa's Percy Montgomery crashes into a TV camera during the Rugby World Cup Final against England. The Springboks had a relatively comfortable path to the final, beating Fiji and Argentina in the quarter-final and semi-final respectively. They had swept aside the English 36–0 in the Pool match earlier in the tournament, but some impressive displays by England in the knockout stage of the competition suggested that the final would be a much closer affair. Although understandably disappointed after their defeat, the England players could look back at some positive performances.

Date: **20th October, 2007**
Venue: **Stade de France, Paris, France**

THAT LOSING FEELING

England's Jonny Wilkinson dejected after losing the Final to South Africa 15–6. A strong defensive display gave a second Webb Ellis Trophy to the Springboks, last crowned champions in 1995. England could be proud of positive performances hinting at a return to the form of 2003.

Date: **20th October, 2007**
Venue: **Stade de France, Paris, France**

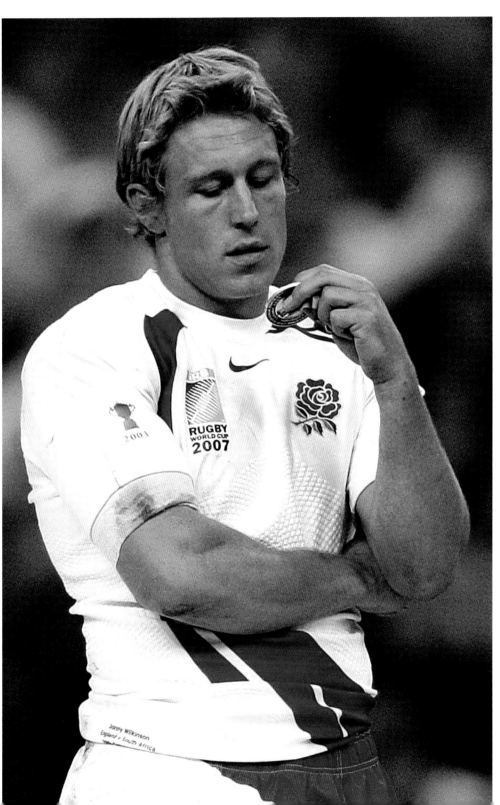

BATHED IN GLORY
Captain John Smit (L) and flanker Schalk Burger (R) salute their supporters following South Africa's 15–6 win over England in the Rugby World Cup.

Date: **20th October, 2007**
Venue: **Stade de France, Paris, France**

THAT WINNING FEELING
South Africa's Percy Montgomery kisses the Webb Ellis Trophy following his team's win over England. Montgomery kicked four penalties, but it was the rock solid South African defence and their dominance of the line-outs that proved decisive.

Date: **20th October, 2007**
Venue: **Stade de France, Paris, France**

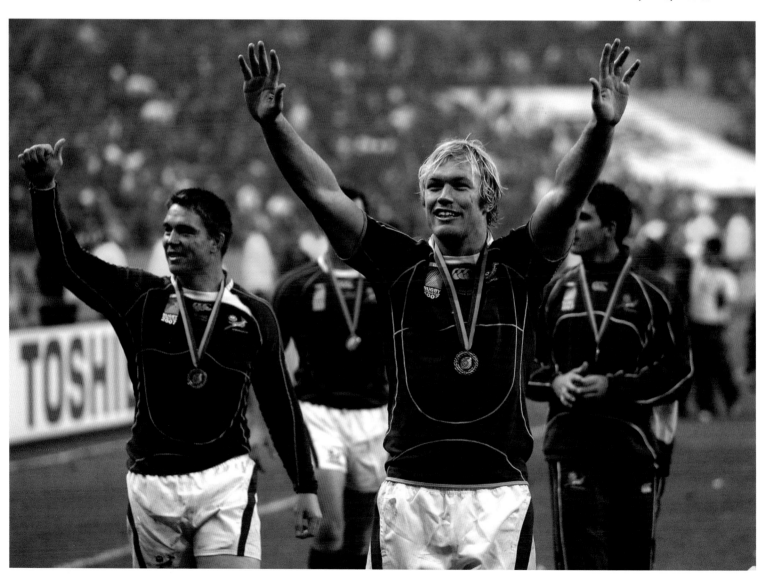

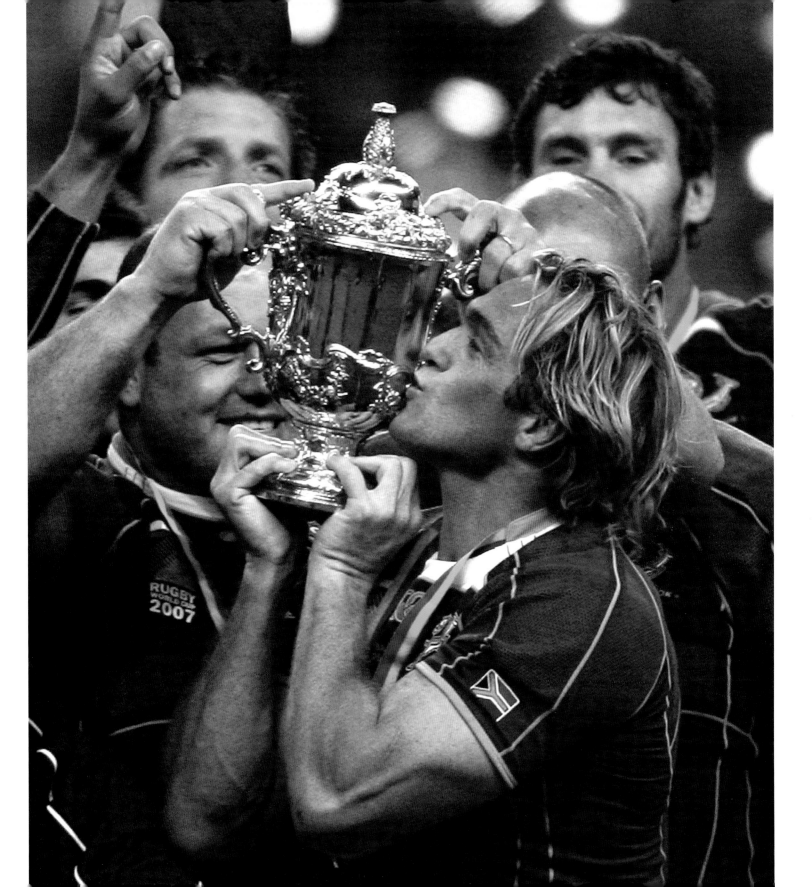

The Publishers gratefully acknowledge Press Association Images, from whose extensive archives the photographs in this book have been selected. Personal copies of the photographs in this book, and many others, may be ordered online at www.prints.paphotos.com

AMMONITE PRESS

PRESS ASSOCIATION Images